PAINTING THE
IMPRESSIONIST
WATERCOLOR

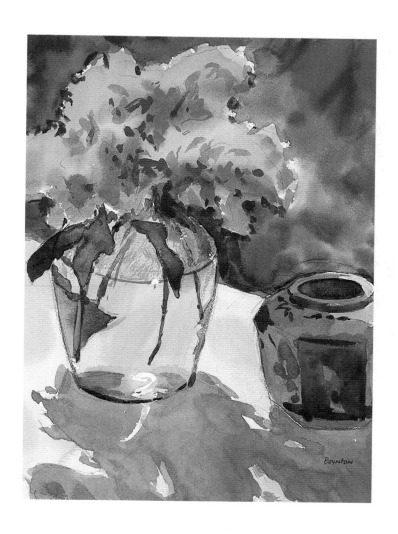

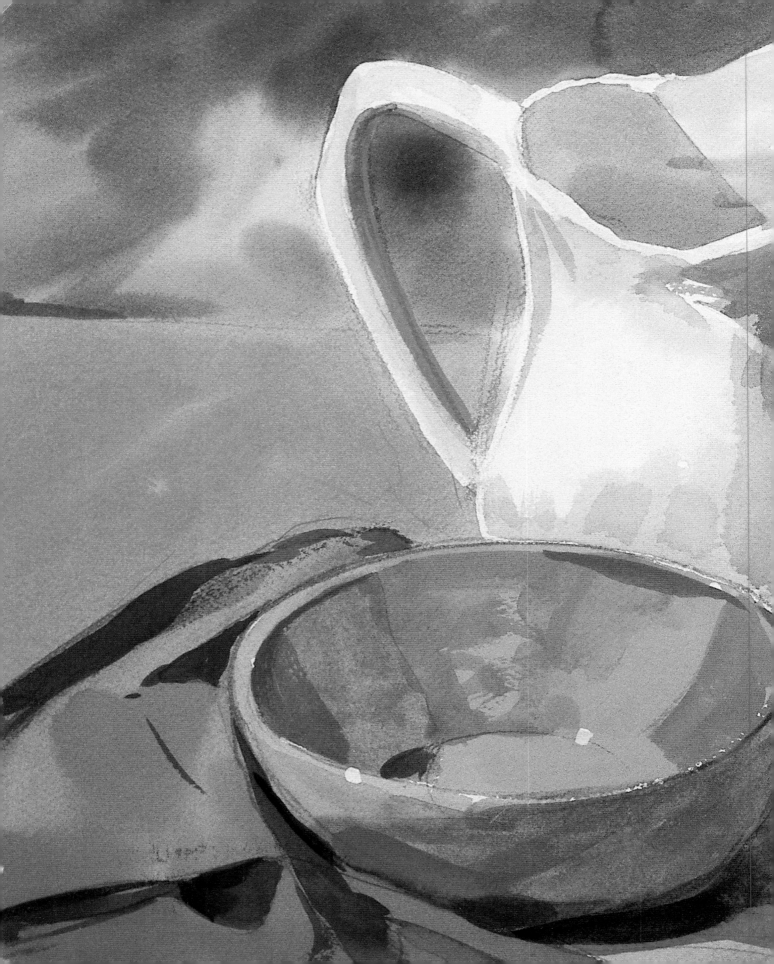

PAINTING THE IMPRESSIONIST WATERCOLOR

LEE BOYNTON
LINDA GOTTLIEB

WATSON GUPTILL PUBLICATIONS / NEW YORK

ACKNOWLEDGMENTS

We extend sincere thanks to Candace Raney, Executive Editor, Watson-Guptill, for seeing the potential in a proposal from two complete novices and making our dream a reality; to Sylvia Warren, for a superb job of distilling our manuscript into a tightly-woven book; to Lois Griffel for her valuable advice and for cheering us on; and especially to our spouses, Martha Boynton and Paul Gottlieb, for their unflagging support, encouragement, and patience, without which our task would have been impossible.

Senior editor: Candace Raney
Production manager: Ellen Greene
Designer: Patricia Fabricant

ISBN: 0-8230-2501-2

©2004 Lee Boynton and Linda Gottlieb
First published in 2004 by Watson-Guptill Publications,
a division of VNU Business Media, Inc.
770 Broadway, New York, N.Y. 10003
www.watsonguptill.com

Library of Congress Control Number 2003112639

Printed in China
First printing, 2004
1 2 3 4 5 6 7 8 9 / 10 09 08 07 06 05 04

CONTENTS

FOREWORD

As a young artist, I was drawn to the richness and painterly-ness of the Impressionists. My first museum experience introduced me to Van Gogh's *Irises*. The luscious, thick paint and glowing color enthralled me and painting became a passion that has never left me. I spent hours trying to emulate the qualities I had seen in the Van Gogh. The myriad of art instruction books just didn't give me the answers that I sought. I found much of the watercolor approach then limited and constraining, and I kept returning to museums seeking solutions. When I visited the watercolors of John Singer Sargent or Winslow Homer, I knew that both of those artists had discovered the secrets of achieving the same Impressionist color qualities in their paintings that I had seen in the Van Gogh. I hoped that someday I would find out how they did it.

Maturing as an artist, I gravitated to the opaque media because with them I was able to achieve the results that I sought. My studies led me to the Cape Cod School of Art and Henry Hensche in Provincetown, Massachusetts. Henry was considered a master in the art of using color to depict the many different qualities of light effects. In short, he was the consummate Impressionist! At the school, I met dozens of artists like myself who were dedicated to the Impressionist way of painting.

THE MOORS, *Lois Griffel. Oil on canvas, 40 x 60 inches.*

The person who stood out from the crowd was Lee Boynton. He not only had mastered the color theory taught by Henry in oils, but he also was the first contemporary artist I had seen who effectively used the concepts and tenets of Impressionism in watercolor. His application had the same quality that I saw in the watercolors of the Impressionist masters. Although there are many books written by wonderful watercolor artists, none come close to explaining the qualities I saw in Lee's paintings. To me, he is the first true successor to the Sargent and Homer watercolor legacy.

When I became the director of the Cape Cod School of Art, I invited many of my colleagues to teach. I wanted to expand the program Hensche had created into a greater variety of media and subject matter. Needless to say, Lee Boynton's watercolor classes have been enthusiastically received by a large number of students.

Lee is not only a wonderful artist, but he also is one of the most truly gifted and generous teachers that I have ever met. One cannot help learning from him; his enthusiasm for sharing his passion with students is second only to his passion for painting. When he and one of his students, Linda Gottlieb, told me they were starting this book, I strongly encouraged them to continue.

When I reviewed what they had written, I became even more enthusiastic. Most of the books teaching the Impressionist way of painting do it through the medium of oil paints. Finally there is a watercolor instruction book that provides explicit details about creating Impressionist paintings in watercolor. You will find that this book is also different from most contemporary watercolor instruction books in its emphasis on the direct application of color by the wet-on-wet technique. Lee's approach frees watercolor from the constraints of more traditional approaches.

Another very important difference is that this is the only instruction book I am aware of that is co-written by an artist and one of his students. This results in a level of detailed explanation that a beginning student needs as well as encouragement to persevere. Lee's co-author, Linda, has succeeded in looking at the explanation of the painting process as if she had never heard it before. She has paid close attention to the need to describe with words what is observed by students who are present in one of Lee's classes. She has also succeeded in including answers to questions that students often ask, but which readers cannot. The collaboration of teacher and student has resulted in an expansion of ideas and the development of an organized and detailed step-by-step description of the painting process which includes an explication of basic concepts of Impressionist watercolor painting.

Both beginners and accomplished artists will find this book a valuable addition to their bookshelf. I can say with all confidence that as soon as you have finished reading this book and following the instructions in it, you are going to be thrilled by the new level of skill that you will achieve and the newfound freedom in your painting.

LOIS GRIFFEL
Director, Cape Cod School of Art

PREFACE

This book is intended to introduce you to several key concepts and a method of watercolor painting that has grown out of my experience of Impressionist painting.

Many art instruction books seem to be aimed at people who already have a lot of experience, and so they can be more frustrating to beginners than helpful. My co-author and I have tried to write a book that someone who has only had drawing instruction or experience can use. While doing that, we also tried to provide information that would be helpful to those already experienced in other mediums or in other forms of watercolor, or who want more systematic instruction in Impressionist watercolor. We hope we have made it clear that while the techniques may differ, the principles of Impressionist painting can be applied to any medium.

Many people, if not most, never go beyond looking *at* the world around them, simply taking in immediate visual input. Another goal of this book, then, was to help you open your eyes and learn not only to *see* but to interpret what you see and portray it so that others can share your vision. As your skill develops beyond the point that you are not continually struggling with the medium and with the basic principles of Impressionist painting, your own vision, interpretation, and style will begin to develop.

Watercolor does not have to be a timid medium. Many new students tiptoe up to it, afraid to make a mistake. It's important to remember that if you don't like the results of your first attempt, you can start again. It's through the experience of painting that you learn, and once you grasp the step-by-step concepts explained in this book, you will be able to paint with confidence.

The book also stresses the importance of becoming more spontaneous and intuitive. Creating the light effect cannot be done through a methodical approach. Spontaneity and light go hand in hand. The moment of conception, that first direct response to the image, is the most difficult moment but also the most exhilarating. It's really the supreme creative act, and there's nothing else like it. That's what painting is all about: the excitement and the struggle side by side. It takes a lot of energy, physical as well as mental, and a great deal of confidence.

Finally, Linda and I hope you will feel some of the passion that we do about the "why" of the artistic endeavor. You must have passion for what you paint. You must love the beauty you learn to see both in grand vistas and in humble canning jars, and it is your work as an artist to reveal that beauty to others through the passionate portrayal of what you see.

LEE BOYNTON

All art in this book not otherwise attributed is the work of Lee Boynton. Most of the paintings are small—9 by 12 inches or 12 by 16 inches—and the paper dimensions are included in the captions only for larger paintings.

INTRODUCTION

My first class with Lee, Impressionist Watercolor Realism, was a revelation. First he went over the supplies list and explained why certain things were recommended and others were definitely not. He seemed a little charged up, but his enthusiasm for painting was catching.

Then he started a demonstration painting. He made a quick sketch and then sloshed water all over his paper. None of the watercolor instruction books I had consulted so far had mentioned this! Several covered wet-on-techniques, but not drowning the entire painting surface. His explanation of why he was doing this went right over my head, not because he wasn't clear, but because I was suddenly in foreign territory and didn't know the language.

While talking about establishing masses of color and separating the light and shadow, he began applying paint to his wet paper. He talked fast and worked even faster, flicking water and paint onto the floor behind him after each dip into the water bucket. Most of the areas bled into each other. And the colors he used were certainly not the colors I saw. When he finished covering the paper, all I could see were a bunch of fuzzy blobs in bright, strange colors. I began to wonder if he had any idea what he was doing.

To my utter amazement, the blobs began to take shape as he continued to work on them. The shapes began to resemble the objects in the setup. The colors were still a little wild, but at least most of them were closer to those I saw in the scene. When he declared the painting finished, I was amazed. All those fuzzy blobs and garish colors had been tamed so that they were a recognizable representation of the scene in front of us. And the painting was indeed filled with light.

I soon realized that my small collection of watercolor instruction books would be useless for this class. So I, and other students as well, searched the libraries and bookstores for books we could consult between classes. We couldn't find any. Some of the titles sounded promising, but the books didn't deliver what the titles promised. A few contained information for beginners, but none covered Impressionist watercolor. And those that promised to show how to put light in our paintings only did so by leaving a lot of white paper.

In addition to this fruitless search, students in Lee's classes would regularly say, "Someone should be writing this down." Often, they were not even referring to the painting instructions he was providing. Lee also talked about the "why" of painting. His love of what he does and his excitement about being able to see and depict color and light are inspiring. That is perhaps the most important thing I have tried to capture in this book.

I've realized that I'll never be an artist, but it doesn't really matter, because Lee has taught me to see. The world around me is so much richer and more beautiful than it was before. I never realized that there were so many shades of green in a stand of trees, as well as red and yellow and brown. I never saw the colors in shadows, or paid much attention to what Lee calls "the veils of atmosphere." And I will never forget the first time I looked at a red block in late afternoon light and realized that the top was not red at all, but a glowing gold. I agree with Francis Bacon: "The beholding of the light is in itself a more excellent and a fairer thing than all the uses of it." (*Novum Organon,* Book I)

After several years of hearing other students express both frustration with the lack of printed material and excitement about the expansion of their vision, I asked Lee if he would like to write a book together and he immediately agreed. The time seemed to be right, and the book you hold in your hands is the result. I hope you will find it both useful and inspiring.

A note about the narrative: Obviously, Lee has provided the raw material for this book in interviews and during classes over the past several years. Both Lee and I have contributed to the text. Having read other books by two authors that try to distinguish who said what, and finding them confusing, I have written this in one voice: Lee's. I want someone who knows Lee to come across an anonymous exerpt from this book and exclaim, "This sounds just like Lee Boynton!"

LINDA GOTTLIEB

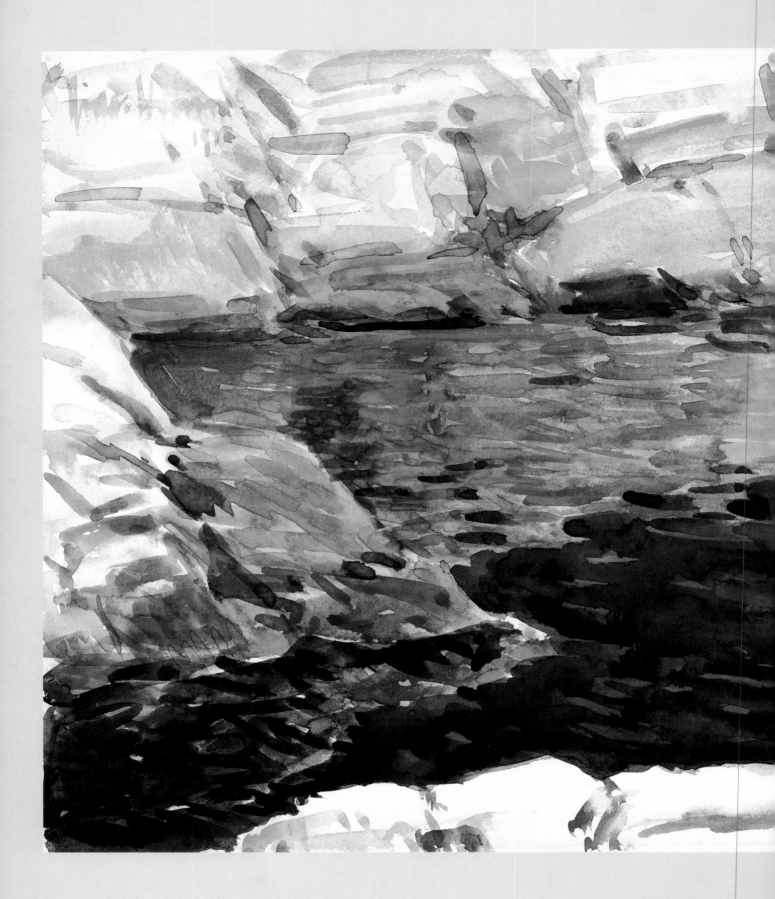

1

IMPRESSIONISM: PAINTING LIGHT

*T*o paint the Impressionist watercolor, you must first understand what Impressionism really is. This chapter provides a brief overview of European and American Impressionism, including the Impressionist watercolor.

LOOKING INTO BERYL POOL (1912), *Childe Hassam.*
Watercolor on paper, 11 x 15 inches (27.6 x 38.8 cm).
Worcester Art Museum, Worcester, Massachusetts.
Bequest of Mrs. Charlotte E. W. Buffington.

Looking into Beryl Pool is a glowing example of what watercolor can depict. The rocks in the sun are predominantly but not exclusively warm. The rocks on the far shore with the water-stained quality are mostly yellows and red mixed together on the paper. The cracks and shadows on the far rock wall are both cool and dark. The foreground rocks are washed with a soft yellow mixed with white so they are slightly warm yet also cool. The deep blues of the sky reflect into the deep water of the hole, where Hassam has used a very dark, rich shade of blue-violet.

THE LIGHT EFFECT

Many think that Impressionist painters use pale colors, often applied in small dabs, to create paintings that have a rather misty effect. In fact, the Impressionist masters were the first to paint light and shadow using all the colors of the natural spectrum. *The primary aim of the Impressionist painter is expressing the effect of light upon the objects in the scene.* The intensity of that light is expressed with the purity of hue, or pigment, in the lighted parts of the scene contrasted with the shadows. Impressionism is not a definable technique, but a way of seeing. The techniques an Impressionist uses are informed by direct visual experience. When we study the works of the Impressionist masters, we are studying their personal descriptions of the light effect. By studying the broken-color work of Monet and other masters, for example, I learned that the sky is never all "blue," even on a sunny day. If you look at Impressionist skys up close, you will see pinks and scarlets in addition to blues. Using those colors is how I give my sky the warmth of the sun.

The Impressionists knew that the color of light changes depending on its source (e.g., natural light outdoors, natural light indoors, or artificial light indoors), the season and latitude, the weather and sky conditions, and time of day. There is a wide range of colors in objects in natural light, which contains all colors in the spectrum. Incandescent light is pitched toward the yellow-orange portion of the spectrum, so blues, greens, and violets are not as obvious.

Claude Monet

Claude Monet (1840–1926) was one of the first artists to paint the same subject over and over, at different times of day and in different seasons. Monet was exceptionally bold in his use of color to depict light; striking examples are his paintings of the cathedral at Rouen at different times of day, two of which are reproduced on the following pages. These paintings are examples of Monet's daring mixtures of colors. From a distance, for example, the doors in shadow look like a glowing orange-red, but on closer inspection, we can see a subtle use of earth colors, not the bright reds we expected. Overall, the result of Monet's use of color is that the stone of the building ceases to be merely color on canvas and is transformed into the thing itself.

Childe Hassam

Childe Hassam (1859–1935) is often referred to as "the American Monet." He painted in both oil and watercolor. All of his watercolor paintings show a daring use of color. The colors in *Looking into Beryl Pool,* for example (reproduced on the first page of this chapter), are the antithesis of the pale, misty watercolor look many people associate with Impressionism. The multitude of colors Hassam wove into this painting are vibrant and glowing. Each stroke has been dashed down quickly with authority and confidence, and the result is a vitality not found in much watercolor painting. His painting is very fresh and direct and not overworked. I show my students *Looking into Beryl Pool,* and others by Hassam, to inspire them to take more risks. Studying Hassam's work shows watercolorists how far they can push color and what astonishing depth they can achieve.

SUMMER FLOWERS, *Bonnie Roth Anderson.*
Oil on board, 10 x 12 inches.
The shadow in the foreground contrasts with and dramatizes the warmth of the sunlit parts of this painting.

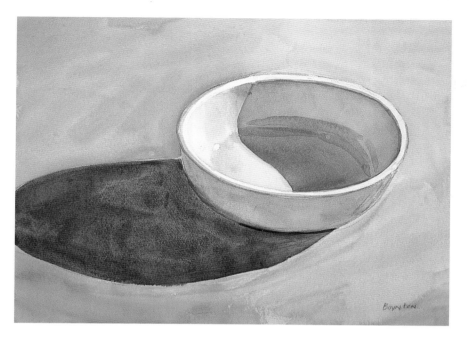

WHITE BOWL OUTDOORS,
Lee Boynton. Watercolor, 9 x 12 inches.

Despite its title, this is *not* a painting of a white bowl. It is an impression of sunlight shining on a white bowl. The yellows in the cloth and the inside of the bowl show the effect of the warmth from the sun. The shadows are dominated by cool colors: blues inside the bowl and purple-blues in the cast shadow. Inside the bowl, the reflected sunlight from the left into the shadow is depicted with a strong yellow-orange applied on top of the wet blues.

PEACHES AND PEONIES,
*Margaret McWhethy. Oil on board,
20 x 16 inches.*

The juxtaposition of the bowl against the vase creates a shimmering light effect. The pink flowers radiate warmth into the background, and the quality of light in the cast shadow is beautifully subtle.

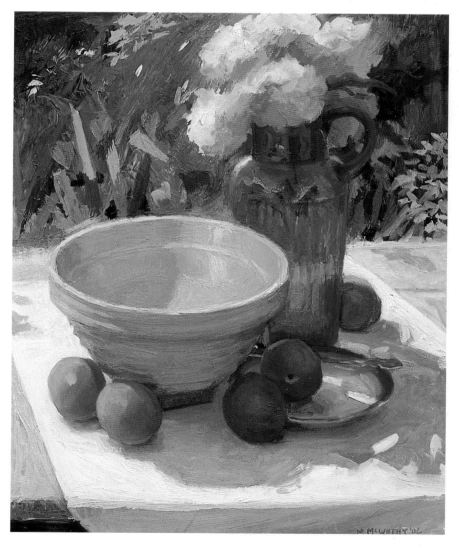

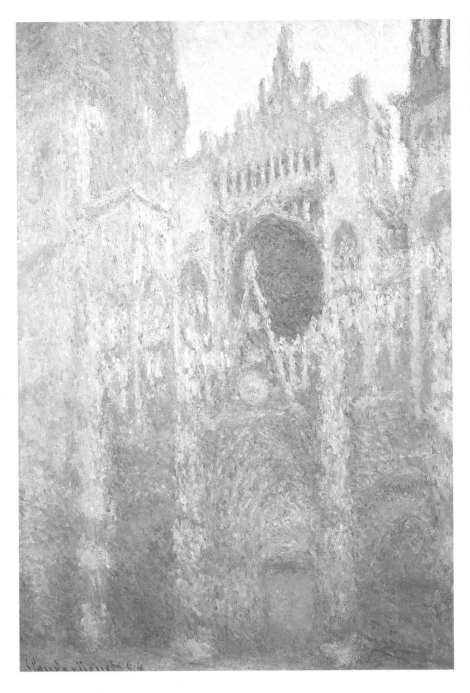

ROUEN CATHEDRAL, WEST FAÇADE (1894), *Claude Monet. Oil on canvas, 39 3/8 x 26 15/16 inches. Chester Dale Collection. Photograph ©2002 Board of Trustees, National Gallery of Art, Washington.*

We know this was painted in the morning because of the angle of the light and because most of the façade is depicted as a mass of bluish-violet shadow. We see reflections of yellow light into the entrance due to sunlight bouncing off the ground in front of it. The cool colors in the shadows—a strong, dominant blue, with some pink-violet in places—are characteristic of Monet. There is a small hint of golden sunlight on the right sides of the towers, and the juxtaposition of that little bit of sunlight against the cool shadow is quite beautiful. The small section of sky we can see is an elusive combination of pinks, yellows, and blues, and is clearly warmer and lighter than the shadowed side of the building.

Opposite page, **ROUEN CATHEDRAL, WEST FAÇADE, SUNLIGHT (1894)**, *Claude Monet. Oil on canvas, 39 3/8 x 26 7/8 inches. Chester Dale Collection. Photograph ©2002 Board of Trustees, National Gallery of Art, Washington.*

The cathedral is bathed in mid-afternoon light. The mass of the light is generally warm, with some yellow and very faint pink highlights; its glow is picked up very subtly in the sky and in the shadowed recesses of the building. In the stained glass and the main entrance we see warm reflected light in the shadows. Monet knew that objects outdoors can have cool colors even in bright sunlight. We can see this effect in the upper towers, which are warmer toward the ground, becoming subtly cooler toward their tops. The upper reaches have a slight amount of red and white mixed together, but the color is cooler than the yellow-orange at the base. The shadows have some subtle blue-violets, as well as reflections from the ground.

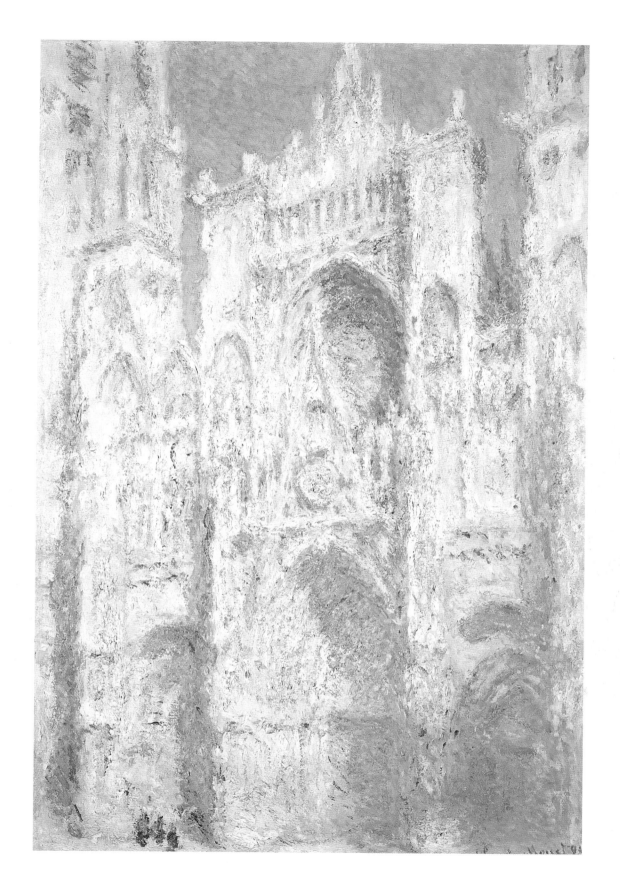

THE AMERICAN IMPRESSIONIST TRADITION AND THE CAPE COD SCHOOL OF ART

I am a link in a chain that reaches back to nineteenth-century Europe and, as some of my students become successful artists, into the future. While my application of contemporary Impressionist ideas to watercolor differs from most other approaches in watercolor, it is rooted firmly within the American Impressionist tradition.

From the Tonalists to the Cape Cod School

The early American Impressionists were trained in the European tradition known as *tonalism,* which emphasized using correct values. They would complete a black-and-white value study, and then glaze the pigment over it. To paint an apple with both light and shadow masses, for example, the tonalists would darken the local color, red, with brown or black to describe the portion of the apple in shadow. They would use the same technique to describe the shadow the apple cast onto the surface on which it was resting. (The term *local color* refers to the inherent color of an object without any influence from either the light shining on it or reflections into the object from its surroundings.)

WILLIAM MERRITT CHASE

The American Impressionist tradition of which I am a part descended primarily from William Merritt Chase (1849–1916). Chase began his break with the past by emphasizing the depiction of natural characteristics and *plein air* painting, which means painting in natural light outdoors. When he took his indoor palette outdoors, he discovered that the necessity of finishing an outdoor painting in one sitting did not allow time for glazing color over a black-and-white painting. Attempting to express the outdoor effects of dark colors or areas in shadow, he added black and other darks to the colors on his palette, but the results were not true to what he saw. This prompted Chase to emphasize the importance of painting directly from nature.

Chase and others of his time never completely broke with their traditional tonalist roots. Most of their paintings were commissions, in which they had to follow the conventions of the day rather than try out new ideas. Also, it is important to keep in mind that the early Impressionist masters painted almost exclusively in oil. Their work is considered Impressionist because they strove to depict the effects of light, especially natural light, on their subjects.

THE CAPE COD SCHOOL OF ART

Charles Hawthorne (1872–1930) studied with Chase. He opened the Cape Cod School of Art, in Provincetown, Massachusetts, in 1899. Like his teacher, Hawthorne was still steeped in the tonalist tradition. Nevertheless, he pursued the development of images through their color and form, and became

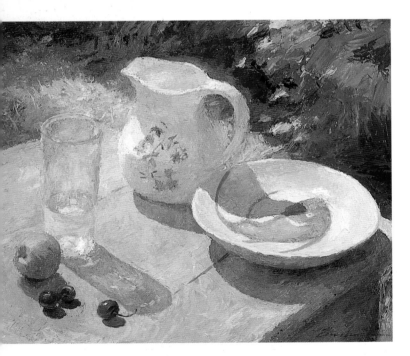

COUNTRY MORNING, *John Ebersberger. Oil, 16 x 19 inches.*
The artist's use of color to depict the form of the bowl and to show the sun reflecting though the glass into the cast shadow is masterful. The weathered tabletop, like the rest of the painting, glows with sunlight.

one of the most admired painters of his day. After his death, his students put together a collection of class notes and published it as *Hawthorne on Painting*.

An interesting dichotomy is apparent in the works of many early American Impressionists. Their indoor painting continued to be academic and conventional, while their plein air paintings, especially landscapes and quick studies, became much more free and were often done in watercolor rather than oil. Although for most of his life Hawthorne painted almost exclusively in oil, toward the end of his career he used watercolor to achieve bold color effects that would not have been possible in oil. The watercolors of Hawthorne and, later, John Singer Sargent (1826–1925), are a bridge from tonalism to Impressionism.

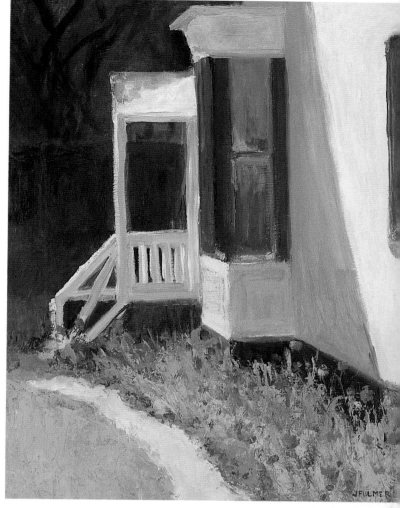

AFTERNOON SHADOW,
Judith Fulmer. Oil, 20 x 16 inches.

Even without the title, we would know when this was painted. The warmth of the late afternoon sun can be seen in the yellowish tinge the painter has given the white house, and there is a strong contrast between the deep shadows and the sunny areas.

MUD HEAD. *Oil on board, 12 x 9 inches.*

Hawthorne required his students to use a broad, stiff putty knife to apply oil paint to a board for both still life and human figure depictions. The faces of his people became known as "mud heads" because only the shape of their faces was depicted, not their features. Using a putty knife forced his students to look only at masses of light and shadow and disregard the details.

THE HENSCHE HERITAGE

Henry Hensche (1901–1992), who came to the Cape Cod School to study with Hawthorne and became its director in 1930, is credited with taking Hawthorne's ideas and putting them into practice in his painting and teaching. Not trained in the European tonalist tradition, he was able to completely break from the past. He continued to paint from nature, and also focused on still life both indoors and out. He was insistent that Impressionism is a way of seeing, not a technique. To Hensche, the study of color and light was the study of reality. The Impressionists did not exaggerate the color in their paintings, but painted real color phenomena. One of Hensche's most important innovations was to forbid his students to use black paint, thus forcing them to see the real colors in front of them. He maintained that when the color masses cease being paint and paper, and become the thing itself, the painter is finally expressing reality.

Hensche also adopted Hawthorne's idea of having students use a painting knife rather than a brush. When painting the effect of light on a subject, the use of the knife forces students to be much more accurate both in their color vision and in their color expression in oil.

The practices of painting outdoors away from cities, where the light is very clear, and of painting under differing light conditions, were both firmly rooted in the European Impressionist tradition. Hensche, however, was the first American artist to teach that the subject of a painting is the color of the light rather than the objects on which the light is falling. He realized that seeing the light effect is a life-long journey of discovery, and his own style matured and changed over the course of his career.

By the 1960s the work of most of the American Impressionists had been eclipsed by the followers of twentieth-century contemporary schools. From 1930 through the late 1980s, it was Henry Hensche who almost single-handedly kept Impressionist realism alive in this country. Without Hensche, the ability of American artists to describe light and color following Impressionist ideas would have been greatly diminished. Today, Impressionist realism is a very important part of the art world, as demonstrated by sold-out shows and lines at Impressionist exhibits that stretch for blocks.

I first went to the Cape Cod School of Art in the summer of 1983, after working as a commercial artist for seven years. Cedric and Joanette Egeli, in Annapolis, had introduced a group of students to Hensche's

PALETTE KNIFE BLOCK STUDY.
Oil on board, 10 3/4 x 14 inches.

Hensche had students paint color studies of blocks, like this one, to force them to focus on the fundamentals of light and shadow. Painting a series of block studies is basic to understanding the way the light effect changes with the time of day and the season.

RED BLOCK IN THE SUN,
Lee Surette. Watercolor, 9 x 12 inches.

Surette is a professional artist who did this painting in his first class with me. Especially noteworthy are the glowing orange-red effect in the light and the subtle greens of the chair arm in the sun.

STILL LIFE. *Watercolor, 9 x 12 inches.*

Before studying with Hensche, my work was based on local color and tonalism. I painted details, not the light effect.

approach to Impressionism before we went to Cape Cod. Cedric also taught us an approach to painting in one shot known as *alla prima* ("at the first") painting, applying paint just as it comes out of the tube rather than using mixtures. I began to use the alla prima technique in my watercolor wet-on-wet painting.

The first day, Hensche, who was then 82, did a demonstration outside for a crowd of beginners. The setup was just a block on an old weathered table. Right from the start, Hensche's powerful use of color and light was a revelation. The painting absolutely glowed in vivid color as Hensche set about creating sunlight on canvas. It was the most riveting, magical thing I had ever seen. I became an instant disciple.

Impressionists don't even see local color. Apples are not just red or yellow or green, and what seems to be a solid red apple may contain hues of yellow and orange and blue. The trunk of a tree is not just brown, but violet-brown, or green-brown, or yellow-brown. A "white" object is not merely white. Nor is a white house white in the light and gray in the shadow. Instead, the lighted portion of the house will have some of the warm yellow of sunlight, with perhaps some green or blue reflected into it by the grass and shrubs. The shadows, in addition to being painted with violet-purple or blue, will contain reflected colors. No black or gray is added to paint the deeper shadows; instead, the darker areas are represented through intensity of hue and getting the values right.

Chapter 5 offers a detailed discussion of value. Here I simply want to stress how important it is for Impressionist painters to recognize the difference between things in the light and things in the shadow and to express those differences by getting the color and the value right. Henry Hensche said that the value will be right when the color is right. Tonalists make shadows dark by adding black to the color in the lighted area. Impressionists create shadow effects by emphasizing the difference in warmth and value between shadowed and lighted areas. Impressionists fuse value and color, making them inseparable in the painting process.

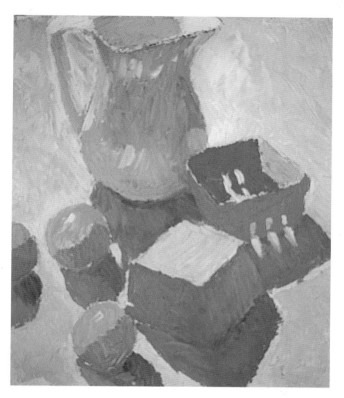

PITCHER WITH BOXES AND ORANGES.
Palette knife, oil on board, 20 x 16 inches.

In this outdoor backlit painting, the Impressionist use of color to capture reflected light, especially in shadowed areas, can be clearly seen.

EARLY BLOCK PAINTING, *Robert Morgan.*
Watercolor, 9 x 12 inches.

This block study was done early in a week-long workshop, when the primary focus is revving up the use of color. The focus in this painting is on intensity and vividness of hue, which brings out the contrast between the warmth of the light and the cool of the shadows.

STAGES OF EXPERIENCE

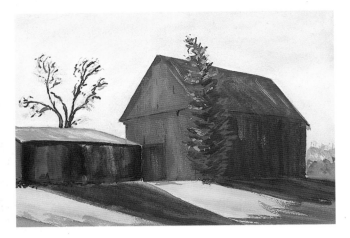

BARN IN LATE AFTERNOON, FALL. *Paula McDaniels.*
Watercolor, 7 x 10 inches.

McDaniels has boldly juxtaposed the rich reddish barns in
the sun against very strong blues and blue-violets on their
shadowed sides. Note that the cast shadows are different
colors than the shadowed sides of the buildings, and the
cast shadow in the foreground is a different, lighter color
than the cast shadow of the large barn. The artist's use of
strong magentas and violets in the shadows creates a dra-
matically obvious shadow up against the light.

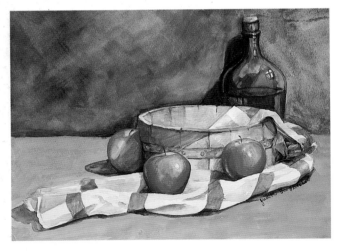

TUB, TOWEL, AND BOTTLE WITH APPLES,
Judith Fletcher. Watercolor, 12 x 16 inches.

The artist has effectively depicted the red-orange-yellow
warmth of incandescent light. Notice the variety of colors
in the apples. The shininess of the bottle contrasts nicely
with the textures of the cloth and the bucket.

The fluid language a student needs to express the
Impressionist color vision in watercolor is
learned in stages, through experience.

First, the student strives to see the world in terms
of bright, glowing primary colors. I push beginners to
see and express the bright, vivid colors that most
nonartists miss. I tell them to "scream at me with
color." Learning to see and paint bright, intense col-
ors helps break the habit of seeing the world in local
color. When students are able to abandon their lim-
ited local-color vocabulary, they make more progress
in their ability to really *see* the colors in nature. I push
them to lose all inhibitions in using the colors on their
palette, to paint with reckless abandon. The block
painting on the previous page by Robert Morgan, a
student at the Cape Cod School, is an example of the
kind of paintings I have my students do at this stage.
The students usually do several of these studies each
class in order to reinforce what they have learned
about making strong, vibrant color statements.

As the artist's vision grows, he or she will begin
to see the subtlety of mixtures of bright colors. The
bright and glowing primary colors will still be there,
but they will be joined by greens, violets, and or-
anges. Later, the complex and subtle earth colors,
such as burnt oranges and reds, and the more neutral
violets, will become a part of the artist's visual expe-
rience. As artists learn to see more of the subtle col-
ors found in the natural world, they will need to paint
with pigments that are not represented directly on the
Impressionist palette, but are a combination of the
from-the-tube colors found there. This entire process
is somewhat circular. As you learn to see more subtle
colors, you will begin to use them in your painting. As
the more subtle colors are added to your vocabulary,
your vision will be stretched, and you will be able to
see and express ever more subtle combinations.

Keeping It Spontaneous

Spontanity is an important part of painting the Impres-
sionist watercolor. As you develop your color vision,
you will more and more be able to get things right in
your early statements. For the viewer, this translates

into a liveliness that can be lost if you overanalyze and overrefine your work. In my classes, I emphasize covering all the white of the paper quickly not only so that my students can see the true relationships among the colors, but also so they will learn to trust their first impressions. Any painting—and especially a still life—can be ruined if the artist fusses with it too much. First impressions, even the first impressions of students, are often the best: the paint is most vigorous, the emotional enthusiasm for the subject is most evident, and the color choices are more honest. All Impressionist paintings, regardless of medium, share a rawness, an unrehearsed response to what the artist is seeing, and that honesty and excitement radiate from the paintings.

Painting Wet-on-Wet

Painting wet-on-wet is not easy. Every new brushload of paint also adds water. I had to learn to create equilibrium by developing the painting as a whole. I found that if I tried to develop the sky, and then the land, leaving the sky alone, the paint from the sky would run into the land and create a mess. In order to keep everything from running completely together, you have to keep all the areas of your painting equally wet. Oils dry slowly, providing ample opportunity for modifications and restatements. Watercolor, even wet-on-wet, dries much more quickly than oil. And in dry, sunny, or breezy conditions, watercolor can dry very quickly indeed. John Singer Sargent once described watercolor as a painting emergency, and that is exactly the feeling I had early in my development, and sometimes still have, when trying to keep the painting wet enough to work on in the early stages.

I do not gradually build up the color in my paintings. Deep, intense colors are not achieved by painting in layers, letting each layer dry before applying the next. I cover the entire paper with color as quickly as possible, working in adjacent areas and getting the color and value of each mass right immediately. That is the only way to see the color relationships that exist in the scene and to be able to replicate them. Remember that it's the relationships among colors that create a painting. It is important to keep these first statements as pure as possible, many of which should use paint directly off the palette.

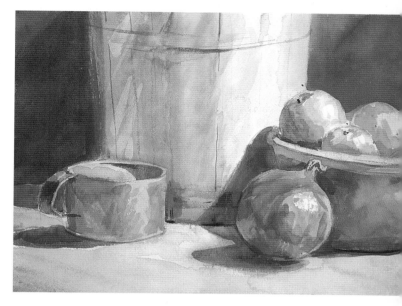

BROKEN COLOR, *Watercolor, 12 x 16 inches.*

This painting shows an effective of use of wet-on-wet broken color in the tablecloth and especially in the weathered bucket. The bucket, which has worn bluish-greenish paint, shows a lot of the warm yellow of the light source on the right, reddish reflections from the onion in the middle, and warm reflections from the copper cup on the left.

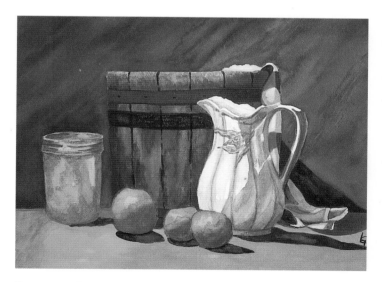

PITCHER, BUCKET, AND PICKLES, *Linda Gottlieb. Watercolor, 9 x 12 inches.*

The artist effectively has used broken color to depict the texture and wear on the bucket, and the pickle relish in the jar. There is just enough detail on the lid of the jar to let us know it has threads and a slightly sunken top.

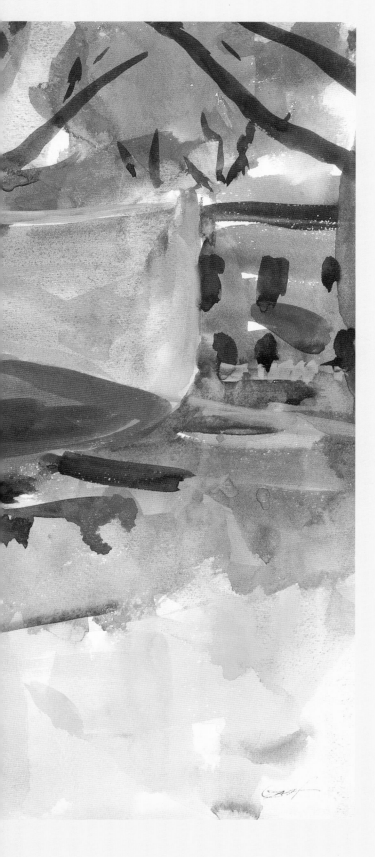

2
GETTING READY TO PAINT

Walking into a big art supply store can be a dizzying experience because there are so many choices for every kind of material. This chapter offers specific guidelines for choosing drawing supplies, paint, brushes, paper, easels, and outdoor equipment.

THE WEIR BOAT, CHARLES W. HAWTHORNE.
Watercolor on paper, 14 x 20 inches, 1927–1930. Courtesy of Babcock Galleries, New York.

Painted late in Hawthorne's career, *The Weir Boat* shows the boldness of his use of color. The shadows contain vivid yellows, reds, and blues, but not a stroke of black or gray.

PAINTING SUPPLIES

Inferior supplies can make learning to paint more difficult. When I recommend specific brands and quality levels, I do so out of long experience with my own painting and with watching students struggle with substandard equipment.

Paint

Get all the colors on the list given below rather than try to economize by limiting what you purchase. Learning to mix colors is difficult enough even if you have all the recommended colors, and the difficulty is compounded when you have a limited palette.

My theory on paint is that the color is much more important than the brand. However, over the years I have discovered that I can't get all the colors I need from one company. I originally used only Winsor Newton paints. As I experimented with others, I found that some colors by other manufacturers had qualities I found more desirable: they were wetter, stayed wet longer on the paper, and/or had finer pigment. When I experimented with paint by different manufacturers I also discovered that the name on the label is not standard from one manufacturer to another. For example, Winsor Newton is the only one that has Cadmium Scarlet, but what is essentially the same color is called Cadmium Red Light or Cadmium Orange by other manufacturers.

Over time, some color formulas changed. Until recently I used Caput Mortuum until it was changed to be almost identical to Indian Red. I needed a cooler dark, so I replaced it with Mars Violet.

My current color list has also evolved as my color vision has evolved. Over the years, I began to see things in nature that needed a particular color for a subtle depiction in my paintings. I substituted Venetian Red for Burnt Sienna, which I think is an obvious cliché dark, and Venetian Red gives my paintings a subtle orangish dark that I didn't have before. However, the different Venetian Reds are not all the same; one manufacturer makes it more orange than the others.

I am always looking for colors to fill the color gaps in my palette. Some colors that seemed important to me in the past no longer seem so useful. Some of those have been dropped entirely, and others have been replaced by similar, but not quite identical, colors. Begin with the colors recommended below. As you learn more about depicting color, and develop your color vision, begin to question the colors on your palette versus the colors you see. We do not all have identical color vision. Check out the choices available to you and be open to new possibilities, to finding a new color that may more closely fit your unique visual language. My reasons for recommending these specific colors will be discussed in detail in Chapter 4, "Light and Shadow in Color."

Beginners may want to start off with student grade paints, since they are less expensive. Winsor Newton's student grade is Cotman. Rembrandt has a student grade named Talens. However, if you want to get the benefit of the true integrity of watercolor, use the artist grades. They have less adulterant and filler, and more pigment. Because of this, the artist grades are the only ones that will give the granular and sediment effects that result when the finely ground pigment particles settle into the paper. Even if you do decide to use student grade paints, you will probably not find all the colors you need, and so will have to purchase the artist grades of those colors.

You will notice that some colors also come in two types. For example, Cadmium Red also comes in Cadmium Red Hue. Many of the student grade paints are paints made of synthetic chemicals that duplicate the original colors as closely as possible. A given Hue isn't always quite the same as the original colors, especially the cobalts and cadmiums. Also, Hues are stains. This means that once they are on your paper, they are there to stay. I think it is better to avoid these staining paints as much as possible.

The list that follows is in the order in which you should place the paints on your palette, producing a spectrum of colors. On the recommended Pike palette there are only twenty wells, so put some Chinese White on the mixing area. If a specific manufacturer is recommended, it is listed in parentheses.

PERMANENT ROSE (Winsor Newton or Schmincke) or Scheveningen Rose Deep (Old Holland). This is a synthetic dye the generic name of which is quinacridone. Winsor Newton has recently begun selling Quinacridone Red, which is not the same thing. Don't get it.

CADMIUM RED (Winsor Newton)

CADMIUM SCARLET (Winsor Newton) or Cadmium Red Orange (Schmincke)

CADMIUM ORANGE (Winsor Newton)

CADMIUM YELLOW (Winsor Newton)

LEMON YELLOW (Winsor Newton) or Titanium Yellow (Schmincke). The generic name for Lemon Yellow is nickel titanate.

NAPLES YELLOW (Sennelier)

YELLOW OCHER

PERMANENT GREEN LIGHT (Schmincke) or Cadmium Green Pale (Holbein)

VIRIDIAN (Schmincke)

CERULEAN BLUE (Winsor Newton or Sennelier; other manufacturers' Cerulean Blues are not the same; it is particularly important to buy one of these two).

COBALT BLUE. This is about the same from all manufacturers; I use Sennelier.

ULTRAMARINE BLUE. This is about the same from all manufacturers; I use Schmincke.

ULTRAMARINE VIOLET (Schmincke)

COBALT VIOLET DEEP HUE (Sennelier)

PERMANENT MAGENTA (Winsor Newton)

COBALT VIOLET LIGHT (Winsor Newton or Holbein)

VENETIAN RED (Sennelier)

INDIAN RED

MARS VIOLET (Holbein is the only manufacturer of this color in watercolor paint)

CHINESE WHITE (Sennelier or Schmincke)

BLACK

Although black will not be on your palette, you should get a small bottle of sumi ink or another water-soluble black ink, which you will use for black-and-white studies. Also get a student-grade black paint to use for full value studies.

Left, THE PIKE PALETTE. *Right,* THE POSSUM PALETTE.
The John Pike palette can be obtained at most art supply stores. You can order
the Possum palette directly from Possum Products: 888 394-7788; their Website
is possumproducts.com.

Palette

I still haven't found the perfect palette. The most important thing is that it be large enough to hold all your paint colors in separate wells. I use an old metal palette. The John Pike palette is the one I recommend to students, especially for studio use. It has twenty wells, a large central area for mixing, and a cover. It is heavy plastic that does not stain. The weight of the palette is important when painting outside. You can get cheaper palettes, made from lightweight plastic, but I have seen clothing ruined when a gust of wind picked up one of these lightweight palettes and blew it against the painter. Even if the palette is blown away from you, saving your clothing, your paint can be contaminated with grass and dirt.

The only problem with the John Pike palette is that the wells are quite shallow at the front edges, and the paint often runs out into the mixing area when the palette is being transported. One of my students says that running a line of silicone sealer along the fronts of the wells can help. I always squeeze fresh paint out along the front edge of the well, which builds up an edge that usually keeps the paint from running out of the well. Students have also tried a variety of solutions, such as using small bead containers with snap-on lids, white ice cube trays covered with plastic wrap, and other small, lidded containers, plus a white butcher's tray for mixing. A new palette has recently become available: The Possum Palette, designed by an Annapolis artist, has cups with lids that attach tightly and three large areas for mixing. Whatever palette you choose, if you use a tightly covered container, leave the lids off occasionally so mold won't grow in your paint.

Don't just randomly put the paint on your palette. Put the palette on a table with the blank edge at the bottom and the wells running along each side and the top. Starting on your left, put the paints on your palette in the order in which they are listed above, with Permanent Rose in the first well and Mars Violet in the last. This way, your palette will go from the cool reds to the oranges and progressively lighter yellows to greens to blues to purples (ascending pretty much in order through the natural spectrum of light) and finally to the earth colors. The earth reds on the end are a sort of adjunct, like sharps and flats rather than clean, clear notes. If your palette is already set up in a different order, I recommend redoing it because there is a natural order to the arrangement given here. This is important; you need to train yourself to think in the language of art. When you paint, what you think and the statements you make in paint are synonymous.

Some watercolor artists insist on starting each painting session with fresh paint. This practice can run up your paint expenses very quickly, and I haven't found it necessary. I add fresh paint as needed, but don't replace the paint already there. If the paint thickens or even dries out completely because the water has evaporated, simply adding water will revive it. Let the water soak in for a few minutes and then mix it up with the end of a paintbrush. Even if your paint has not dried, it may have separated. *No matter how eager you are to begin painting, it is very important to take the time to thoroughly stir your paint before you start.* The paint and the water should be thoroughly mixed together, with an even, saturated consistency. Even paint right out of the tube should be thinned a little and mixed thoroughly with water. This is, after all, watercolor paint.

Paper

Good watercolor paper is expensive. There is no way around this. Buying cheap paper with no cotton fiber is perhaps the biggest mistake beginners make. Cheap paper is not made of 100 percent cotton and has a harder finish that is not very absorbent. Paint just doesn't behave the same way on cheap paper. It usually doesn't flow and mix as well. Sometimes it sits on the surface and doesn't soak in enough. The more expensive cotton fiber papers allow the paint to flow, mix, and soak in well. They are more archival than the cheap papers, and will last longer without yellowing or disintegrating.

Watercolor paper varies also according to manufacturer and method of manufacture, weight, and amount of sizing used. I recommend using a watercolor block with 140-pound cold-pressed paper made by Arches. The heavier the weight of the paper, the thicker the paper is, and the thicker the paper, the less likely it is to wrinkle. Buying the paper in blocks is recommended because, since the edges of the sheets are glued together, there is no need for wetting and stretching a sheet taken from a block. The painting is left on the block until the paint is dry, or nearly so, and then cut off. The only other way to avoid having to stretch the paper is to get 300 pound paper or heavier, which can be prohibitively expensive.

Cold-pressed papers have rougher surfaces than hot-pressed papers. Hot-pressed paper has a harder, smoother finish, so the paint does not soak in as quickly and details are crisper. It also makes a wonderful drawing paper. It is not good for wet-on-wet painting because the slicker surface causes more bleeding between colors. Rough paper is just that: rough. It can add interesting texture, but makes it more difficult to depict details clearly. It is definitely not for depicting glass and other smooth, glossy surfaces. There is less difference between rough and cold-pressed paper than between hot-pressed and cold-pressed. After you have become experienced with cold-pressed paper, you might want to experiment with these other varieties.

Sizing is an animal gelatin glue that is used to protect the surface of the paper. Each brand of paper uses a different sizing formula; in addition, some have more sizing and some have less. The Arches papers—cold-pressed, hot pressed, and rough—have more sizing than many others, which makes them less like blotters than softer papers with less sizing.

Brushes

The six brushes listed here are the minimum needed for a beginner. As you gain experience and begin to paint more complicated scenes, you may want to explore using other sizes.

- A medium-sized sumi brush
- A flat brush for applying water
- A # 8 round
- A #10 round
- A #12 round
- A small bristle brush (for scrubbing edges, not for painting)

Sumi brushes were developed in Japan for doing the traditional Japanese brush painting known as sumi; they are used for fine detail and for calligraphy. You will use your medium sumi brush for your ink painting exercises as you learn to identify and depict the light and dark masses. When you progress to regular paintings, you will need a flat brush for water, and round brushes in sizes 8, 10, and 12.

I use only round brushes to apply pigment. The round brush is *the* most versatile tool for the watercolorist. With them you can make squared-in marks on your paper, as well as very thin or very thick lines. I never use flat watercolor brushes because they are not as versatile as round brushes. I mainly use Winsor Newton's Series 7 or Raphael brushes. A top-quality brush lasts a long time with proper care, and will come to a point even after it looks like it's dead. A beginner probably doesn't want to spend hundreds of dollars on brushes, but don't just get the cheapest ones. Good brushes for the beginner will be made of natural red sable or a mix of sable and synthetic hair. Do not get a brush that is all synthetic. Be sure you don't get natural hog bristle brushes, which are meant for oil painting. They are too stiff and do not hold enough water-saturated paint. In my own painting, when I want to soften the transition between color areas or soften a highlight, I scrub the area with a wet, stubby bristle brush.

When the brush is wet it should come to a fine point. Depending on the size of the paper and what I have to do, I use the size of brush that can cover the most paper in the shortest time because that's what watercolor demands. Your flat brush is just a 2- or 3-inch natural-bristle house painting brush that you can get in any hardware store. You will use this brush to wet your paper before painting.

Water Containers and Buckets

For indoor painting, get a plastic bucket that will hold at least a quart of water (mine holds 2 quarts), with a handle so you can hook it onto your easel. Cups and canning jars just do not work. They are too small, and also tip over too easily. The larger the volume of water, the cleaner the water will be and the less muddy your painting will become. And absent-mindedly dipping your brush into your coffee cup or taking a drink of your paint water can be a nasty surprise. For outdoor painting, you may want to use a bucket that is large enough to hold a 1- or 2-quart water bottle with a cap, which makes for slosh-free transporting.

Paper Towels

I tell my students to use Bounty quilted paper towels. They are thick enough to be really absorbent, and heavy enough to be sturdy. You do not want threads of paper sticking to your brush, or bits sticking to your paper if you need to blot or rub it. My really thrifty students use the same towels more than once, washing them and hanging them out to dry.

Applicator Bottle

You will need a small plastic squeeze bottle that holds 4 to 8 ounces of water. The easiest way to wet your paints is to squirt water into them with this bottle. You can also use it to squirt water onto your palette to clean it.

Masking Fluid

Masking fluid keeps paint from adhering, preserving white places on the paper. I use Winsor Newton masking fluid in yellow. It also comes in clear, but this is hard to see after it has dried. Some brands come in other colors, but I prefer yellow because it is closer to what the color of the paper is under incandescent light or sunlight and thus has a more natural relationship to the colors surrounding it.

One thing the label will not tell you is that masking fluid has a shelf life of about 6 months after being opened. It will still go on all right, but taking it off can be very difficult and you can damage the surface of the paper in the process. When I first open a new bottle, I mark the date on the label. You probably won't come close to using a bottle in 6 months, so you might consider splitting it with one or more friends.

Your brush must be protected from the masking fluid. If the fluid will not wash out, it dries and gums up the brush. It can be removed with rubber cement thinner, but you can keep it from hardening in the first place with ordinary hand soap. Use a pure bar soap like Ivory rather than a deodorant or perfumed soap or a liquid soap. You will wet your brush and get it soapy, then dip it into the masking fluid. When you are finished, the fluid will rinse out of the brush.

Materials for Drawing

For thumbnail sketches I recommend a 2B or 6B pencil. For drawing the scene on your paper, use an HB or B pencil. I have found that the best choice for black-and-white value studies is a black Sharpie marker for small studies and the Super Sharpie marker for larger studies. You may also use stick charcoal.

There are a variety of erasers to choose from. I like to use a white plastic eraser that comes in a holder like a ballpoint pen. Artgum erasers are also effective. Kneaded erasers tend to abrade the surface of watercolor paper, but they can be used when you are drawing thumbnails or value studies.

You will need a sketchpad or notebook as large as your watercolor paper. As you will learn, sketching a scene or completing a black-and-white value study before beginning your color painting can be very important. Since producing a finely finished drawing is not your object, you do not need to get archival paper, which costs more. I prefer a spiral-bound notebook because the pages will lie flat and I can stick my pencil or marker in the spiral binding. Whether you use a sketchpad or notebook is up to you, but the pages *must* be large enough so that your drawing can be the same size as your painting.

Left and Middle, FRONT AND BACK OF HOMEMADE VIEWER; *Right,* BLUE PLASTIC VIEWER.

Viewer

To make a viewer, get a 7- by 6-inch mat board and cut a 5- by 4-inch window in it. Pierce the centers of each side and string butcher's string through the holes, dividing the window into quarters, as shown in the illustration. Tape down the ends of the strings. Sewing thread is too thin and yarn is too thick. You can also purchase plastic viewers in art supply stores.

When you are making your sketches, you will look at the scene through the viewer, so you can more easily draw the objects on your paper in the same relationship to each other as they are in the scene.

Additional Recommended Equipment

KNIFE

A small pocket knife is very important. The kind that comes with a screwdriver and other tools is particularly handy. The screwdriver may be needed to fix your easel. Some kind of a knife is needed to remove the painted sheet from the watercolor block. It is also best to sharpen your pencils with a knife because you can expose more of the lead so you can use the side of it when drawing. If a paint tube gets dried out, you can cut the tube and shave the paint into a well of your palette.

EASELS

An adjustable easel will save your painting by saving your back. You can't paint if your back hurts. Watercolor is a medium that is frustrating enough without the problems that you will have if your easel isn't right. If your easel isn't steady or the right size when you're

juggling a bucket of water and your palette, you will just make an already difficult task seem impossible.

You should be able to adjust the height of the easel so that you are comfortable using it no matter where it is set up. It is usually better to stand than to sit when you paint. When you are sitting, you often cannot see the tops of the objects in your scene. I realize that some of you may have problems standing for long periods of time, and you will sometimes need to adjust your easel so that you can sit. If your easel is too high or too low, you will be too uncomfortable to concentrate on your painting. Some easels are better than others if you want to paint while sitting. Try them out in the store before you purchase one.

There are a variety of easels you can purchase or make. My style of watercolor painting requires that your paper and palette be horizontal, so the paint will not run. The best easel is still the original French easel made by Julian, or one that offers the same features. It comes in two sizes, and the three telescoping legs, and the tilt, are adjustable, so that you can adjust the height of the easel as necessary, and use it even when the ground isn't level. The Julian easel, cannot, however, be lowered enough for sitting. Also, the surface is small, so I put a 22- by 30-inch piece of masonite on top of it, so there will be room for my equipment. You can also use a TV tray or a small, portable table. Some students make their own easels by using a piece of masonite or plywood about 20 by 26 inches as a table screwed on top of a camera tripod. You can also buy an easel with a tripod design.

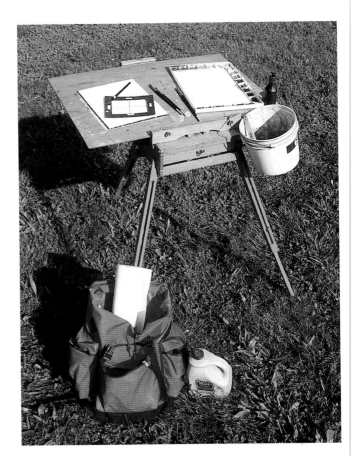

EASEL SET UP FOR PAINTING, BACKPACK, AND LARGE ORANGE JUICE JUG FOR WATER.

CARRYING CASE

I use a large backpack with several pockets so my hands are free to carry my palette, easel, and bucket with water bottle inside. If you get a backpack or carrying case that is large enough, you can even carry your water and pail in it. Some students use a large tote bag. A tote bag with a shoulder strap will also free your hands to carry other things. Remember that no matter what you are using for a carrying case, you will need to carry your palette in your hand in order to keep it level unless it has individual wells with caps. Some students have recently begun using folding wire baskets or plastic cartons on wheels to transport their equipment.

OUTDOOR EQUIPMENT

You will need a baseball cap or other hat with an opaque brim, both to keep the sun out of your eyes and help keep the sun off of your head and neck. The

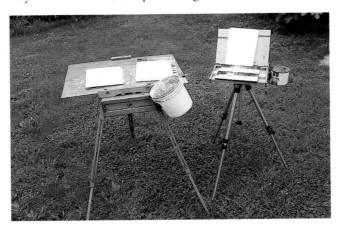

Left, FRENCH EASEL WITH MASONITE BOARD;
Right, TRIPOD EASEL WITH TOP FOLDED.

broader the brim is, the better. The glare on a white piece of watercolor paper is considerable and a hat will keep you from getting a bad headache. You can wear sunglasses while you work on your drawing, but you should take them off when you begin to paint because they will distort the colors. Your hat should be a sort of a medium, dull color so as not to reflect into your painting.

We're all concerned with the consequences of too much sun. It's really easy to get so engrossed in your painting that you lose track of how long you've been exposed. Get a good sunscreen and pay special attention to the back of your neck, especially if your hat brim isn't large enough to shade it (remember that you will be bending your head when you paint), and to your hands and arms.

Many plein air artists are increasingly concerned with the effects of ultraviolet light on the eyes, and try to sit in the shade. This is not always possible, however, and while your hat may shade your face, it does not protect against the light reflected off your paper and other surfaces. An umbrella can help with this problem as well as keep you cooler in the heat. You can buy a painting umbrella that clips onto your chair or easel. Painting umbrellas are made out of white, translucent material. They are expensive. You can improvise with some other style of umbrella, as long as it is white or opaque. What you really want to avoid is a multicolored or brightly colored umbrella that does weird things to the light shining through it onto your paper.

Avoid wearing clothes in vivid colors while painting, especially outside; choose one of the dull colors. Sunlight will probably be hitting your shirt much of the time you are painting, and you may not realize that a color is reflecting onto your paper until it's too late. I often wear a gray shirt or a black sweatshirt to paint.

You will probably get paint on you as well as on your paper, so wear clothes that won't be ruined. If it's windy or chilly, dress in layers so you can stay comfortable whatever the weather.

Insects can make painting outdoors miserable if you are not protected. Even if flying insects are not a problem, protect your feet and legs with tick repellant if you are going through a grassy field. Lyme disease is not fun.

Setting Up a Studio

Setting up a space devoted to painting will make it easier to paint and you will do so more often. The problem with the kitchen or dining room table is that you constantly have to set things up and put them away again. Choose a place with adequate natural light, if possible. Make sure there are convenient outlets to plug in your lamps. A light on both your subject and your paper is ideal. I use incandescent light in my classes, but there are now some full-spectrum bulbs available that are supposed to be more like natural light, and you may want to try one of them. The most important thing about the light shining on your setup is that it should be from one direction.

You will need enough space for a table on which to put your still life setups, and a table or easel on which to put your paper and paint. Poor ventilation is not a major health concern with watercolor, but a well-ventilated room will be more pleasant than a stuffy one.

The table or easel you set up in your studio, like the one you use outdoors, must be flat. In a studio, where your equipment need not be portable, a table works fine as long as it is the right height to use either sitting or standing and is portable enough so that the distance and angle from your setup can be changed as necessary. Art supply and craft stores carry tables with adjustable legs. If you are going to sit while painting, a knee-high table will allow you to see both setup and painting, and you won't have to hunch over to reach the painting surface. If you do paint sitting, make sure your chair is comfortable. If you paint standing, the table must be high enough that you don't have to be bent over all the time.

In addition to an easel or table, you will need a place to set your palette and water bucket. You will also need handy storage areas for your paper, pencils, erasers, and other supplies. Some other items that are nice to have are a sink, a cushioned mat to stand on, and, if your studio gets hot in the summer and cold in the winter, a heater and fan.

3
LIGHT AND SHADOW IN BLACK AND WHITE

*L*earning to see the light and shadow masses in scenes you want to paint is the first and most important step in learning to create Impressionist paintings in any medium.

STUDY IN BLACK INK

LIGHT AND SHADOW

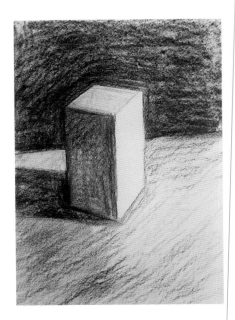

**FULL VALUE
DRAWING**

The aspiring artist must learn, from the very be-ginning, what is the foundation of Impressionist painting: Understanding the black and white masses of all objects. The surfaces on an object that receive light from the light source are known as the *light mass,* or simply "light." The surfaces on an object on which the light does not shine directly are known as the *shadow mass.* Where something prevents light from reaching part of an object or part of the background or table surface, there are *cast shadows.* Areas in a scene that are part of the shadow mass, plus the cast shadows, are called "shadow." Separating the light and the shadow is the first task of an Impressionist painter, so light and shadow are the first two values depicted in a painting. I do not call these values "value 1" and "value 2" be-cause they are equally important. This fundamental truth is called "the shock of the light."

The light mass of an object, sometimes referred to as "the object in the light," consists of two areas: the areas that are in direct light (the light) and the areas that are not in shadow but are also not receiving the most direct light (the *halftones).* When first separating light and shadow, the halftones are part of the light mass. In many setups, especially when one or more of the objects is shiny, there are also *highlights,* the light-est and brighest spots in the scene, in the light mass.

The shadow mass is sometimes referred to as "the object in the shadow." Both the shadow mass and the cast shadows often contain reflected light, and re-flected light in the object in the shadow is the fourth value to be put in a painting.

Value and Form

To create form—the illusion of three dimensions on a flat piece of paper—you need to describe at least three values: light, halftone, and shadow. It is not necessary to depict highlights or reflections into the shadow. The best way for you to visualize the first three values is to create your own black-and-white setup. Either find a rectangular white or light-col-ored box, or make a 4- by 8-inch block and paint it white. Stand it on end and shine a light on it from the right. The light will reach both the top and front sur-faces, or planes, of the block. They are both part of the light mass, but they are not lighted equally. The lightest side is the side that directly faces the light source. The top surface is the halftone: it is slightly darker than the lightest surface, but it is not as dark as any of the shadows.

The values of the light, the halftone, and the shadow mass correspond to three different colors you would see in a rectangular colored block. Before you tackle color painting, however, you need to learn to see and depict the light and shadow masses in black and white. If you learn to see value in black-and-white setups, you will be more able to see it in color. You do this by making numerous black-and-white studies of the light and dark masses in a still life scene to rein-force your understanding of light, shadow, and halftones before you start painting the scene.

Black-and-White Painting

Before you start to make a black-and-white painting, you need to make a contour drawing which includes not only the objects in the scene but also delineates the light and shadow masses. You will start a contour drawing for a black-and-white painting just like you start a full value study: drawing the intersecting hori-zontal and vertical lines on your paper and looking at the scene through the viewer. Look for simple geo-metric shapes and make a quick contour drawing of

the major shapes that maintains the relationships you see through the viewer.

For any drawing for painting, you need to be very careful to see and capture the correct relationships among the elements of the scene. For the white block, for example, you would mentally continue the line of the tablecloth against the background as it passes behind the block, making sure that the line emerged in the correct place on the other side of the block. You would also pay close attention to where the cast shadow was as you looked at the scene through the viewer, making sure that the relationship of the shadow to the edge of your viewer window was the same as the relationship of the shadow to the edge of your paper. When you are painting scenes with more than one object, you will also need to be concerned

EXERCISE 1: *Full Value Drawing*

1. Make sure the light is shining on your white rectangular block so that the light, halftones, and shadow look more or less like they do in the drawing at the top of the previous page.

2. Using a 2B pencil, charcoal, or graphite, lightly draw horizontal and vertical lines through the center of your paper, dividing it into fourths. Then look at the scene through your viewer and note how the block, the table, and the background relate to the four lines of your viewer.

3. Lightly make a contour drawing of the geometric shapes of the block and the edge of the table so they are in the same relationship to the horizontal and vertical lines on your paper as they are to the lines in your viewer.

4. Next, with the side of your charcoal or pencil, shade in the left side of the block and the cast shadow of the block. These two shadows should be the same value. *Don't differentiate between the shadowed side of the block and the cast shadow.*

5. Shade in the background, which is mostly in shadow. This will help to delineate the top and right side of the block. The background is not quite all the same value; it is lighter on the right because that part is closer to the light source. Shade it in gradually darker as you go from right to left, leaving all of the lighted part of the block and the tablecloth white. *All of the lighted areas should be one value at this point.* You have now separated the light and shadow.

6. Lightly shade in the top, keeping the value lighter than the background and the shadows, but slightly darker than the lit side of the block.

7. Moving to the tablecloth, notice that the lightest area is on the right because that area is closest to the light source; it becomes gradually darker as you move from right to left. Shade it in with the side of your pencil, making it darker as you move left. Overall, you want to create a value slightly darker than the lit side of the block, but definitely lighter than the shadows. You still have three values: the lit side; the shadows, which are still all equally dark; and the halftones.

8. The shadow mass of the block is slightly lighter than the cast shadow on the tablecloth. Darken the background, especially around the block, and also darken the cast shadow so the block will seem lighter in contrast. Now your drawing should have four values.

9. The top of the shadow mass of the block is darker than the bottom, so shade it in. This is an example of *simultaneous contrast:* the top looks darker because it is surrounded by the light mass, while the bottom is surrounded by shadow. The bottom part is also closer to the light reflected from the tablecloth into the shadowed side. Gradually darken the top and right edge of the block in the shadow, fading into the lighter value you originally put down.

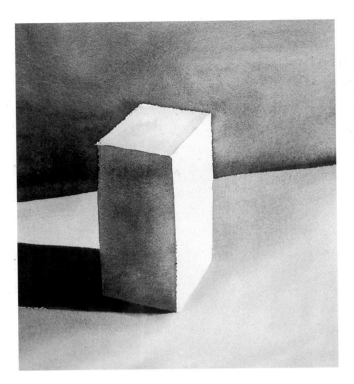

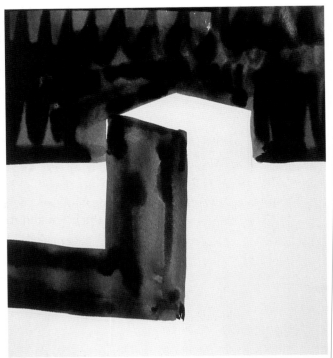

BLACK-AND-WHITE PAINTING

This black-and-white painting of the white block was painted using only black paint and white paint, which were mixed to obtain the halftones.

LIGHT AND SHADOW STUDY

There are only two values in this study: (1) the light of the top and right sides of the block and the part of the table-cloth not in shadow and (2) the shadow side of the block and cast shadow on the tablecloth. Notice that there is no line of demarcation between the lit side of the block and the tablecloth because they are both the same value.

EXERCISE 2: *Making a Black-and-White Painting*

1. Make a contour drawing of your white block. First draw the outline of the block and then the line of the back of the tablecloth. Delineate the light and shadow areas by drawing only their shapes. When you have done this, the form of the block will be differentiated into three masses: the top, the lit side, and the shadow side. Then draw in the shape of the cast shadow.

2. Mix your black and white paint to obtain the needed halftones.

3. Begin with the shadowed side of the block and the shadow of the block on the table as the same value, a medium dark.

4. Put in the background cloth behind the lighted side of the block and up to the table using a value similar to the value of the shadow in Step 3.

5. Paint in the tablecloth, making it lighter to the right, where it is closer to the source of light.

6. Darken the cast shadow on the table so that it is darker than the shadow mass on the block. In the finished painting, this should be the darkest area.

7. Distinguish the top plane of the block from the front plane by making it darker than the front. Be careful not to make it too dark; it should be the second lightest surface in the finished painting.

with the relationship of the objects to one another: where they intersect, where they overlap, and their relative sizes and proportion. The relationship among objects is more important than the details of the objects themselves. As with the full value drawing, your goal is not to produce a fully finished and detailed drawing, but to delineate the basic structure on which to build your painting.

Light and Shadow Drawing

One good way to sharpen your ability to identify light and shadow masses is to learn to see and represent on paper *only* the light and shadow shapes. Halftones are rendered as light so that the finished ink painting contains only two values.

This exercise is not my students' favorite, but it is important. It clearly shows, using only two values, the simple truth of one object on a table lighted by a clear, single source of light. It is the foundation for all the painting that follows.

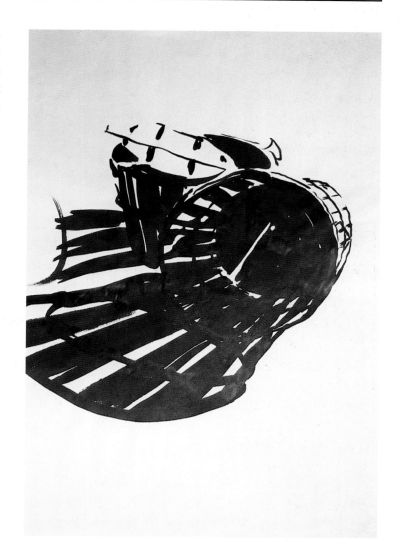

BUSHEL BASKET IN BLACK INK

Like the black-and-white study on the opening page of this chapter, this strong, bold study is a dramatic example of "the shock of the light."

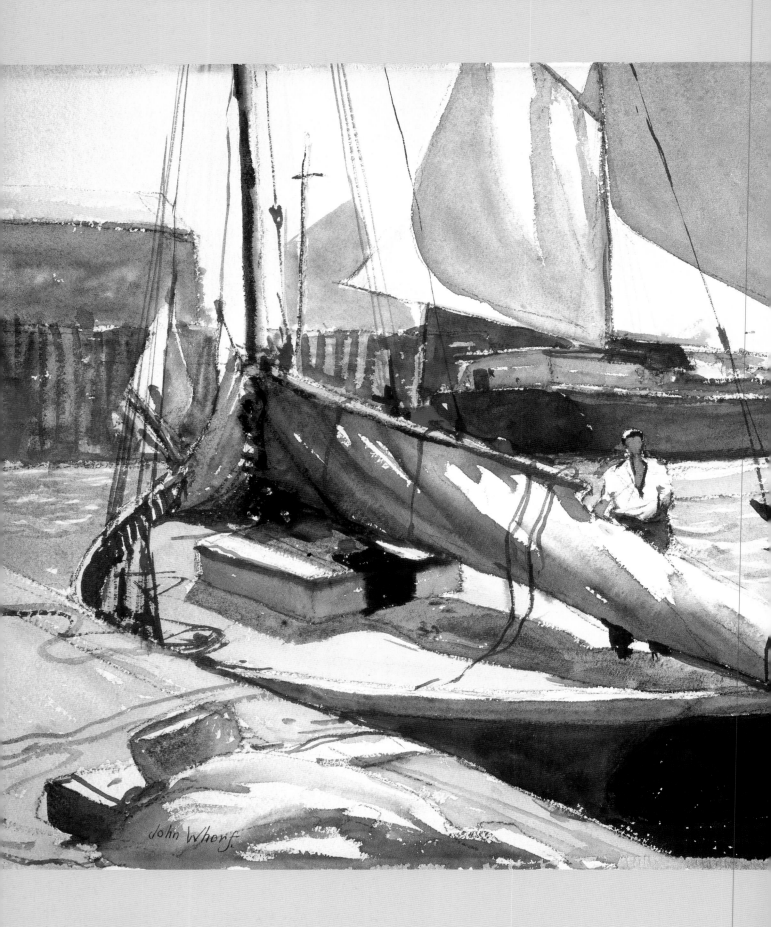

John Wherf

4
LIGHT AND SHADOW IN COLOR

This is *not* a traditional watercolor instruction book. The information here about color and paint application is different from that in most other books about watercolor. The cliché darks are not in the Impressionist palette, so the painter is forced to look at what color the shadows really are and avoid compromise in selecting the right color to depict them.

SAIL BOATS (ABOUT 1920–1930), *John Whorf (1903–1959), Watercolor, 14¼ x 21¼ inches (36.2 x 54 cm). Gift of Frederick L. Jack. ©2002, Museum of Fine Arts, Boston.*

Whorf's color choices clearly indicate experimentation with the Impressionist palette in watercolor. In the foreground he has used hot reds in the shadows on the deck. The shadow of the boat reflected on the wharf and its adjacent water is painted with some cool blues first, then slashes of hot red are added. In the water to the right of the boat he used yellows with blues on top. The shadow of the building on the left edge is depicted using strong blues and reds together wet-on-wet. And the shadow on the hull of the boat in the distance is green and then yellow mixed on the paper. The blues of the shadowed sails in the distance are a mixture of yellow and red-violet, also mixed wet-on-wet.

UNMASKING VISUAL TRUTH

If you look up at the sky and say "What a brilliant blue the sky is today," or describe a person in a crowd as "the one in the red dress," you are using the names of the color families red and blue. But if you want to paint that sky or that dress, you have to go beyond the local colors "blue" and "red." For the sky, you might start by choosing one of the varieties of blue, for example, Cerulean Blue, but to really paint the color you were seeing, you would almost certainly have to mix together two or more colors. You may think of grass or leaves as "green," but if you want to paint a specific patch of grass or background foliage in a still life, you will always need to mix colors to get a precise green rather than use Permanent Green Light or Viridian from the tube.

The colors in any scene, and the relationships between them, are subtle and precise. The ability to describe them accurately must come from experience in translating visual input into paint choices that capture the relationship between the light and shadow. One of the most important legacies of the Impressionist masters is the recognition that visual *experience*, rather than theory, gives us the keys to understanding the subtleties of light and shadow. Blindly following any theory can inhibit our ability to see the visual truth unmasked.

Look back at John Whorf's *Sail Boats*, on the opening page of the chapter. Whorf mixed the colors directly on the paper, resulting in a calligraphy of broken color that is descriptive of the phenomena of light and shadow in life. He was Hawthorne's student, so we know that he specifically studied the depiction of light and shadow in color. He was also one of the first who applied the Impressionist color theory to watercolor.

Whorf summered in Provincetown, which appears to be the setting for *Sail Boats*. This painting is a particularly good illustration of his strong use of the color of light. The sky is a clear, raw yellow, as is the deck of the boat in the foreground and the wharf. We can see the same use of yellow in the boat in the distance and in the reflections in the water. Overall, this use of yellow throughout the painting conveys the brightness and warmth of a summer day. Like the Impressionist masters, Whorf depicted the vitality of sunlight by using a bright and high-key description of the color of sunlight. Throughout, his bold use of color is reminiscent of John Singer Sargent.

The charming watercolor *Nasturtiams in a Vase* is a wonderful example of the collaboration of Benson and his wife, Ellen. She grew the flowers and arranged them; he painted her creations. Notice how sure this painting is, especially in the calligraphy of the flowers on the vase, where each stroke is deft and nimble. The flowers are also very clean and clear. He has not overworked them or tried to give them too much detail. It is obvious that he developed this painting as a whole; every piece is carefully considered. There is very little white, even on the vase, which is mostly pale yellow with a bluish color to model form.

Where *Sail Boats* glowed with brilliant colors, *Nasturtiams in a Vase* is more subdued. The lesson here is that the brilliance inherent in most outdoor settings is best captured by bold, bright colors; the quietness of most indoor settings by subtle, obscure colors. As part of your growth as an artist, you must learn to really *see* the differences between outdoor and indoor settings.

MIXED AND UNMIXED VIOLET

Looking at a purplish background, you may be tempted to depict it with an unmixed violet from your palette. In most cases, you should resist the temptation. The swatch on the upper left here is Permanent Rose and the one on the upper right is Ultramarine Blue. The middle swatch is Ultramarine Blue over Permanent Rose. The bottom one is pure Ultramarine Violet. The mixed violet is much more subtle, much quieter, than the pure Ultramarine Violet.

The Color Wheel

The base of the color wheel is three primary colors: red, yellow, and blue. These are referred to as "primary colors" because they cannot be made by mixing two other colors. The corresponding paint colors on your palette are Cadmium Red, Cadmium Yellow Deep, and Cobalt Blue. The so-called "true secondaries," which are a mixture of two primaries, are orange (Cadmium Red + Cadmium Yellow Deep), green (Cadmium Yellow + Cobalt Blue), and violet (Cobalt Blue + Cadmium Red). Colors opposite each other on the color wheel are called complementary colors.

Students often make the mistake of using color theory as a crutch. While knowing about primaries, secondaries, and complementary colors can be useful, choosing colors on the basis of what you see on the color wheel will not help you develop your own color vision. The true complement of a shadow against the light, for example, is a precise balance, and to depict that color you need a complete visual understanding of the colors you see.

The labels we assign to colors can also inhibit our ability to see the truth. For example, referring to a color as "warm" or "cool," although often appropriate, can limit our ability to really *see* color, to progress to more advanced levels of seeing. Beginners may not be able to get beyond these labels to see the subtlety and beauty of what may be very fleeting effects in color.

NASTURTIAMS IN A VASE, *1926, Frank W. Benson.*
Watercolor on paper, 21³/4 x 17⁵/8 inches. Private collection.
Photograph courtesy of Berry Hill Galleries.

The background and the bluish foreground in this painting are somewhat somber; both are rather obscure, dull colors. However, the bold, forceful color statements in the flowers and the vase provide a dramatic contrast to the background colors, popping them out and making them come forward as the center of interest. We can see his obvious color mixing on the paper in the foreground's yellow ochers and blue-greens and in the background, where a warm earth color underlies the blue-green at the top and right of the flowers. There are also blues and blue-violets mixed wet-on-wet, with possibly black and blue mixed together on the paper to create the dark area behind the vase.

THE COLOR WHEEL

In the circle of large color spots, the primary colors—red, blue, and yellow—form a triangle, as do the true secondaries. The small circles of color on the outside are, starting at the upper left, Cadmium Orange, Permanent Green Light, and Cobalt Violet Deep Hue directly from the tube. If you compare them to the three true secondaries, you can see that any two colors mixed together produce a more subtle color than one right off the palette. This is particularly true of green.

The Boynton Palette

The paint list in the chapter on materials is very specific with regard to name and, often, manufacturer. The designation of light, medium, and dark is also important. You cannot substitute one for another because in most cases those labels are not really descriptive of different values of the same color, but are really three different colors. For example, Cadmium Red Light is very similar to Cadmium Scarlet; it has more yellow in it than Cadmium Red or Cadmium Red Medium. Cadmium Red Dark, on the other hand, tends toward a color that is a cool purply rose.

The colors I have recommended for your palette are those closest to the colors we see in nature, and in objects in natural light. You generally have three tones of each color: cool, medium, and warm. For example, the reds on your palette are Permanent Rose (cool), Cadmium Red (medium), and Cadmium Scarlet (warm). This variety of tones also applies to most of the other colors. As I said in the chapter on materials, in the beginning, when I was first learning from Hensche, he allowed only the cadmiums, three blues, two greens, and a few violets. These are all very obvious and bright colors. The watercolor colors closest to those oil colors are the ones that still form the core of my palette.

My palette has more yellows and violets than many others do. An Impressionist painter describes sunlight generally as yellowish, especially in the summer. The shadow is generally cool blue or blue-violet. The color in the light is often pale, and the color of the shadow is usually dark. Within this general schema, there are a great variety of color effects possible. The sunlight is not always the same color of yellow, nor are the shadows always the same color violet, even within the same painting. We see this same trend in the winter as well as the summer. When there is snow on the ground, the lighted areas usually have a yellowish cast and the shadows are often Ultramarine Blue with a little violet.

Certain colors are *not* on my palette, and I discourage my students from including them on theirs: Payne's Gray, Ivory Black, and all of the umbers, which are often used to paint "brown" objects. Hensche didn't use any of the earth colors because they are often used as substitutes for learning to see and paint the actual colors in the scene. Brown, for example, is an incomplete color idea. Nothing in nature is truly brown. Instead, there are greenish browns, reddish browns, etc. Indian Red is a red-brown, Burnt Sienna is an orange-brown, Naples Yellow and Yellow Ocher are yellow-brown, and Mars Violet is a violet-brown.

The colors through Cobalt Violet Deep Hue are arranged on our palette in the order they appear in the spectrum, so you can move up and down the spectrum to achieve the necessary subtlety in mixing in a way that is logical and easy to use. For example, when you see a particular color, like the pink in a cloth in the light, you look at the middle red on your palette, which is Cadmium Red. Then if you decide that the cloth is a warmer color, you start with the warm color adjacent to the medium red-pink on your palette. This color will be Cadmium Scarlet, because it is the red closest to the yellows of sunlight, rather than Cadmium Red or Cobalt Violet Light, which would be going too far afield on your palette. With the colors

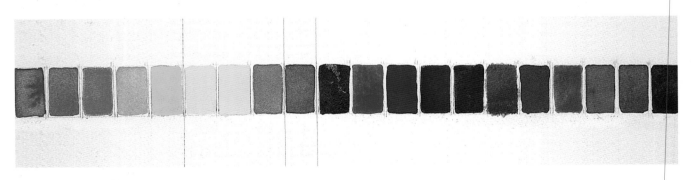

THE BOYNTON PALETTE

arranged in order, if your first or even second choice is not right, then you can go farther up or down the spectrum. The earth colors, which are not part of the natural spectrum of light, are grouped together.

The greatest advantage of my recommended palette is its diversity. To depict the myriad of color effects we see in nature, to be specific in our description of light and shadow, we need a wide selection of colors on our palettes to use alone and in mixtures. If a cloth is pink-violet, we need a choice of pinks to use. Does the pink tend toward Permanent Rose or Cadmium Red? Some palettes have only one of these, but we need both of them in order to mix a color that accurately depicts what we see.

Beginners may find the number of colors on this palette overwhelming. It is true that it offers no shortcut to mastering visual language, but as Hensche said, "Limited palettes are for limited minds." If you can learn the fluency of the language of the colors on this palette, you will learn the language of the colors of nature and the language of natural light. An extensive palette like mine serves both the novice and the advanced painter.

Watercolor is a transparent medium compared to gouache or acrylic, but within that overall category, some colors are more opaque than others. The importance of transparency in the watercolor medium is overemphasized at the expense of color and truth. My palette is more opaque than traditional watercolor palettes. Opacity and transparency do not figure into my thinking; this book is about becoming more sensitive to color.

Colors on the Palette

PERMANENT ROSE. This is a cool red, a 100 percent permanent stain that will not turn brown in ultraviolet light.

CADMIUM RED: This is a clear, very bright, obvious red apple color.

CADMIUM SCARLET: This is the color of a red apple in the light, especially incandescent light. It is a strong, emphatic color that is a more powerful red than Cadmium Red. It has orange overtones without actually being orange.

CADMIUM ORANGE: I use this a lot for oranges and pumpkins. Is it lively and strong and is capable of many subtleties in creating sunlight. In a mixture, it is also capable of producing a variety of olive greens.

CADMIUM YELLOW: This is liquid sunlight, bold and bright, both straight out of the tube and mixed with other yellows and oranges. I often use it under Cerulean Blue for a sunny clear sky or a blue object in the sun.

LEMON YELLOW: This is a cool, less insistent color than Cadmium Yellow. It often recedes into the distance. It is also useful for giving yellow light to a strong blue or green object .

NAPLES YELLOW: Like Lemon Yellow, this tends to be a receding yellow, though it is more orange than Lemon Yellow is. It is considered one of the earth colors and is helpful in shadows and in creating subtle gray-greens.

YELLOW OCHER: This is another useful earth color, a burnt yellow. Combined with blue or green it creates subtle olive passages. It is useful in shadows and in the light to produce a dull yellow. Mixed with Naples Yellow or Lemon Yellow, it is especially good for the light on natural surfaces like weathered wood.

PERMANENT GREEN LIGHT: This is not the color of grass, not even new spring grass. It is too bright and harsh straight from the tube, but in combination with Lemon Yellow, Naples Yellow, or Cadmium Yellow, it is bold and useful for bright green objects in the sun. It is also helpful in a cast shadow or dark object where strong greens are reflecting into the area.

VIRIDIAN: This green is almost a blue. In objects like a green bowl in the light (see Demonstration 2, page 99), it becomes a lively color when added to Lemon Yellow. It is also helpful in creating strong darks when mixed with Indian Red or Permanent Rose.

CERULEAN BLUE: This is a blue that is almost a green. It is a strong color for depicting a blue object in the light. In conjunction with Naples Yellow or Lemon Yellow, it usually produces a teal color in the light mass of blue objects. It is also useful as a quiet cool in the shadow, producing a greenish color when mixed with Mars Violet or Indian Red.

COBALT BLUE: This is a very strong, but middle-of-the-road blue. It is neither greenish nor purplish. With Permanent Rose or Lemon Yellow, it is useful for depicting a strong blue object in the light. In shadows, it produces a medium dark color when mixed with Mars Violet, Indian Red, or Yellow Ocher.

ULTRAMARINE BLUE: This is the strongest of the three blues on the palette. It produces a really dark color when mixed with Mars Violet, Indian Red, or Yellow Ocher. It tends toward violet, which is helpful in shadows and very dark objects.

ULTRAMARINE VIOLET: This is an obvious color that is more violet than Ultramarine Blue. It is not demanding and doesn't jump out at you. It is very natural in shadows and is versatile mixed with greens, blues, and earths. It can look either warm or cool depending on the other colors mixed around it.

COBALT VIOLET DEEP HUE: As I said in Chapter 2, I usually discourage students from purchasing hues, but I use this one because it is the only way I can get this particular color. It is a middle violet. It is warmer than Ultramarine Violet, but is not hot. It provides good contrast to the light without being too garish, especially when mixed with earth colors, greens, and blues. It tends to have an interesting mineral-pigment, grainy look when dry, which helps in depicting texture.

PERMANENT MAGENTA: This is a redder violet color than Cobalt Violet Deep Hue, and provides a strong complement to the light, especially in the shadow sides of a red apple, red onion, or red block. It keeps the shadow cool while adding a reddish cast. It is a lively color that is hard to keep quiet, however.

COBALT VIOLET LIGHT: This provides an interesting complement to the yellows. It can look warm or cool depending on what it is next to. It is an interesting tint color; it will quiet down, but when it dries it has a reddish-pink tone. It is very helpful in shadows, especially when there is a warm color reflecting into a cool color. It is often warm enough to glow but not so hot that it changes blue to brown.

VENETIAN RED: This is a strong burnt orange that is strong enough in the shadow of an orange to look like warm reflected light without taking over like Cadmium Orange will. It is also helpful in the light as a less obvious, slightly cool red-orange and is especially quiet when mixed with Chinese White.

INDIAN RED: This is an unusual color that looks red or pinkish purple depending on the color or colors it is next to. Mixed with Chinese White, Indian Red is a cool, pinkish violet-red. It is a useful pinkish purple in shadows without being loud like Permanent Magenta. It is also useful in the shadow of a red block or apple. It can be cooled with violets and warmed with oranges or reds.

MARS VIOLET: This is made by only one manufacturer, but there are good reasons for tracking it down. It is a color that often occurs in nature, a quiet, subtle violet without brashness. It is cooler than Indian Red, but like that color, it is a chameleon, looking red or violet depending on the other colors in the painting and on the colors that are mixed with it. It looks dull and extremely dark when mixed with green or blue. It can also be a quieting color. You can use it mixed with Naples Yellow or Lemon Yellow to paint sand in the light. You can use it mixed with Chinese White to subtly tint colors in the light.

CHINESE WHITE: Despite what many watercolorists will tell you, white is a color, and an indispensable addition to your palette. It is an extension of my color vocabulary, not just something extra thrown in as an afterthought. I use this white to keep colors true when layering them. You can't do without Chinese White when painting blue in the light; any other color you use to get the warmth of the light will turn the blue green. Chinese White is a cool color; it will not cover another color, but added to any other color it changes the inherent nature of that color, making it cooler. The introduction of Chinese White gives you better control over the subtlety of your color choices. It is also needed to mix a light blue. The masters such as Sargent, Turner, and Homer used Chinese White to describe atmospheric effects.

The Boynton Color Chart

There are many, many mixing variables, and you need to learn the various combinations. I have all of my students make a color mixing chart which they can refer to when trying to nail down a precise color. When it is finished, you will be able to see the way every color on your palette looks under every other color and over every other color, and how they look subtly different depending on whether they are under or over the other colors. Throughout this book we describe the color in the light as warm and we put the warm color down first and then put the cool color over it. For example, a rosy tablecloth in the sun will be described first with one of the yellows, with the cool rose over the yellow wet-on-wet so the yellow shows through the rose. The opposite is true of cool shadows. Areas in shadow are first described with a cool color and the warm reflections of light into the shadow are put in over the predominant cool color wet-on-wet. Right now, at the beginning of your learning, this may not seem like a significant distinction, but it will become clear as you progress.

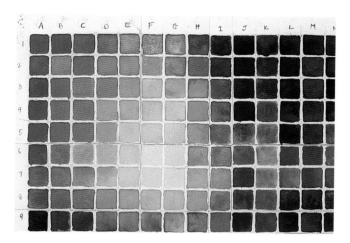

A DETAIL OF THE UPPER LEFT OF THE COLOR CHART, SHOWING THE NUMBERING SYSTEM.

On a large piece of watercolor paper mark off 1-inch squares horizontally and vertically with ⅛-inch spaces between them. It may make it easier if you number the colors on your palette from **1** to **21,** starting with Permanent Rose (1) and ending with Chinese White (21) and label the squares on the paper as shown. There will be 21 squares in the horizontal rows, and 20 in the vertical columns because Chinese White, color 21, is only used *over* the other colors.

On your palette, mix equal amounts of paint and water. (This exercise will be easier if you use two brushes, one for the main color and another for the added color.) Do not wet the paper. Starting with square **1A,** put down Permanent Rose. Skip to square **1C,** and put down Permanent Rose again. (It is easier to keep the squares from running together if you paint every other square.) Skip to square **1E,** and put down Permanent Rose again, and so on until you reach the end of the row. While the paint is still wet, put down Permanent Rose over the Permanent Rose that is in square **1A.** Skip to square **1C** and put Cadmium Scarlet (color 3) over the Permanent Rose, then to square **1E** and put Cadmium Yellow (color 5) over the Permanent Rose, and so on with all the odd-numbered colors until you have put Chinese White (color 21) over the Permanent Rose in square **1U.** It is best to wait until this row is dry before filling in the remaining squares. You may not be able to complete laying down all the Permanent Rose without the first squares drying before you add the additional colors to it. If you find that

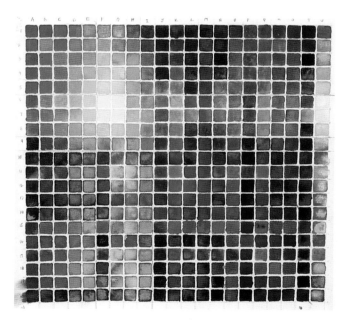

LEE BOYNTON'S COLOR CHART

When your chart is finished, you will have over 400 combinations to choose from when you want to nail down precisely the right paint mix for a specific color that you see in front of you. The results are well worth the effort.

your first colors are drying too fast, you may have to do only half a row, or a third of a row, or whatever number of squares you can work on before the paint dries. I want you to do this so the colors will mix on the paper wet-on-wet in the same way they will when you are establishing the color masses in your painting.

Now, starting with square **1B,** put down Permanent Rose in all the empty squares in row **1.** While the paint is still wet, go back to square **1B** and put down Cadmium Red (color 2) over the Permanent Rose, then put down Cadmium Orange (color 4) over the Permanent Rose in square **1D,** and so on with all the even-numbered colors until you have put Mars Violet (color 20) over the Permanent Rose in square **1T.**

When row **1** is dry, go to row **2,** but this time start with Cadmium Red (color 2), skipping squares, as before. When you have put down Cadmium Red in every other square, go back to square **2A** and put down Permanent Rose over the Cadmium Red, then to square **2C** and put down Cadmium Scarlet over the Cadmium Red, and so on as you did for row **1.**

When the chart is finished, horizontal row **1** will have Permanent Rose *under* every other color on your palette, row **2** will have Cadmium Red under every other color on your palette, row **3** will have Cadmium Scarlet under every other color on your palette, etc., and row **20** will have Mars Violet under every other color on your palette.

Vertical column **A** will have Permanent Rose over every other color on your palette, column **B** will have Cadmium Red over every other color on your palette, etc., and column **T** will have Mars Violet over every other color on your palette.

Once your chart is completed you can use it to find out how to mix a specific color that you see in front of you. Look at an object and then find the closest color to it on your color chart. Start with the mixture of colors in that square, and then adjust the mix if necessary to more closely match the color of the object you are depicting. Experiment with letting the colors mix on the paper and with mixing them together on your palette. It is also a good idea to experiment with mixing different proportions of various colors *before* you start painting.

Colored Blocks

Painting colored blocks is the starting point for beginners. Even experienced artists will find it useful to return to painting colored blocks now and then. It is important for the beginning painter to start with primary colors. It easier to learn to see bright, glowing colors than subtle blues and earth colors. Learning to see the obvious effects of light and shadow on unmistakable colors is the fundamental exercise of color painting in any medium.

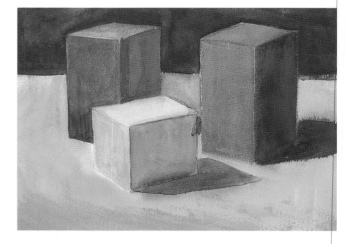

WATERCOLOR PAINTING OF PRIMARY COLOR BLOCKS

STRETCHING YOUR COLOR VISION

Before starting any painting, it is absolutely crucial to understand the light effects of the conditions under which you are painting. Then we must translate what we see into paint on paper. What we need to do to paint what we see—and it is not easy—is to gain enough visual experience so that we can *trust* our ability to see these color changes and to depict the effect of the color of the light accurately.

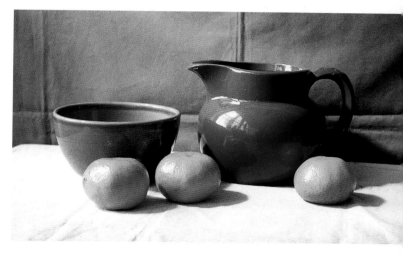

INCANDESCENT LIGHT INDOORS

Every object in this scene has distinct light and shadow with reflections from the oranges and tablecloth into the shadow masses on the bowl and pitcher. The cast shadows are well defined and distinct. The oranges reflect into their cast shadows, and the backgound reflects green light into the cast shadow of the pitcher.

APPLE
Watercolor, 9 x 12 inches.

The yellow-orange incandescent light gave the local color of this apple, red, a yellow-orange cast. I developed the brightness of its lighted side with Cadmium Scarlet + Cadmium Orange. To get the darkness of the shadowed side, I started out with Indian Red. Reflected light will always be specific to those things that surround the apple. Here we see some violet, some green, and a lighter spot that is "redder" than the rest of the shadow. The cloth in the light here is Naples Yellow with a little earthy red against the shadow, which is blue-violet with some green. The light and color effects are unique to this setup. The same apple placed outdoors on a hazy day would not look the same.

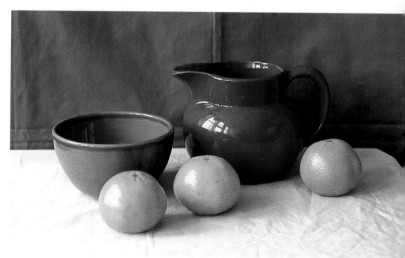

NATURAL LIGHT INDOORS

The light here is coming through a window to the left of the objects. The light and shadow masses are not as differentiated as they are under strong incandescent light; the light masses are darker than in the setup above; the shadow masses do not look quite as dark. Overall, this scene is darker and cooler in the light. The cast shadows are faint and the reflections into the shadows are not as developed.

EXERCISE 2: *Artificial Light*

1. On a large plate or tray arrange several objects with different colors and reflective qualities. At least one of these should be a solid-colored object with a flat top.

2. In a room with ample natural light, but not direct sunlight, place the tray under an incandescent light and turn the light on.

3. What color is the light present in all the parts of the scene directly receiving the light, that is, the light masses? Notice the differences in color between the top surfaces in the light and the vertical surfaces in the light.

4. What color is the light present in all the shadow masses as contrasted with the colors in the light masses? Notice the differences among the shadows depending on reflected light and depth of shadow. In general, the range of colors seen in shadow masses is cooler than the range of colors in lighted areas.

5. If possible, repeat this exercise under fluorescent lighting and halogen lighting.

Some Basics of Lighting

The only way to learn to see the color changes under differing light conditions is to observe objects under different conditions. I can tell you what you should be seeing, and show you some pictures of objects in different light to point you in the right direction, but the only way to develop your color vision is through direct observation.

For the accompanying exercises, you should find as many differences as you can. Repeat them with a greater variety of objects. The more experienced you become in painting, the more subtle differences you will be able to see in your different setups under varying conditions.

Shadows and Reflected Light

What happens to color in the shadows? Your observations about a scene in shadow, or about the shadow masses in a scene, are all partial answers to this question. What we see when we're dealing with shadows is very much affected by reflected light. The light that bounces into shadows influences their color. One of the reasons all shadows are not the same color is that

EXERCISE 3: *Natural Light Indoors*

1. Set up the same tray of objects you used for Exercise 1, in the same room, with ample natural light. Focus on one surface, turn off the light, and pay careful attention to the color changes you see. Turn the light on, focus on another surface, and turn off the light.

2. Analyze the specific color changes for each surface when the incandescent light is turned off. For example, a blue background will lose its red-orange-yellow cast and become much bluer. With the lights on, the blue is washed out by the warmth of the light and is replaced by violet. All the colors will become cooler and quieter with the light off. Some surfaces may seem like a different color altogether.

3. If possible, repeat this exercise under fluorescent lighting and halogen lighting.

EXERCISE 4: *Natural Light Outdoors*

1. Carry your tray of objects outside on a bright, sunny day in the morning. Look at the colors you see. Look at the setup outdoors in the middle of the day and in the evening, paying close attention to the color changes.

2. Repeat Step 1 on a day with hazy sun and on a cloudy day.

3. Carry the tray into a shadow cast by a building and also into a shadow under a tree. Note the differences in the light effect between the shadow under the tree and the cast shadow of a building.

4. Carry the tray out of the shadow and back into it again. Watch carefully for the change when you go from shadow to light and back again. Pay especially close attention to the color changes in the flat top surfaces of your objects.

different colored things reflect into different shadows.

There is more color in shadows than you will probably see at first. Standing up instead of sitting down can help, as can putting your setup on a surface below eye level. The more of a shadow you can see, the more color you will see in it. Don't overanalyze; learn to develop and trust your color vision. Try to see each shadow as an individual color. Also, beware of formulaic reactions, such as "It's purple, so it's got to be one of the purples on my palette, like Ultramarine Violet." Be a little more daring.

You have to think about light as a moving thing. It's not static. The metaphor to keep in mind is water. Like water, light splashes. The light shining down onto the tablecloth in a still life is splashing back into the shadows of the other objects, influencing the color of each. Especially in situations where the light is strong—under a lamp or in direct sunlight—the effects of reflected light are extremely significant.

To accurately paint the colors of light, whether direct or reflected, you must first see them. Our classrooms are painted white. My students are always amazed when I have them look at the four walls of a room and they discover that each is a slightly different color. Before you start the following exercise, look carefully at the first of the photographs here. For Steps 1 to 3, your objects should be in the same relationship to each other as they are in the picture.

SETUP FOR REFLECTED LIGHT

In these four details of a still-life setup, the differences in the reflections into the pitcher and into the shadows are striking.

EXERCISE 5: *Seeing Reflected Light*

1. Cover a large plate or tray with a colored cloth in a room with an incandescent light source coming from the left. Place a large opaque ceramic bowl or jar with a reflective light-colored finish—not white—on the cloth. Add an apple and lemon. Observe the colors reflected into the objects by the tablecloth. Look for the reflections in the shadows and find the sources of those reflections. Notice the differences among the colors of the shadows, and how the color of the light changes with distance from the source.

2. Get an orange cloth and put the edge of it up against your objects, covering part of your original cloth, but leaving at least one shadow uncovered. Observe the changes in the reflections into the pitcher. Observe the change in the shadow you have left uncovered by the orange cloth. It is much yellower now, with a tendency to orange.

3. Place the red cloth over the orange one. Now the shadow becomes even more orange. Do the same thing with all your colored cloths, observing the changes in the reflections into the pitcher and the color changes in the shadows.

4. Move the objects around and notice the changes that occur in the colors of the objects and in their shadows.

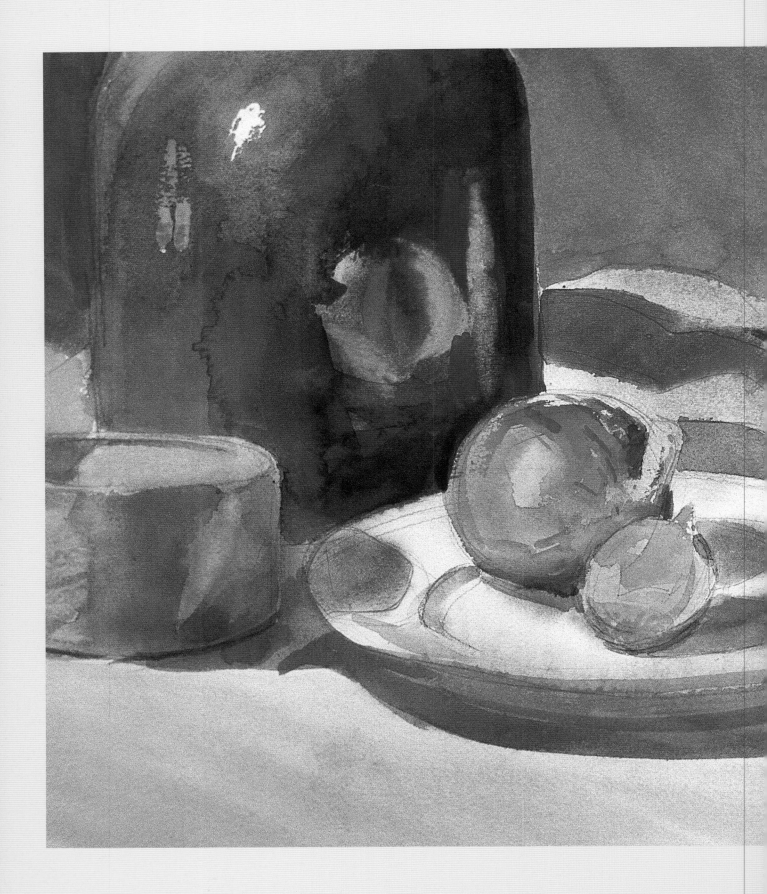

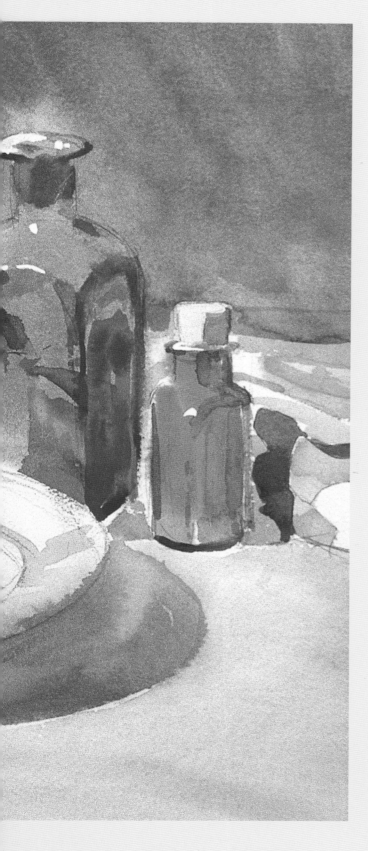

5
VALUE

In Chapter 3, you did value studies in black and white because you needed to be able to see and depict value in black and white before learning to see and depict it in color. For the Impressionist, however, value and color are inseparably linked.

LIGHT AND DARK OBJECTS, *Lee Boynton. Watercolor, 12 x 16 inches.*

Notice the value difference between the shadows on the white plate and the light mass on the front of the blue bottle. Both the shadows on the plate and the bottle in the light are blue, but the shadows on the white plate are darker than the light mass on the front of the bottle.

VALUE AND COLOR

When describing in color the shadowed side of a blue bowl, an Impressionist does not attempt to assign it to a black-and-white idea. It is all right to describe a shadow in a black-and-white painting as black, but in order to describe a color scene you must train your eye to see all shadowed areas as colors. You must ask yourself, for example, "Should that blue in the shadow of the pitcher be greener, or more violet, or pinker, etc.?" "How can I make the color deeper?" Of course, you must also ask whether it is dark enough. You must also remember that if the value of a given shadow note is lighter than any of the areas in the light, the illusion of three dimensions will be destroyed. Yet without black, dark gray, and burnt umber, which are not on the Impressionist palette, your must create color changes that make a color in the shadow deeper, not blacker. Some of the colors on your palette are already fairly dark, and any color can be made deeper by increasing the intensity of hue—that is, the concentration of pigment—by using less water.

In the exercises in this chapter you will learn to make value scales which you can use to accurately determine the values of both white objects and of a range of different colors. You may think you know which areas in a scene are lighter and which are darker, but I predict you will be surprised by some of your findings. This is something you cannot learn by reading about it; you must see it for yourself.

Using Value Scales

My students are often astonished to learn that two very different colors are the same value, or that colors they thought were the same value are actually quite different in value. If you are going to develop your ability to see value, it can be helpful to learn how to use a value scale.

With the exception of cast shadows with clearly defined boundaries, or objects with corners, value usually exists in the world around us as a continuum. We do not see light, halftone, and shadow on an object as clearly defined stripes. Instead, we see value as a continuous and almost imperceptible flow from

VALUE SCALES

The middle scale illustrates the continuum of value we see around us. The top scale shows the same series of values as the middle scale, but broken down into discrete steps. The bottom scale illustrates, from left to right, progressively lighter values of the same color.

dark to light, not as a series of discrete, clearly delineated steps. However, in order to create the value changes that give us depth of form when we paint, we need to proceed step by step, as in Exercise 1.

Be sure you follow the steps in the order they are listed rather than try to start from the lightest or darkest and work to the opposite value. As you fill in the rectangles, make sure that each value is halfway between the one to its left and the one to its right. There is also a good reason for doing the dark and the light value before doing the middle, or halftone, group. In a painting, we do the same thing: we differentiate the light and shadow first, then paint the halftones.

After your scale is dry, compare it to the top scale shown above. If you haven't got all the values right, keep making new scales until yours matches the one in the illustration. If some of your values seem right, but others do not, cut the strip apart and replace only the values that are wrong. When you have them all right, staple or glue the individual rectangles to a strip of paper. Once you are satisfied, use a punch to make a hole in the center of each rectangle.

EXERCISE 1: *Making a Black-and-White Value Scale*

1. On a piece of watercolor paper, use a ruler to draw a row of ten 1-inch x 2-inch rectangles, with ⅛-inch spaces between them. You should end up with a strip 2 inches high and a little over 11 inches long. Starting at the right, number the rectangles from #1 (which will be the white of the paper), to #10, the darkest value (which will be black paint straight from the tube).

2. Starting with the rectangle at the left, mentally divide these rectangles into two groups of three then one group of four. The right group of four represents the light, the middle group represents the halftones, and the left group represents the darkest values, the values that correspond to the shadow. Divide your palette or other mixing surface into three areas, one for mixing the light tones, one for the middle values, and one for the darkest values.

3. Begin with the darks. Mix some black paint with a little water. You are not aiming at the darkest value in this group, but at a medium dark. To begin, use about 1 part paint to 2 parts water for this middle value. Paint this mixture on the middle rectangle of this group (rectangle #9). It is important to mix up enough of this and all subsequent mixtures to save some for later steps.

4. Now move to the light group, and make rectangle #3 slightly darker than the white rectangle, #1. It is important not to make it too dark; it can be made darker later if necessary.

5. Next, move to the middle group. To the mixture you made for #9, add some water a little at a time to make value #6, the middle value of this group. You are aiming for a value halfway between value #3 and value #9. Now you have all the middle values stated.

6. Repeat the procedure for rectangle #8, diluting the mixture you used for #9. Do the same thing for #5, using diluted #6, and for #2, using diluted #3.

7. For rectangle #4, mix a value halfway between #5 and #3, which you already have down. Do the same thing with #7, mixing between #6 and #8.

8. For #10, the darkest value, use very little water with the paint. You want it almost pure from the tube, with just enough water to make it paintable.

EXERCISE 2: *Using a Black-and-White Value Scale*

1. Place a rounded white object on a table so that some areas are lighted and some are shadowed. Starting with what you think is the shadow mass, look at the area through the hole in the middle of the dark- and middle-value groups and decide which value the area matches most closely. Squinting your eyes will help to compare values. Do the same thing for the lighted masses and the halftones. Do the same thing with the white block you used in Chapter 3. The form changes on the white block are easy to see; they occur at the corners. Notice that every form change in the objects requires a value change.

2. Find a catalog or newspaper advertising supplement with an ad for T-shirts or towels in a variety of colors. Use your value scale to compare the values of the different colors.

3. Make a black-and-white full-value drawing of the colored objects in the ad.

Mastering Value Comparisons

To paint light objects in both light and shadow, we need to have a lot of experience in making color decisions. We need to be able to paint different values of the same color without ending up with the wrong color altogether.

Context is very important here. As always, the value of a light object in shadow must be lighter than the value of a dark object in the light. Turn back to the painting on the opening page of this chapter and use

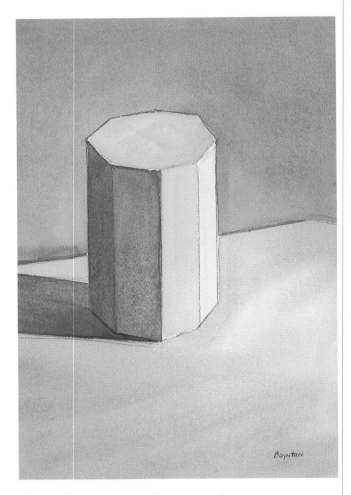

EXERCISE 3: *Testing Your Value Vision*

1. Look around your house and collect a group of objects that you think are the same value and use your value scale to test your perception.

2. Collect a group of objects that you think are different in value and use your value scale to test your perception.

BLACK-AND-WHITE FACETTED CYLINDER

This painting clearly shows the values from lightest to darkest. The light mass consists of the top and the two right facets. The halftone, which is part of the light mass, is the top and the second facet from the right. The shadow mass is the two left facets and the cast shadow on the tablecloth to the left of the cylinder. Reflected light into the shadow mass on the block lightens it and creates the fourth value.

COLOR PAINTING OF FACETTED CYLINDER

This is the same cylinder as the one in the illustration on the left, but painted with color only. No black or gray paint was used.

your value scale to look at the different objects. You will see that many areas that seem to be different values are really the same value. For example, both the shadows on the white plate and the light mass of the bottle are blue, but the shadows on the plate are darker than the light mass on the bottle where there are no dark reflections.

It can also be difficult to nail down the value of bright colors, which are often erroneously seen as being lighter in value than a similar color that is not so bright. Light colors, which require less pigment, are generally washed out in brightness. Don't confuse "brightness" with light intensity. The brightness of a color depends on the purity of its hue, its pigment. The pure colors on your palette are brighter than any mixture of them will be. Lightness, like brightness, is a relative concept. A light color is not necessarily bright, and a bright color is not always light. For example, royal blue is darker *and* brighter than baby blue. Cadmium Yellow is darker and more intense than Lemon Yellow, but is still a lighter color than Cadmium Red.

Colors that appear to be bright are often fairly dark in value. For example, red and yellow are both bright, but do not have the same value. Under the same light, pure Cadmium Red will always be darker than pure Cadmium Yellow. A strong statement of pigment is needed to make many bright colors.

PAIRS OF COLORS WITH SIMILAR VALUES

If you look at these colors through your value scale, you will see that the colors in each vertical pair are the same value. You can also see that similar colors can be different values.

EXERCISE 4: *Describing Colors*

1. Take out your color chart. Stand back and look at the whole chart while squinting your eyes and decide which areas of the chart have colors that are the same value and which areas of the chart have colors that are different in value.

2. Still looking at your color chart decide which colors are bright and which are dull or obscure. What are the brightest colors? Which are light and which are dark? What are the lightest colors?

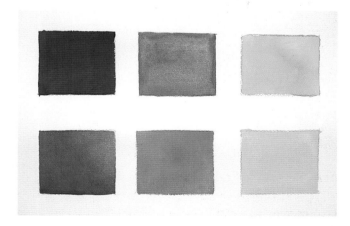

PAIRS OF BRIGHT COLORS

In each vertical pair, the top and bottom squares are equally bright.

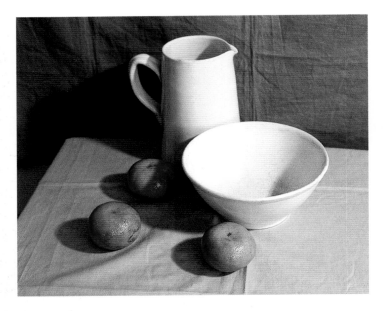

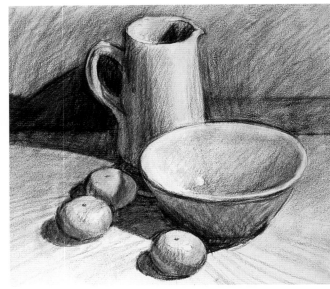

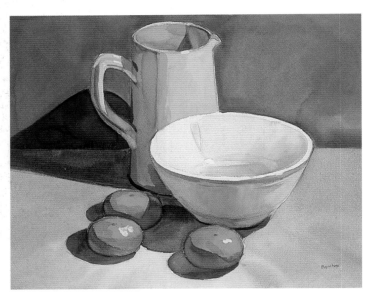

LIGHT COLORS IN LIGHT AND SHADOW

Top left, an ivory-colored pitcher, a white bowl, and oranges on a pale blue tablecloth under incandescent light; top right, a full-value drawing of the setup; left, a watercolor painting of the same setup. The main consideration here is the color and value relationship among the various masses. The lighted part of the white bowl is the lightest part of the scene, and the shadowed part of the bowl is the next lightest mass, even lighter than the pitcher in the light. In painting these objects, I had to make sure that the shadowed side of the pitcher was lighter than the cast shadows while remaining dark enough to read as shadow. I didn't leave the inside of the bowl in the light the white of the paper because I wanted to represent the warmth of the light, but I also had to make sure the inside of the bowl was the lightest part of the painting, even lighter than the lighted part of the pitcher, in order for it to read as white and the pitcher to read as off-white.

EXERCISE 5

1. Set up some light-colored objects that are partly in the light and partly in shadow. Make a black-and-white full-value sketch.

2. Analyze the colors in the scene, and make swatches that match the colors you see as closely as possible.

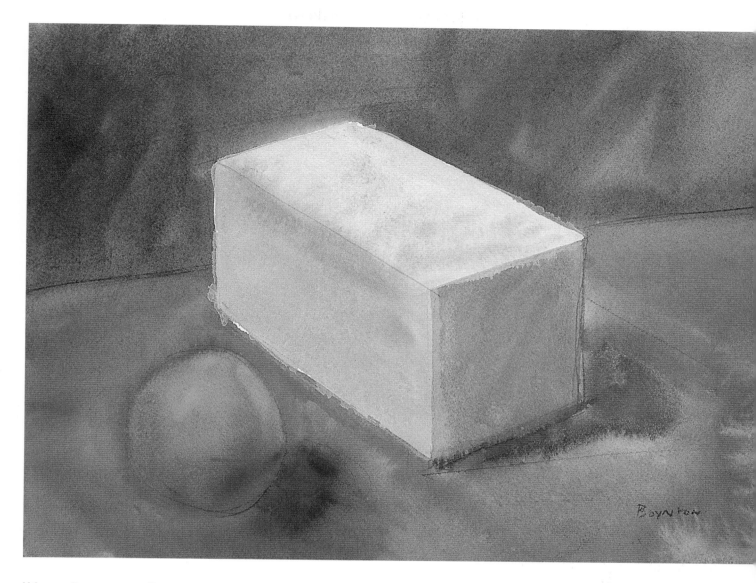

White Block and Orange

This is a good example of what happens in the shadowed sides of a white object. The top of the block shows a lot of sky reflection. The long side is lighter than the end, which is completely in shadow. Both the side and the end have pink reflections from the cloth, and the long side also reflects the orange. If you compare the shadowed side of this block to the shadowed side of Monet's cathedral painting in Chapter 1 (pages 14 and 15), you will see some of the same colors.

PAINTING BLOCK STUDIES

This is the first of two demonstrations in which you have the opportunity to paint along with Lee Boynton, following his step-by-step approach to creating an Impressionist watercolor that glows with light and color. If you follow along conscientiously, at the end of the process you will have come a long way toward developing your color vision.

RED AND BLUE BLOCKS IN OUTDOOR SUNLIGHT

There are a lot of interesting color variations in this simple block study. The shadow on the tablecloth contains a lot of blue from the sky with the warmth of the cloth added to the cool statement of the shadow. The vertical, shadowed sides on the red block show some reflection from the table-cloth, while the shadow on the top plane is more purplish due to the reflection from the blue sky. The side of the red block facing the blue block also has some of the blue reflected into it on the right. Moving from left to right on the shadow between the blocks, first there is reflection from the shadowed side of the red block into the cast shadow, then a lighter stripe on the right edge where the lit part of the red block reflects into the cast shadow.

GETTING READY

Painting block studies teaches you to put light and color into your paintings before even thinking about creating the illusion of three-dimensional form. In a block study, you pare the painting down to its most basic elements: colored geometric shapes on a table. That tells us the truth. With block studies, you don't have to worry about drawing details, so you can concentrate on putting down the masses of color to represent the light effect. If you don't have the simple truths of light, you have nothing. With block studies, it's obvious when you've got the truth and when you haven't.

It is crucial to read all of the sections on painting the block study, paying close attention to the analyses and explanations of the stages of the painting, before you begin. You need to know where you are going before you start out.

There is a difference between a color study and a finished painting. If you are a beginner in this medium or in this style of painting, you should paint many more color studies than finished paintings. Your first color studies should consist of no more than Stages One and Two, and probably no more than Phases One and Two of Stage Two. The emphasis in a color study is on separating the first two values—light and shadow—and making color and value as accurate as possible. Stage Two, Phase Three, which is getting the third value—the halftones—is not necessary for creating the Impressionist light effect. If you haven't successfully separated light and shadow, there is no reason to go on. When you can consistently and sucessfully finish Stage Two by beginning to add halftones and to model form, you can move on to Stage Three. Beginners may have to make a lot of Stage One and Stage Two, Phase Two paintings before they can even move on to the final phase of Stage Two, where they get more accurate color statements by adding color variations to the light and shadow masses.

If you can make the block say what you're trying to say about light, you can do anything as long as you keep practicing and make it a part of your painting vocabulary. Even if you're able to say "light" the first time, you've got to do a hundred more studies until you can achieve the effect of the light consistently.

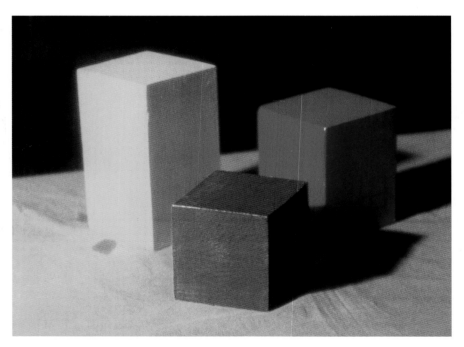

RED, BLUE, AND YELLOW BLOCKS UNDER INCANDESCENT LIGHT

STAGE ONE: ANALYSIS AND DRAWING

First, you must analyze the scene and then complete some preliminary drawings in order to identify the masses and refine the composition.

PHASE ONE: *Analysis*

There are several preliminary questions you need to answer. Most importantly, analyze the light effect. What kind of light is it? What is the direction of the light? How does it affect each object in the scene? The beginner should set up the objects so that the objects are half lighted and half shadowed.

The setup shown in the photograph is a 4- by 8-inch yellow rectangular block, a 4- by 4-inch blue block, and a 4- by 6-inch red block. The incandescent light, which is shining from the left, gives all three blocks a more yellow-orange cast than they would have under natural light and the light and shadow masses are readily identifiable. The tablecloth is orangey, and the background cloth is dark blue, almost black. The tablecloth has distinct, and constrasting, areas of color: cast shadows and where the light is falling directly on the cloth.

As you paint along with Lee in the following sections, this illustration will be your setup. Unfortunately, because of the limitations of the printing process, you may not be able to see all of the color variations described. Just do your best.

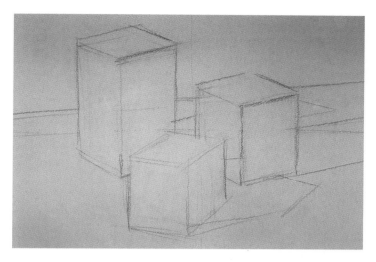

CONTOUR DRAWING FOR BLOCK STUDY
Pencil, 9 x 12 inches.

You will be applying paint over this drawing, so the paper you draw on should be a sheet of cold-pressed paper in a block, no larger than 9 by 12 inches.

PHASE TWO: *Drawing the Blocks*

Referring to Chapter 3, page 35, use your viewer to do a contour drawing of the blocks on your watercolor paper. Then put down the viewer and draw the outline of the cast shadows on the tablecloth and on the blocks. (This setup has no cast shadows on the background, but some setups will, and if they do, you will need to draw them as well.) Last, draw the line of the table against the background. In this kind of painting I'm primarily interested in the color relationships. The drawing is a guide to where the masses of color will be in the painting. Concentrating on relationships starts in the drawing phase and gives us a philosophy that will serve us well at every stage of the painting.

STAGE TWO: THE SHOCK OF THE LIGHT

This stage is the most important: the wet-on-wet stage. At the end of Stage Two, your painting might look out of focus, but that is a necessary means to an end. In the early stages of painting, you are building the foundation for all that follows. The foundation, which is the integrity of the light description, must be there so other elements can be built upon it. You must get used to making starts without worrying too much about finishing the paintings. It is getting all the spots of color correct many times that makes this process become a part of your understanding.

Stage Two is where you will capture all the excitement and brilliance of the effect of the light effect. It's the stage where I tell students to scream at me with color. Putting in halftones, reflections, and small color variations tones down this raw brightness.

Practicing your starts is like playing scales in music. A beginning musician concentrates on getting all the notes in without making mistakes. The musician with more experience and authority no longer has to worry about getting the notes in without making mistakes, and can concentrate on playing each note with clarity and brilliance of tone. Clarity and brilliance are the painter's goals also. Henry Hensche taught that if an artist achieves accuracy in the beginning, the painting will be true from the start and less additional development will be needed.

PHASE ONE: *Separating the Light and Shadow*

The most important thing in this phase is keeping the statements about color and about value very simple in order to express what Henry called the "shock of the light." The light masses must be similar in value to each other, and the shadow masses must also be similar in value to each other. The contrasts between light and shadow masses occur where the two come together.

You need to work fast, so that you cover up the white of the paper rapidly. Colors look brighter and everything looks darker next to white. You do not want your first statements of value and color to be affected by the white of the paper, so it is necessary to obliterate that white as quickly as you can.

For your first statement pick the most obvious color—one that is most like a color taken directly off of your palette with nothing else mixed in. This will usually be in one of the lit masses of your setup. Because getting this kind of mass right is relatively easy to do, this statement is the most logical starting place. The second, third, and fourth statements are then made in the areas adjacent to the beginning point.

Building the painting by working in adjacent areas will define the color relationships of the masses of the painting to start. Keep your early statements as simple as possible. It is important to remember that the color is right when the value is right and vice versa: color and value must be inseparable.

You must lay down your early statements quickly because you will be letting most of your colors mix directly on the paper wet-on-wet.

CREATING A TEST SHEET

Once you have decided on your initial statement for an area, put down a large area of that color on another sheet of watercolor paper. Then, when you are refining the light effect, in Phase Two, you can test the accuracy of the mixtures you plan to use on that sheet before you actually add them to the painting.

It is only through long experience that you can hope to achieve the right balance of boldness and caution needed in this phase, so you don't have a lot of time-consuming and difficult fixing to do in the next phase. I would rather see a strong study with some mistakes than weak, safe statements. This is not a style of painting in which we build up the color gradually. Instead, we go for broke right from the beginning. If you get it irretrievably wrong, you can start over!

> Throughout the demonstration, the illustrations showing the progressive stages of the painting are placed as closely as possible to the specific instructions for applying paint to the paper. For example, the illustration labeled *Painting Phase One: First Colors* shows the painting *after* you have put in the yellow block and the background.

WET-ON-WET

The technique called "wet-on-wet" cannot be reduced to a recipe. When you paint wet-on-wet you are wetting the paper before applying paint, then applying paint, then adding any additional colors before the first color has dried. The principle is the same whether you wet the entire painting surface before beginning to paint or wet only the area in which you will be working next. Nonselective wet-on-wet can be terrrifying to novices, especially when they have seen how much mixing between adjacent areas it may cause, and they will automatically turn to selective wetting. However, I always try to push students to wet the entire paper and use nonselective wet-on-wet throughout the early stages of the painting process so they will learn to be bolder in their descriptions, to take risks, and to apply paint more spontaneously. The following directions assume that you are willing to try it also. As the painting progresses and some areas begin to dry (this happens especially quickly outdoors), selective wetting may be the only option. To arrive at the wet-on-wet approach that works best for you, you will need to experiment with various amounts of water and paint, learning as you go along how paint behaves under each set of circumstances.

First, use your wide brush (your 2- or 3-inch natural-bristle house painting brush) to put clear water all over your paper, making sure the paper is as wet as possible to begin with. Scrub around with the brush, and let it soak in so the paper is like a damp blotter. A sense of timing is very important since each situation is a little different. The only way to develop this sense is through experience, so don't be discouraged if your paper is too wet or too dry at first.

PAINTING PHASE ONE: FIRST COLORS

Now you will begin to use your color vision. There is no way to quantify how much of one color to mix with another. When I say "Mix color A with color B," I mean that you should use approximately equal amounts of both. "Mix color A with some color B" means that you will use less of color B, and "Mix color A with a little bit of color B" means that the mix will have much more of color A than color B. Try to match the colors you see in the setup.

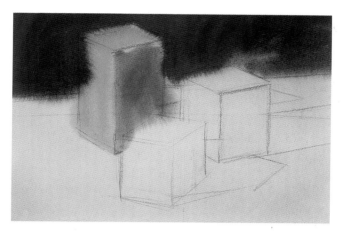

PAINTING PHASE ONE: FIRST COLORS

Yellow Block

Begin with the most obvious color: Cadmium Yellow in the light mass of the yellow block. The most important thing is the color relationship: putting two pure Cadmium Yellows on the top and side next to each other. For now, disregard any halftones. Don't separate those two surfaces in the light; you need to be sure to get the *shock* of the light rather than the *form* of the object. I want to make that distinction very clear: in the beginning you want to get the light. It's not enough just to make a block study. You've got to make a glowing block study.

Keeping in mind that we'll always be working on adjacent areas, go next to the shadow mass on the yellow block and cover it with Yellow Ocher. Over that, paint a few strokes of Permanent Green Light, letting the two mix right on the paper wet-on-wet. A typical beginner's mistake is to blend all the colors together, overmixing them. Just put one on top of the other, letting the previous colors show through. The object is not to completely cover the Yellow Ocher, but to accent it with the green.

Background

Start with a color that will create some warmth in the light. Use Mars Violet and a small amount of Chinese White mixed on the palette to surround the block and cover up the white of the paper as quickly as possible. Mixing Chinese White with a color is an exception to the usual mixing on the paper, but the Mars Violet needs to be lightened a bit before being applied

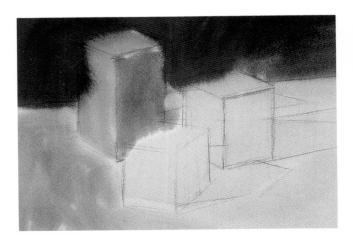

PAINTING PHASE ONE: TABLECLOTH

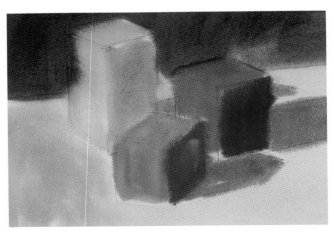

PAINTING PHASE ONE: BLUE AND RED BLOCKS, TABLECLOTH CAST SHADOW

to the paper. The color of the background cloth might be described as "bluish," but there's really not a lot of blue in it. Now add Ultramarine Violet over the Mars Violet + Chinese White that is already on the paper, rather than adding a true blue.

PAINTING PHASE ONE: SECOND STATEMENTS

Tablecloth

Start by putting in the warmth of the light with Naples Yellow. The result isn't quite warm enough, especially to the left of the blocks. On your palette, mix some Cadmium Scarlet with a little bit of Naples Yellow and float it over the Naples Yellow on your paper, putting more of that mixture into the area to the left of the blocks than to the rest of the tablecloth.

Blue Block

The color of the *blue block* requires a judgment call. Mix together on your palette Cobalt Blue and a little bit of Chinese White and put that mixture on the lit sides only. For the shadow, first put down Ultramarine Blue wet-on-wet. Then put some reflected light into the shadow mass using Cobalt Violet mixed on the palette with a little bit of Chinese White. Just make two brushstrokes in the middle, without blending it all in.

Red Block

For the *Red Block,* mix together Cadmium Scarlet and a little Lemon Yellow and put this mixture on the lit side. Paint the entire shadow Permanent Magenta.

Tablecloth Cast Shadows

Start putting the cast shadows on the tablecloth. Mix Ultramarine Violet with a little Chinese White for the cast shadows of the red block and the cast shadows of the blue block. At this point we're just trying to get the white covered up.

PHASE TWO: *Refining the Light Effect*

This is where you make your Phase One statements more accurate. The first phase recorded your immediate impressions. Now you take a second glance and perform a second analysis. Identify the differences between the scene and what you have painted so far. Decide what emergencies need to be corrected.

Now that the white of the paper has been covered and your first color statements have been made, you can further refine the colors by adding another color while the painting is still wet. Don't try to make too many color changes at this point, however. Getting all the color masses right and in the proper relationship to one another is difficult enough as it is.

Often, the color changes you are making in Phase Two will require that you apply several colors directly on the wet paper one on top of the other, as quickly and boldly as possible. For the shadow masses, this

usually means making them darker. Then evaluate the light masses and make necessary adjustments. Pay attention to the value statements so that subsequent statements keep the shadow in the shadow and the light in the light.

You should be working as quickly as you can. The more experience you get, the more quickly you will be able to work, so don't be discouraged. One of the difficulties in watercolor painting is just staying ahead of it, trying to get the necessary elements in while the painting is still wet enough. It's important to remember that these colors will simmer down and become lighter when the painting dries. If you paint during Stage Two using the method described here—where you're establishing all the relationships in the scene at one session—when the painting dries the relationships will still be there, so the lightening of the colors is not as much as a problem as when you paint in a drier manner to begin with.

PAINTING PHASE TWO: FIRST STATEMENTS

At this point, your painting will not need exactly the same fixes that mine did. When I refer to a problem, like excessive bleeding, that might not be in your study, I'll use the first person.

After I look around to see what I need to fix, the first thing I'm going to do is to reduce the bleeding in my yellow block. One of the most difficult things to learn is how to control the flow of the color into unwanted areas by keeping the entire painting equally wet. Some bleeding in these early wet-on-wet stages is almost inevitable, and can be fixed later. The shadow mass of the red block needs to be modified and darkened a little. Look for bleeding edges in your painting. Also identify places that need to be lighter or darker. Remember that at this stage the paper is still wet, so the colors we put down can still mix on the paper.

Yellow Block

Start with the light mass. Mix Lemon Yellow with Cadmium Yellow on the palette and apply the mixture to the lit top and side to modify the color a bit, not to make it opaque, but to make a more truthful statement. I'll fix the bleeding in my painting by going

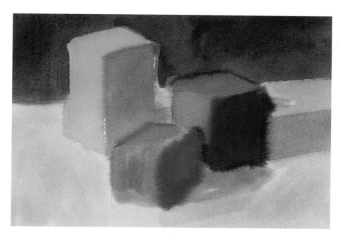

PAINTING PHASE TWO: FIRST STATEMENTS

over the edge with the Lemon Yellow + Cadmium Yellow mixture. You can do the same if your yellow block has too much bleeding. This will only work in the wet-on-wet stage. If I had let the area dry, my only option would be to cover the bleeding by going over it with the darker color, and that would make the entire block too narrow.

Put some Yellow Ocher mixed with Venetian Red into the shadow mass, then add a few strokes of Permanent Green Light on top of the Yellow Ocher–Venetian Red mix. Beware: Although shadows can have warmth in them, they are inherently cool: If you use too much Venetian Red, you will make the shadow too warm.

Background

Paint the background all over with Ultramarine Violet, letting some of the Mars Violet seep through. The color of the background cloth in the setup is not a very "clean" color. Add just a little Viridian over the Ultramarine Violet on the right side, not covering all of the original Mars Violet and Ultramarine Violet.

Red Block

Use a little Indian Red and Cadmium Red to modify the color of the shadow side of the red block. (With the initial color statements down and the white of the paper entirely covered, I see that the Permanent Magenta is just a little too forceful.) Remember: You need always to analyze and try to paint the relation-

ships between colors, not individual, isolated colors. Each color affects every other color, and so you must always look at individual masses of color in the context of the entire painting.

There's also a cast shadow on the lit side of the red block toward the bottom. Pop that in with the Cadmium Red + Indian Red mixture. Often the light shining on a setup, particularly incandescent light, is so warm that it requires us to paint the objects with extra warmth. In this case, the lit side of the red block requires a bit more force. Warm it up just a bit—turn up the light—with some Cadmium Orange.

Blue Block

The shadow mass on the blue block needs some help. To make it darker so it contrasts more with the light, use Ultramarine Violet over the Phase One Cobalt Blue. Add the reflected light using Cobalt Violet Deep Hue mixed with a little Chinese White. Just dab it in with a few strokes without covering the entire shadow mass. Go over the lit top of the blue block next to the yellow block and down the side with Cobalt Blue mixed with Chinese White.

PAINTING PHASE TWO: SECOND AND THIRD STATEMENTS

It's important to note that even at this point, where we're firming up some of the edges, we aren't creating any value changes in the light masses of the blocks. The presentation of light and shadow is one thing and the presentation of form is another. So far we have painted reflected light, but we have not really painted form.

Toward the end of Phase Two, you will begin to pay more attention to reflected light in the shadows. Concentrate on painting the light and shadow separately as accurately as possible without any regard to form. I will be telling you to mix together several different colors on the palette because now we want to be able to lay them right down rather than have to keep putting a lot of colors together on the paper to get the color we need.

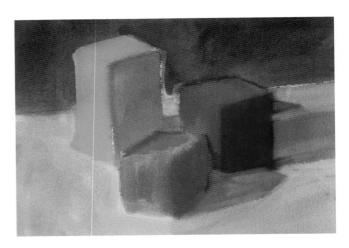

PAINTING PHASE TWO: SECOND AND THIRD STATEMENTS

Tablecloth, First Look

The tablecloth needs some quick attention. Go back to the Cadmium Scarlet mixed with a little bit of Naples Yellow that you used in Phase One and apply it over the entire lit part of the tablecloth.

Cast Shadows

As the light goes across this table surface it gets denser and darker in color to the right, which means that the cast shadows need to come down in value. First paint the cast shadow of the red block, then the cast shadow of the blue block, then the cast shadow of the yellow block. We're working from larger area to smaller area at this point, primarily because the time we have to finish the painting is limited by the drying time of the paper. We paint rapidly not to show off, but because we need to put down the paint before the paper dries.

Mix together some Mars Violet and a little bit of Chinese White and put the mixture into the cast shadow of the red block to make it a little darker and a little warmer. In doing so, cover the bleeding of the red block into the shadow to sharpen the edge. Add a little Ultramarine Violet mixed with Chinese White over the Mars Violet + Chinese White mixture you just put down. The cast shadow of the blue block needs a little Cobalt Blue and Chinese White to get the effect of a bluish kind of haze. This is an opportunity to clean up the edges of both the red block and the blue block up against this cast shadow. The shadow

from the yellow block, because it's farther from the eye, as well as farther from the light, can be a little darker. Darken that shadow to clean up the bleeding from the red block. Modify it with some Ultramarine Violet mixed with Chinese White. As always, we are working from one area to an adjacent area.

Red Block, First Look
Add a little bit of Cadmium scarlet to the lit side of this red block to heat it up a bit.

Yellow Block
There's also some reflection into the shadow mass of the yellow block. Mix a little Naples Yellow with Yellow Ocher and apply it just above the blue block.

Tablecloth, Second Look
Sharpen the edge of the yellow block against the tablecloth to both the left and right by mixing a little Cobalt Violet with Chinese White and putting a few strokes of this mixture on the tablecloth next to the background cloth to the left and to the right of the yellow block. It gets a little cooler away from the light on the right side of the scene. The hottest spot from the light is on the left side of the yellow block.

Blue Block
Put a little bit of reflected light from the red block into the cast shadow of the blue block using a mixture of Cadmium Scarlet, Cadmium Red, and Naples Yellow. Use the same mixture to strengthen the reflection into the shadowed side of the blue block.

Red Block, Second Look
The red block now looks a little too hot. Mix Venetian Red with Permanent Rose and put it into the shadow side of the red block. Add some Cobalt Violet Deep Hue, darkening that shadow.

> **Stop now and make a thoroughly honest assessment of where you are. If you are not able to consistently paint the light effects described in Stage Two, Phases One and Two, you should not go on to Phase Three.**

PHASE THREE: *Adding Halftones and Modeling Form*

BEGINNING PHASE THREE PAINTING
Before proceeding, we need to assess where we are. Drawing and using color are two different mental operations; we have to concentrate on one or the other. First, concentrate on any drawing problems; then, tackle color.

DRAWING CORRECTIONS
Look again at the painting that shows where I was at the end of Stage One, Phase Two (page 66). I see that I do have some drawing problems I need to work out. Maybe you will see some in your own painting. Don't forget that you can draw on your painting with your pencil to refine your statements as well as correct lines with your brush. Your drawing may have different problems than mine does at this point. I'll describe what I see and how I go about fixing the problems in my painting. You can use this section as a guide when looking at your picture, but you will not necessarily need to do the same things. The changes described below, even though they involve adding paint, are essentially drawing corrections.

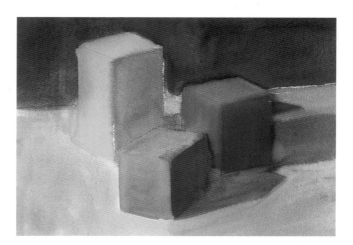

STAGE TWO, BEGINNING PHASE THREE

Red Block

There is a slight perspective problem on the bottom edge of the red block in the shadow: that edge is not really sharp enough, and the right edge of the shadowed side is too long from top to bottom. The angle of the bottom right corner needs to be corrected, making the right side of the block shorter. (Yours might be fine.) I'll use some of the color in the cast shadow, Mars Violet mixed with Chinese White, over the bottom edge of the block to correct it and sharpen that edge. Then I'll make a minor correction in the background around the block, using Ultramarine Blue mixed with a little Mars Violet to try to sharpen that edge a bit. (As the paper dries, you can get a little bit more edge.)

Blue Block

I'll add a little Cobalt Blue to the shadow mass of the blue block to sharpen the edges.

COLOR CORRECTIONS

Blue Block

Add some Cobalt Blue mixed with Chinese White to the lit side of the blue block to even out the color; toward the bottom, add Cobalt Violet. The next warmest color to most of the blues is violet, so blue objects in the light have a tendency to look violet.

Yellow Block

Add a little Cadmium Orange to the shadow mass just above the blue block to get the reflection from the red block.

CONTINUING THE PHASE THREE PAINTING

Although the painting is not dry yet, it should be very nearly dry. Generally, you should put the halftones in before you let the painting dry completely. The *only* way to get the maximum effect of the light mixing into the different masses is to paint wet-on-wet. Making these changes is a drier application, but should not be a completely dry one at this point in Stage Two.

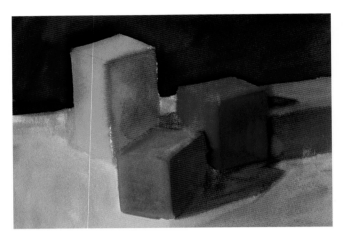

CONTINUING THE PHASE THREE PAINTING

Every time I come back to my easel after taking a photograph, I assess what has been done and how to make the study better. Even if you are not taking photographs of your work, you need to pause at regular intervals—probably at the end of each of the painting phases—to take stock. Just taking a short break is a good idea. Sometimes it takes a fresh eye to make the right judgment call!

Yellow Block

The lit side of this yellow block needs a little more contrast with the background. Next to the yellow block, add Mars Violet, Ultramarine Violet, and Cobalt Blue to make a slightly darker edge there, forcing the light statement by using the contrast with the background. Also sharpen the edges where the background and the yellow block come together.

Red Block

There's a little reflection from the tablecloth into the shadow mass on the red block. Paint it with a mixture of a little Cadmium Scarlet and Cadmium Red with a little bit of Naples Yellow.

FINISHING PHASE THREE— AND STAGE TWO

Now bring out a smaller brush. In the previous steps, I was using a #12; for this phase, I am using a #10. You can use an even smaller size if that makes it easier for you to paint in smaller areas with confidence.

Yellow Block

The halftone on the top of the yellow block is a darker value than the side directly facing the light. To get it dark enough, use a mixture of Yellow Ocher, some Lemon Yellow, some Cadmium Yellow, and a little touch of Cadmium Orange. You may need to apply that several times and add more Yellow Ocher to get just the right value. Another problem is the lit side of the yellow block. It still isn't where it should be. Add pure Cadmium Yellow on the right edge to make the contrast with the shadow obvious.

Blue Block

Now look at the top of the blue block in the illustration on page 68. If you've painted along with me, you'll see that there is not enough contrast between the yellow block and the blue block. Use a mixture of Cobalt Blue, Ultramarine Violet, and a tiny bit of Chinese White on the top of the blue block to bring out the yellow next to it. The color still needs a little more violet, so use some Cobalt Violet Deep Hue mixed with Chinese White in the top of this blue block. This will make it contrast even better with the yellow block.

Red Block

Now put a little bit of Cadium Red into the light mass of the red block. Always try an initial dab as a little test to see how you've done. In my painting, the red was too warm, so I added a small amount of Naples Yellow. I also saw that I needed to add just a little more of the high-octane, almost pure, Cadmium Red, against the front of that halftone. You may not need to make quite the same adjustments. Use your judgment.

Tablecloth

That little section of cast shadow from the yellow block in the center needs help. Use a mix of Ultra-

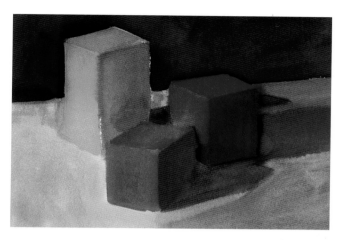

FINISHING PHASE THREE— AND STAGE TWO

marine Blue and Cobalt Violet Deep Hue with a little Chinese White to give more contrast with the lit side of the red block. However, it has to be different enough from the blue block, so add a little bit of Mars Violet to it, just sort of dabbing it in there without completely covering the previous colors.

We have now reached the end of Stage Two. Evaluate your painting to see if you have fully and accurately depicted the light effect. Are the color and value right? If not, stop here and make more studies of Stages One and Two until you *have* reached this point successfully. You can't go on to Stage Three, refining the forms, until you have fully worked out Stage Two. If you have successfully completed Stage Two, let your painting dry before proceeding to Stage Three.

STAGE TWO GOALS

It is important to know what you can hope to achieve in Stage Two: describing the major variations in form. Resist the impulse to do the whole painting in Stage Two. That is an impossibly daunting task. You have to prioritize, to make a decision as to what's important and necessary, and to recognize that not all objects have to be developed to the same degree. Two values, and possibly the beginnings of a third, are enough.

STAGE THREE: REFINING THE FORM

A major distinction between Stage Two and Stage Three is that the painting is dry when you start Stage Three. In this stage, you will work by selectively wetting the areas of the painting to be worked on. Many of the changes you will make at this stage can-not be done until the painting is dry.

The initial part of Stage Three is the most impor-tant. You must ask yourself where you have achieved your purpose and where you have not. You need to study the painting to determine what it needs and to develop a strategy for achieving your goals. Shadow areas often need development. Once the painting is dry, you can assess the value of a shadow and decide whether making it darker—which emphasizes the light—will be an improvement. This is also your chance to finish cleaning up the edges of light and shadow masses.

Correcting the Drawing

In Stage Three I usually work from those areas that take up the largest part of the painting to the smallest areas. Decisions now include evaluating whether the back-ground needs to be darker to sharpen the edges of ob-jects in the light and give them greater importance. This stage requires more thinking than doing. As the painting develops, more time goes into making decisions and thinking about how to accomplish your ends. The re-finement necessary in this stage is accomplished by making more specific the shapes and values of the areas that are the shadows, the light, the background, and the foreground. Stage Two is the guts of the painting, the foundation. Stage Three builds on that foundation.

Remember that you can use a pencil again, as well as a brush, to correct some of your drawing if neces-sary. Modifying the drawing so that everything in the painting is more clearly defined is a big part of finish-ing the painting.

Red Block

I use my pencil to redefine the bottom of the red block. Next to the blue block is a little bleed. If you have that bleed also, try to correct it by painting Cad-mium Orange over it. Overstate the red by making it almost pure Cadmium Orange around the blue block. That color really bounces. There is reflected light in the cast shadow on the bottom of the lit side of the red block. Use a little Naples Yellow and some Indian Red to get that small edge in there, that little bit of re-flected light coming through the area between the two blocks.

Yellow Block

Sharpen the edge of the yellow block along the edge of the blue block using Yellow Ocher mixed with a little bit of Viridian and a little bit of Indian Red to better define the strip of shadow on the bottom of the yellow block. In my painting, this corrects a few minor mis-fires, such as the white paper showing through.

Correcting the Color

Before making your final color changes, let your eyes scan back and forth over the entire setup again to find the areas that need a color change to be more accu-rate and to better see any misstatements of the rela-tionships among the color masses. If you stare at any one thing to the exclusion of the others, you won't be able to see the color relationships.

Cast Shadows

In the cast shadows, there's both warmth and a violet coolness. It's seemingly indescribable because it is not clearly one color or another. That's a red flag to me. If it's not real obvious what the color is, it's probably a mixture of something that's earthy, rather than of the cadmiums or some of the other bright colors. The color in the cast shadows here is just such a color: a quiet confused warm rather than an obvious, loud one.

Yellow Block

There's another example of a confused color in the upper right-hand corner of the lit side of the yellow block. At the left-hand corner of the shadow is a slight color shift, a green created by the blue reflecting into the upper part of the yellow block. It's very, very quiet, but it's definitely there. You have to mix just the right color combination to achieve these effects.

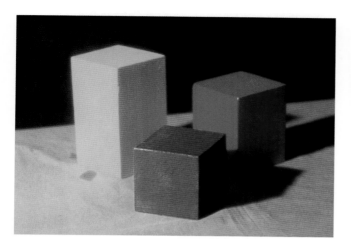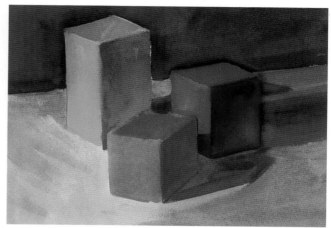

Left, THE SETUP. *Right,* THE COMPLETED PAINTING.

Tablecloth

Mix Cobalt Violet Light with Chinese White and lightly skim it onto the piece of tablecloth in front of the blue block. Don't get carried away. It needs to stay in the shadow. Some of that iridescence is also back in that little hole between the yellow block and the red block. Mix a little Cobalt Violet Light with Naples Yellow and lightly touch it to that shadow near the top.

Blue Block

The blue block seems to get a little bluer toward the back of the shadow side. The edge against the cast shadow and the red block needs to be sharpened. Rewet it with a little bit of water right over the whole thing to soften it, and let things come together. There's a very soft transition between these effects. They don't jump out at you; they're there, but they're not easy to see. Often in certain areas—shadows and reflections, for example—there are variations in the mass, or small areas of change. In the shadow mass of the yellow block, for instance, the color changes from yellow-orange, into a yellow-green that's more yellow than it is green, and then into a cooler color up in the highest-contrast area against the light at the top of the block. Maybe that's part of the reflection of the blue block. This is the kind of change that you won't get if you quit too soon.

Red Block

There's some reflected light in the lower right shadow side of the red block. Add a little bit of Naples Yellow mixed with Cadmium Red to that area. Put a strip of Mars Violet up toward the top edge, going from a gradation of a lot of reflected light down in the right corner to getting cooler and a little darker up toward the top left and down the left side. Add a little Permanent Rose on top of the Mars Violet.

When to Stop

At this point, you need to look at every area of your painting and decide whether you have achieved the truth of the scene. The way I put it to myself is, "How much can I sacrifice?" That's always a hard question to answer.

A color study is finished when it tells the story of what you're trying to do. The aim of a color study is to separate the light and shadow, and to learn to differentiate the spots of color, thus creating form. The more color studies you do, under a variety of light situations, the better your color vision will become. What is very curious about this process is that at some point we begin to see everything in terms of color changes. We are no longer fully aware of the objects we are looking at. When we stop *consciously* trying to create form with color changes, and instead concentrate on depicting color changes accurately, that's when we are truly painting.

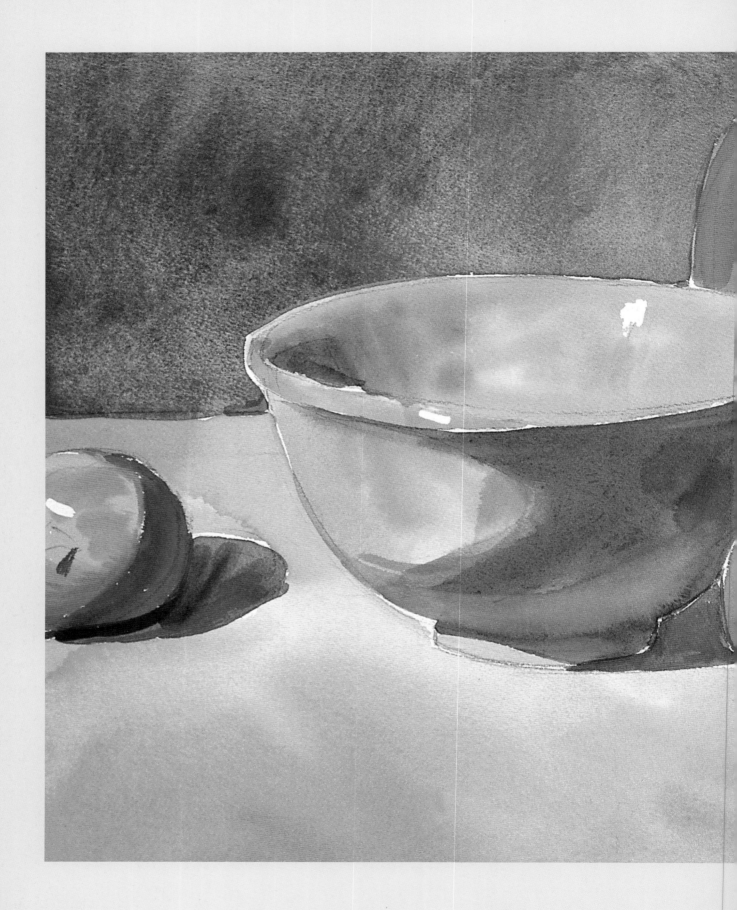

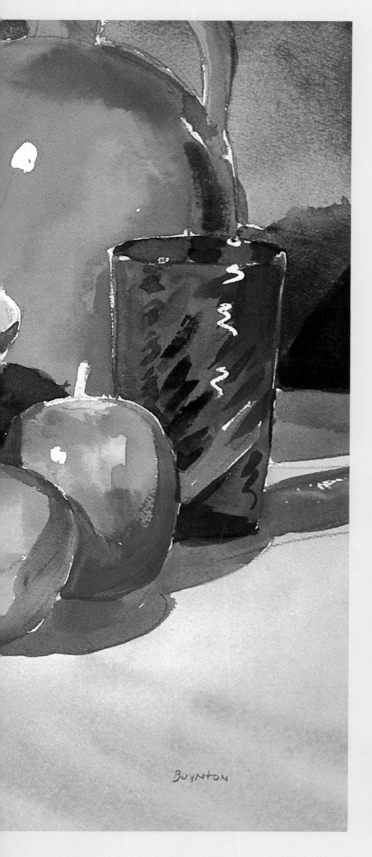

BOYNTON

6
ADDING VARIETY

In Demonstration 1, we painted three primary-color blocks: red, blue, and yellow. What we see in the world, however, is a myriad of additional colors, many of which are subtle and difficult to nail down. The more adept you become at seeing and painting those colors—the secondary colors and beyond—the truer your painting will be.

STILL LIFE WITH GREEN BOWL AND BROWN JUG
The red apples and the blue glass are represented with two of the primaries. The brown earthenware jug, which is a deep orange in the warm light, and the light mass of the bowl are secondaries. Against the olive background, the bowl takes on a brighter, more intense color.

THE SECONDARY COLORS

The secondary colors are not as easy to see and depict as the primary colors. Our visual experience of them is more ambiguous. We particularly need to train our eye to see how the secondary colors appear in all the varieties of natural light. Violets, for example, tend to be the opposite of colors in the light mass, and so we don't see them as easily. This is especially true of violets in incandescent light or sunlight, which gives them a yellowish cast.

There are many oranges, greens, and violets in nature, particularly under natural light, with the almost infinite variety of greens presenting a major challenge. Violets are also important, particularly in cast shadows. Oranges are crucial in the lighted sides of objects, and learning to see and paint them will vastly increase our color vocabulary.

I believe that some of the color variations that are traditionally described as combinations of primary colors cannot in fact be mixed from the primary colors. This idea is a controversial one in the art world. Some artists insist that any color can be made by combining the primary colors. I find that in practice there is more variation in nature than any combination of primary colors can depict. Remember that we are trying to describe the natural world as mixtures of light, not in terms of pigment, which is, after all, just colored mud. This is another idea that sets Impressionism, and the ideas in this book, apart from other color theories. Though the theory of combining primary colors to make all the secondary colors sounds plausible, I contend that although true combinations of primaries can make the colors in the second ring on the color wheel, there are in fact pure violets, greens, and oranges in the natural spectrum that are not mixtures of primaries. The "pure" secondaries on my palette are Cadmium Orange, Permanent Green Light, and Cobalt Violet Deep Hue, the middle colors in each family grouping. I also believe that the effect of light shining on the world around us produces a greater variation of colors than a prism can produce. If this were not so, the three primary colors would be all any painter would ever need on his or her palette, which is clearly not the case.

Having the secondary pigments on our palettes helps us to give a color punch to the description of sunlight that we could not get without them, but keep in mind that mixing any two colors together, such as yellow and blue to make green, results in a less bright and more natural color than any pigment straight off of your palette. The whole idea of painting block stud-

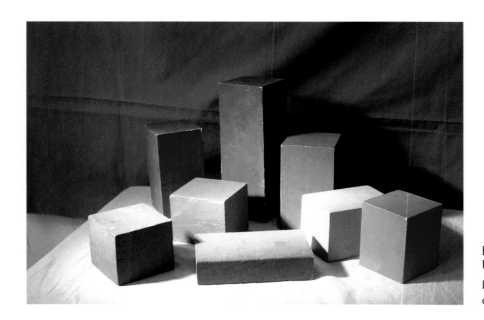

**BLOCKS IN SECONDARY COLORS
UNDER INCANDESCENT LIGHT**
Learning to paint blocks like these will
expand your color vocabulary.

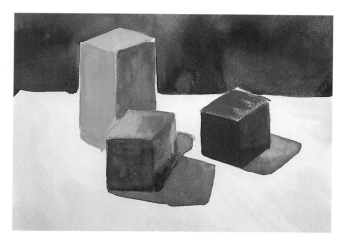

BLOCKS IN BRIGHT SUN

These blocks were painted in late morning. You can see the number of primary colors needed to represent the light masses. The secondary colors are especially evident in the green reflection into the lit side of the yellow block, the shadow masses and reflections into them, and the cast shadows. There are mixtures of greens, red-pink, red-violet, blue-violet, and violet.

ies is to learn to see the more subtle colors in the natural world with more accuracy and familiarity. Learning to see violets in nature, for example, comes from the study of a purple block. Some of the colors and variations we see are combinations of primary colors and some are not. When painting bright colors like flowers and objects colored with synthetic dyes, you will often want to use pure pigment right off your palette because the colors are likely to be brighter than any combination you can mix.

Natural subjects other than flowers, even bright green grass, usually require a mixed color. Even early spring grass is not really Permanent Green Light, but a combination of blue and a yellow. In the shadowed side of a green vase, Permanent Green Light may have more influence than any combination of blue and yellow. We need all that variety on our palette in order to express the full range of what we see.

In bright sunlight, the greater the range of bright primary and secondary colors you will see in objects lighted by the sun, and the brighter the colors you need to describe the sunlight in your painting. The bright sun of summer contains all the primary and secondary colors.

EXERCISE 1: *Secondary Colors and Color Families*

1. Collect as many examples of secondary colors as you can. Be sure to include some leaves. Refer to your color chart as you do this, as well as to the colors on your palette, and paint swatches of mixed colors to match the colors of the objects in your collection.

2. Experiment with making charts for a variety of color families. See how many variations you can create while maintaining the family's redness, blueness, greenness, etc. Play with your paint and see how far you can push a color before it is no longer in the same color family.

EXERCISE 2: *Simultaneous Contrast*

1. Before starting this exercise, you may want to review Chapter 5, "Value." Make a number of swatches painted on watercolor paper in a variety of colors.

2. Punch or cut a hole in the middle of each and look at the squares on your color chart through the holes. Notice how the colors on the chart seem to change depending on the surrounding color.

EXERCISE 3: *Making a True Light Blue*

1. Paint a swatch of Ultramarine Blue. Paint progressively lighter swatches using a mixture of Ultramarine Blue and progressively more water.

2. Paint a swatch of Ultramarine Blue, then progressively lighter swatches using a mixture of Ultramarine Blue and progressively more Chinese White.

3. Compare the blues with only water added to the blues with Chinese White added.

EARTH COLORS AND GRAY

Many colors we see in the world around us, both in nature and in manufactured objects, are earth colors, or "off notes." Leaves and tree trunks, for example, are dull, earthy colors that cannot be depicted using primary or secondary colors, or mixtures of these. Weathered wood, which I often use as a background for still lifes, is rarely a color on the palette, and is rarely bright. The gray-black cloths I use for backgrounds have warm colors from the light that are not easy to get, either. Often the earth tones I see are rusty reds and oranges, like Indian Red, Venetian Red, Mars Violet, and others that use ferrous oxide. This is when I turn to the earth colors on my palette, which help bridge the gap between obviously warm and obviously cool. Quite often, the lighted side of an object is a combination of warm colors, but with a cool subtlety mixed in. Similarly, a shadowed side will not be entirely cool, but will also have some subtly warm colors in it. Every situation is different, and you must trust your vision to guide your color choices.

I often push earth colors by adding a more obvious color to them. For example, I might start with Indian Red for the lighted side of a red brick house in the light, then add warmth by using Cadmium Scarlet or Cadmium Orange. For the shadowed side of the house, I wouldn't use Cadmium Red (warm) or Permanent Magenta (cool), but Indian Red with some Cobalt Violet Deep Hue added, to make the shadow more obviously purple.

Gray is the most subtle and difficult to depict of all the colors. Usually, what we might call "gray" is actually violet or blue, or a subtle blue, violet, or green mixed with its complementary color. Even an object that we see as gray, for example, a tablecloth that the manufacturers have labeled "gray," may in fact be more blue than gray. You need to think of gray as an idea, not a color. It is through daring experimentation with the colors on your palette that you will develop your color vision and learn not to fall back on "gray" (or "brown") to describe the colors that are actually there.

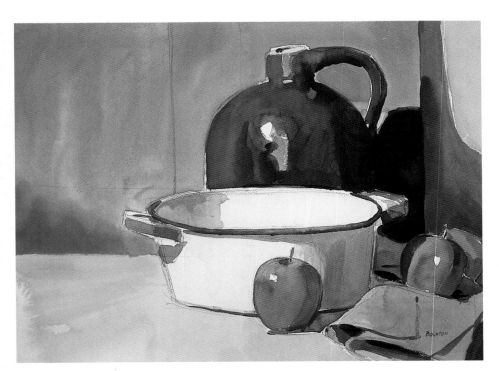

STILL LIFE USING EARTH COLORS

The jug in the still life shown here is an almost black combination of earthy colors, yet there is a subtle warmth in the lighted areas. The lighted surfaces of the other objects are warm, so for consistency in the painting, the lighted surface of the jug must show warmth also. The color right next to the highlight is a strong Cadmium Yellow. I used Yellow Ocher plus Indian Red as the basic color of the lighted part of the jug. The shadowed part of the jug is predominantly cool, and I mixed Ultramarine Violet, Ultramarine Blue, and Mars Violet. The coolness in the light is in reflections of subtle blues under the highlight on the jug. The background is an old weathered shutter, which is a wet-on-wet warm-cool mixture of a rusty red-rose and an olive green.

PAINTING ROUNDED OBJECTS

Painting a rounded object is very different from painting a square one. A square object has a marked difference in color and value from one plane to another. The planes are obvious, and change abruptly at the corners. The color and value on a rounded object change gradually as the object curves. They are more subtle and more difficult to identify than the color and value changes on an object with edges, but you must pin them down.

Lighted Side

On rounded objects, the highlight occurs in the area where the light hits the object straight on. These areas in the facetted ball are the facets, or planes, that are left the white of the paper, with no color in them. In all the other areas of the light mass, the light hits obliquely, so the value is slightly deeper and darker. Each value change is also a color change, and will depend on several factors, such as the light from the sky if the object is outdoors and reflected light both indoors and outdoors. Note that a facetted ball has more facets, or planes, and therefore more value and color changes, than a facetted cylinder. It is easier to see those changes on the facetted ball than it is on the smooth ball or the orange, because the plane changes on the smooth spheres do not have sharply defined edges. However, the overall color pattern, in terms of light, halftone, and shadow, is the same on all three. Finally, seeing and painting a rounded or spherical object that is colored is the most difficult because you need to be concerned about the accuracy of your colors in addition to showing light, halftone, and shadow blending one into the other.

WHITE FACETTED BALL, WHITE BALL, AND ORANGE

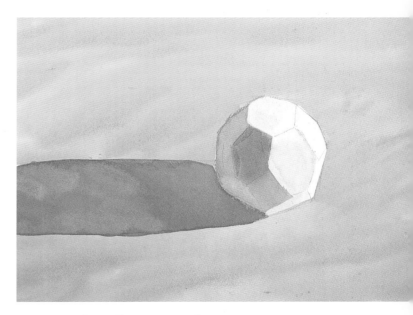

FACETTED BALL PAINTED IN COLOR

EXERCISE 4

1. Look carefully at the facetted sphere in the accompanying illustration. Identify the highlight and see the value and color changes to the right and left.

2. Look at the orange and unfacetted ball in the same illustration and repeat Step 1 for each.

In the painting of the facetted ball (previous page) we can clearly see the light and shadow sides, with the light on the right and the shadow on the left. We can also see the effect of the warm, late-afternoon sun on the surfaces on the right, while the shadowed surfaces are generally cool. I left the extreme right surface the white of the paper to demonstrate the highlight reflection of the sun. The halftone surfaces on the top, middle, and bottom next to that pure white facet are clearly differentiated. I started out by painting all three Naples Yellow. Then I added Cerulean Blue mixed with Chinese White to show the sky reflection. The side is mostly Naples Yellow with a little Cadmium Yellow and Chinese White, and the bottom facet, which reflects the tablecloth, is Naples Yellow plus a little Cadmium Red and Chinese White.

The shadowed side is predominantly Cobalt Blue. The topmost facet on the left that reflects the sky is Cobalt Blue plus Chinese White, the middle facet has more Ultramarine Violet with Cobalt Blue, and the underside facet has a little Yellow Ocher and a little Indian Red. The facet on the extreme left reflects the tablecloth; it was initially Cobalt Blue, then wet-on-wet Naples Yellow plus Venetian Red and a little Cadmium Orange.

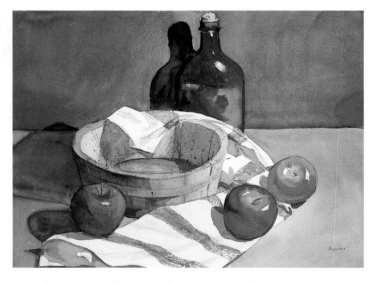

TUB WITH TOWEL, APPLES, AND BOTTLE
The reflections into the cast shadows of the objects in this scene glow with subtle color. However, none of the reflections lighten the shadows so much that they no longer look like shadows.

EXERCISE 5
1. Paint a large area with Indian Red and add warmth to it by adding Naples Yellow.
2. Represent the shadowed side next to it by painting Cobalt Violet Deep Hue and adding Mars Violet.
3. Refine the relationship between the light and shadow by adding some Ultramarine Violet and Chinese White to the lighted side and some Cobalt Blue and Chinese White to the shadowed side.

Shadows

The shadowed side of a round object is where the greatest incidence of reflected light occurs and where we can see that effect most clearly. Remember that we can create three-dimensional reality by describing three values: light, shadow, and halftones. The fourth value, reflected light, can be confusing and difficult to depict. When you are painting reflected light in the shadowed side of an object, you must establish the complexity of the shadow first; then, as you put in color changes to create form, you must keep the reflected light darker than any area in the light regardless of how it actually appears in the scene you are painting. The key is to first make the shadow dark enough compared to the lighted side, and only then make reflective variations part of the shadow. To summarize: Reflected light may be cooler or warmer than the main color in both the light and the shadow, but you must keep it in either the light or in the shadow. When you paint, you are not just copying what is in front of you, or taking a photograph. You must *interpret* what you know about form in the light and shadow masses.

Whenever you paint, you must never stop trying to identify all the reflected colors within the light and shadow masses. Even when an object's color seems to approach black, there is usually color reflecting into it that keeps it from being a dead spot, devoid of light. Paying close attention to reflected color will prevent your painting from becoming muddy and dull.

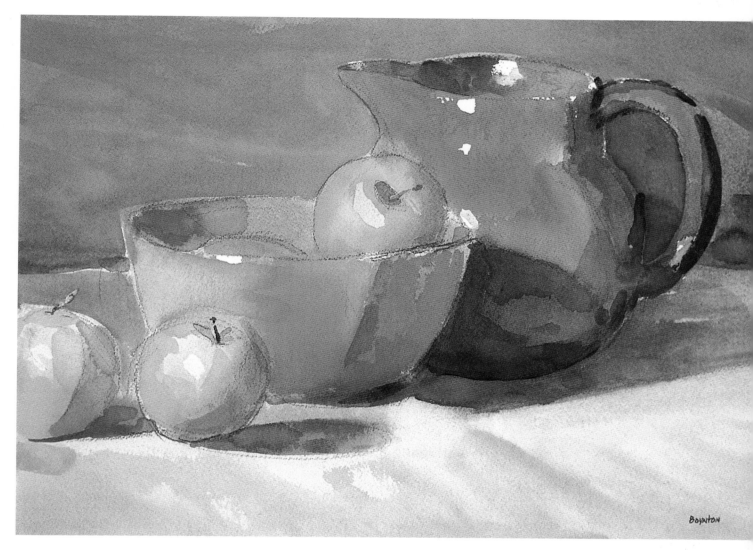

Jug with Bowl of Apples

In this illustration, you can see the reflection from the tablecloth into the lower shadow on the jug as well as into the shadowed side of the bowl. The orange bowl reflects warmth into the cast shadows of the apples, and there is also a warm reflection into the cast shadow of the bowl. None of these warm reflections, however, while they fill the shadows with light, are light enough to cause the shadow not to look like a shadow.

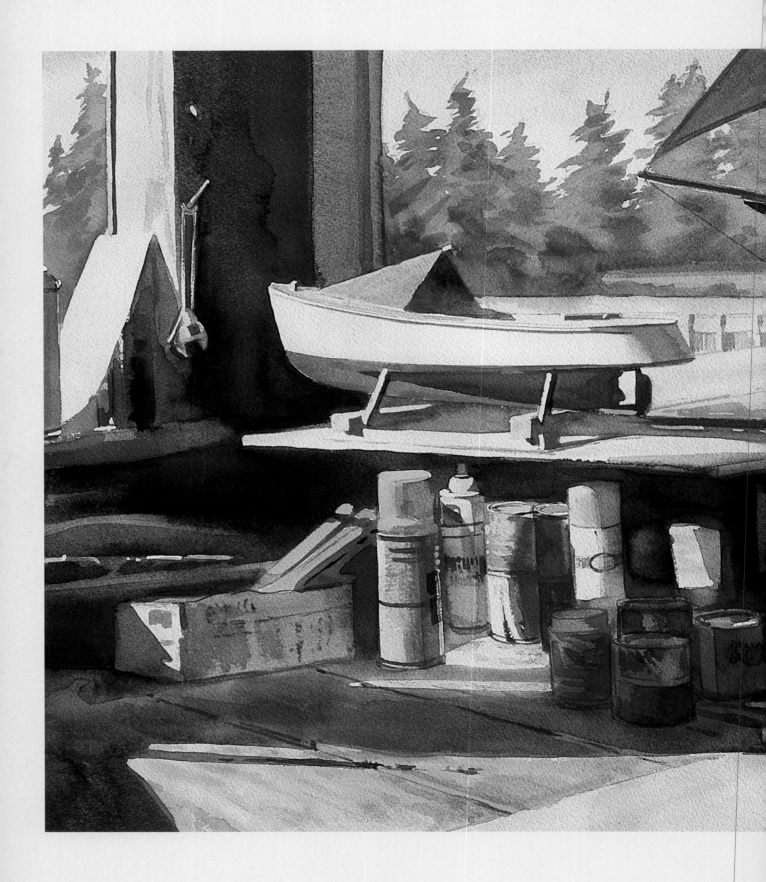

7
SETTING UP
THE STILL LIFE

Wh-- setting up a still life, you need to choose the objects you will paint, as well as the background and tablecloth, for maximum interest with regard to shape, size, color, reflectiveness, texture, and composition. This chapter provides some basic guidelines for making shape, size, and color choices that will give you the best results, as well as some fundamental principles of composition.

MODEL BOAT STUDIO, *Lee Boynton.*
Watercolor, 16 x 20 inches.

CHOOSING AND SETTING UP OBJECTS

CLOTHS FOR STILL LIFE SETUPS

Background cloths left to right: olive, dark blue, rusty red-brown, purple. Tablecloths left to right: light blue, orange-yellow, light olive, rose.

OBJECTS SUITABLE FOR BEGINNING STILL LIFE

The three light-colored objects here are a cardboard fruit carton, an upturned flower pot, and an upturned basket.

Choosing the cloths for your table and background should be one of your first considerations, not an afterthought. Solid-color cloths in fairly easily identifiable colors are the best choice for setting off the objects in your still lifes, especially when you are just starting out. I often use a dark background cloth and a light tablecloth. The true subject of the Impressionist painting is light, and a dark background cloth will provide an obvious, dramatic contrast to the lighted areas. For the tablecloth, a warm color that is lighter than the background and most of the objects is usually the best choice. In my classes, I often choose a tablecloth that is a complementary color to the background, such as an ocher tablecloth with a dark blue-violet background, or a red-brown tablecloth with a dark green-olive background.

Although the background cloths and tablecloths that you collect should be colors that are relatively easy to identify, avoid bright, obvious reds, blues, yellows, and greens. You don't want the cloths to be too loud or overpowering. Especially when you are just starting out, only use cloths in solid colors. It is much more difficult to paint stripes or patterns than it is to paint solid colors, and too much pattern will distract attention from the objects in the still life.

Beginning and intermediate painters should mainly stick to ceramic bowls, pitchers, and vases or jars in bright, solid colors. Plates lying flat are difficult to draw and paint. When choosing fruit, also look for solid, easily identifiable colors. Solid red or green apples, yellow lemons, oranges and tangerines, red pears, and pumpkins are all good choices. At first you want to paint objects that let you focus on light and shadow. Trying to paint multicolored objects like variegated apples will only serve to distract you from that focus, so save them for when you have more experience.

Choose objects in a variety of shapes and sizes. A scene that includes a tall pitcher, a bowl of medium height, and a few oranges or apples is more interesting than one with two bowls that are the same height. Rounded and squared-off shapes can be juxtaposed in interesting ways. Your scenes will also be more interesting if all of your objects are not brand new and

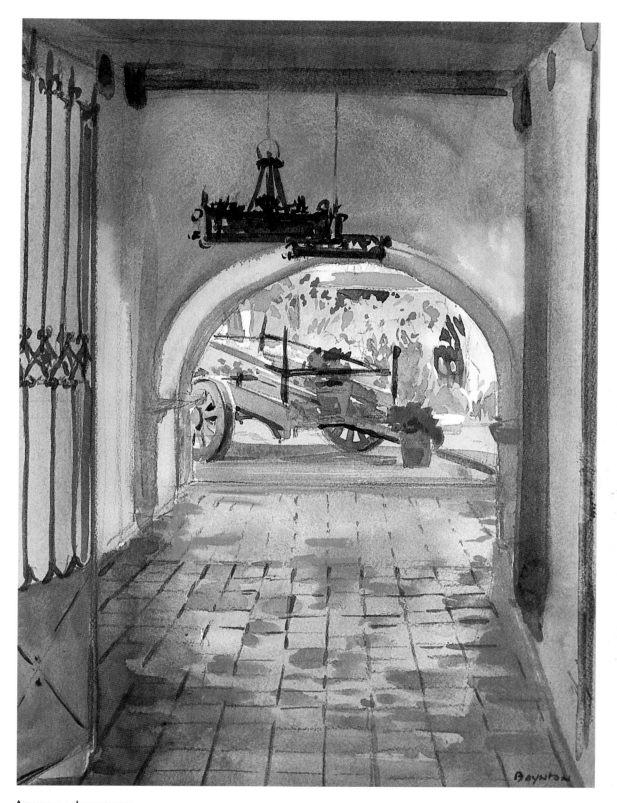

ARIZONA INTERIOR
Here none of the objects is the subject, but rather the interior itself. The tiles glow with subtle, opalescent color.

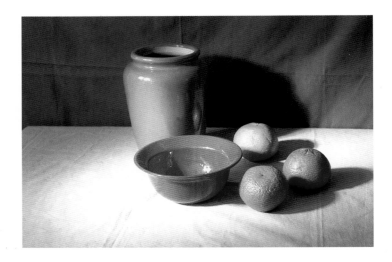

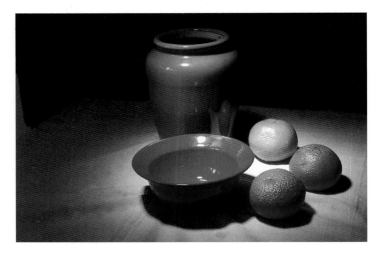

flections and surfaces seen through glass. Don't choose objects with irregular shapes, like stones, until you are consistently able to depict objects with clearly defined shapes.

Arranging the Still Life

Once you have collected a variety of cloths and objects you can begin thinking about which ones you will choose to combine into a still life setup. There are a number of considerations to keep in mind both when choosing the objects and when setting them up.

At first, keep your setup simple. In my classes, when we move from block studies into our first still lifes, I set up only one object at a time. We work with single objects for several weeks before I add one or two more. It is easier to learn to begin to depict light and shadow when you do not have to worry about the spatial and color relationships among several objects, as well as the relationships of multiple objects to the background and foreground cloths. Remember that the subject of your painting should be light, so you want arrangements that create an obvious demonstration of the light source.

Turning on the Light

The first step in setting up a scene is turning on the light. If you are painting indoors, make sure you have a single or dominant source. Double shadows from different angles created by setting up the table so that it receives light both from your interior light source and from light coming in through a window can be very confusing. When you paint outdoors in sunlight, the light is obvious; your indoor light should be equally unambiguous. Make light the subject of the painting by identifying it right at the start. The light should hit the scene at a relatively low angle so there will be long, obvious shadows. For your early efforts, you want to try to get an equal amount of light and shadow on all the objects.

Whatever the number of objects you have, the light should come from one side or the other. When objects are lighted from behind or from a source directly in front of them, the contrast between light and shadow is diminished. If you have more than one object, put at least one of them close enough to the background cloth

BALANCING LIGHT AND SHADOW

In the setup at the top, the light masses of the jar, bowl, and oranges are more or less equal to the areas in shadow. The light-shadow contrasts are strong. In the setup on the bottom, where the light is shining from above, the spotlight effect surrounds the scene in amorphous darkness. There is too little light on the sides of the objects; the shadows are too short.

perfect. Some chips and wear add character. Amass a collection of well-used found objects. I deliberately put some of my objects in the garage or on the porch so they will collect a film of dust.

In addition to avoiding multicolored surfaces, beginners should stay away from highly reflective surfaces like metal and from transparent glass objects. You need to learn to consistently depict light and shadow before you confuse the issue with strong re-

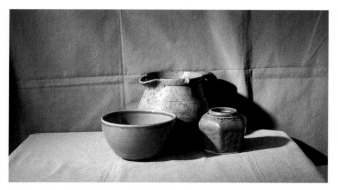

A Simple Yet Dynamic Still Life Setup

The green background cloth and olive tablecloth here are from the same color family, and the bright red bowl, which is a complementary color, provides visual excitement, contrasting with and dominating both background and tablecloth.

What Not to Do

The background and cloth in this setup are the same colors as they are in the setup with the single red bowl, but the lighting is less effective. The pitcher is in the same color family as the tablecloth, and the blue bowl and small green jar are too much like the background. The green object here almost does a disappearing act, and the cast shadows obscure, rather than enliven, the color.

to cast a shadow, creating shadow shapes that will break up the space on the cloth. Set the objects up so that the cast shadows create interesting shapes. After your objects have been placed in the scene, move the light around to find the best effect. If the day is sunny, you can also put your setup next to a window. As you gain experience, you will want to experiment with many different light angles and conditions.

When you are painting a still life with only one object, pick one that has a strong, obvious color, like red or green, and make sure your background and foreground cloths work well with it. As you gain proficiency in seeing color and light, you can experiment with more subtle effects. I've always been drawn to the more dramatic effects, particularly when I am setting up still lifes for my classes, because they are easier to see. I will often tell a student to make the darkness of the background cloth more obvious in their painting, which has the effect of creating more intensity in the color of the light on the objects.

Start setting up by hanging up the background cloth you have chosen and putting down the tablecloth. When you are setting up a still life with more than one object, you will first put down the dominant object, such as the red bowl shown above, then choose another one that will complement the first one. Pick something that has a different size and shape than the first object. If your dominant object is a red bowl, don't put another red object, or another bowl that is

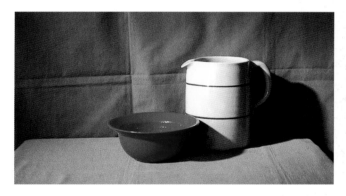

Two-Object Still Life Setup

Here is the red bowl again, with the same olive background and olive tablecloth. The tall white pitcher, which is rounded like the bowl, has been set to one side and behind the bowl, creating a sense of depth.

close to the size of the first one, in the scene. The same guideline applies to the choice of second, third, etc., objects. (When you have more experience, you can choose objects of similar colors for a setup, to test your ability to describe them accurately, but when you are just starting out, you need to keep it simple.)

When you have everything arranged, look at the setup carefully. If you don't see the effects you want, you can change the background cloth, the tablecloth, or any of the objects in the scene.

STILL LIFES with MULTIPLE OBJECTS

When you start painting more than one or two objects, composition begins to play a role in how you arrange them in your scene. However, most of my teachers stressed, as I do, that not until the student has mastered the basic mechanics of painting can the focus be shifted to advanced composition. In my beginning classes I set up the still life scenes for the students. If you are ready to set up your own still lifes, you can use the following guidelines to get the most interesting and pleasing results.

With multiple objects, place them so there is an obvious design. Use objects of graduated heights. Arrange the objects with the light on and try them several different ways. Variety is very important. Do not put two objects next to each other so that they are just touching. Not only will that negatively affect depth and form, but viewers' eyes will be drawn to those objects for the wrong reasons. You do not want their proximity to be the center of attention in your scene, to the detriment of everything else. Instead, have some of your objects overlapping each other in order to clearly describe their spatial relationship.

Don't put just one apple in a bowl or on the table-cloth. Three objects are more interesting than two, or five instead of four; even numbers are more static. Make groupings, rather than spacing everything equally. Two groups of two are static, but a group of two plus one alone, like two apples and a bowl, or even two apples together and one on its own, are more dynamic and interesting. Very integral to the portrayal of light is creating drama in the scene by arranging the setup to use the light most effectively. Place some objects in the light and others in recesses of the shadow of another object rather than placing them all in the light.

Center of Interest

When you arrange the objects in your scene, you want one of the objects to be the clear center of interest, and you need to make sure that none of the other objects competes with that center of interest. Somewhere in the scene must be an object or particularly vivid color passage to which all the other objects lead the viewer's eye. When you are selecting the

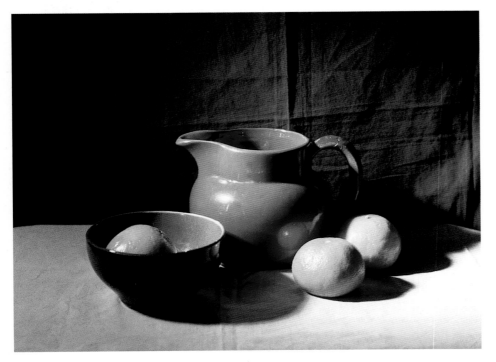

Left, **Still Life Setup with Oranges**

In this well-lighted and interesting setup, the bowl, pitcher, and oranges all have a harmonious, rhythmic roundness to them. The bowl doesn't have a lip, but is a true half-sphere, and the bowl opening repeats that roundness, becoming an echo of the shape of the bowl.

Opposite page, **Still Life with Multiple Objects**

These objects are a variety of colors, shapes, and sizes. The range of values, strong light-and-shadow contrast, and deliberate overlapping of objects provide a strong three-dimensional effect.

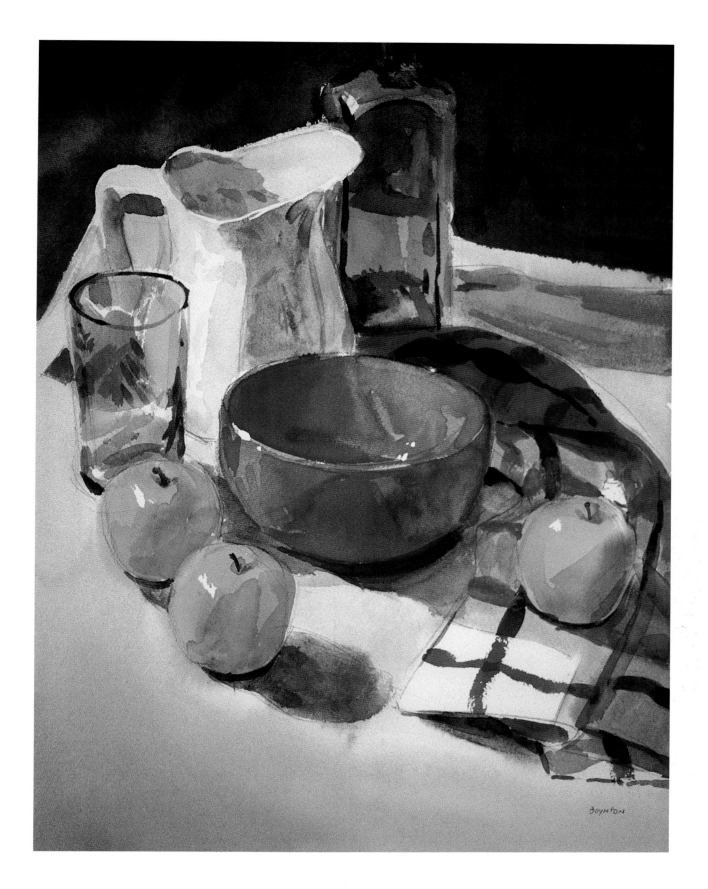

Left, DRAWING OF A TRIANGULAR COMPOSITION; *Right,* DRAWING OF A CIRCULAR COMPOSITION

objects for your still life, keep in mind that *one* of them must be the dramatic center of interest. All the others will play a supporting role.

When you are using the viewer to make preliminary drawings—whether they are full-value studies, contour studies, or thumbnails (thumbnails are covered in detail in the next section of this book)—make sure you don't hold it so that the center of interest is where the strings intersect. If you do, the spaces around the object will be too symmetrical, and therefore static and uninteresting. In addition, no line, such as the edge of the table, the edge of the towel, or any hard edge to an object, should be centered horizontally or vertically, or placed dead center.

Circular and Triangular Composition

Still lifes don't have to be static. In addition to choosing the right lighting conditions, and setting up objects in a variety of shapes and sizes so that some of them overlap, we can promote a sense of movement by focusing on the overall shape of the arrangement. The two most fundamental shapes are the triangle and the circle. Triangular compositions are created by arranging three or more objects in descending (or ascending) order of size. Circular compositions lead the viewer's eye from object to object in a circular pattern. If you choose a triangular composition, make sure it is not an equilateral triangle, which will have the same deadening effect as putting the center of interest in the middle of the painting. The painting of the triangular composition above is on page 124.

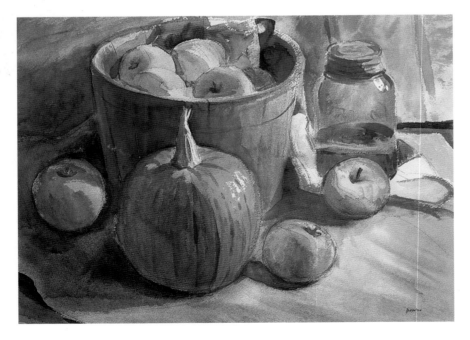

CANNING TIME

Canning Time is the painting of the circular composition shown above left. The placement of the apples and pumpkin in the foreground leads the eye around the bucket to the glass jar to the interior of the bucket, around the rim, and back down to the cast shadow and the shape of the apples on the left. The placement of the towel and the glass jar on the towel, with the towel diminishing upward and reappearing as it falls into the bucket, leads the eye from the lower right to the upper center of the painting.

BEYOND OBJECTS ON A TABLE

The guidelines for choosing the objects in our still lifes up to now have been concerned with lighting, shape, color, variety, and composition. You might also consider choosing and arranging objects that create a narrative, so that your painting says something about what you like, the kind of environments you enjoy. You can even create a setup that makes it look as though some action has just happened or is about to happen. Apples accompanied by a canning jar, a bowl, and a knife tell a story of an activity that will probably take place in the kitchen. A teapot, mug, lemon slices, and cookies tell a story about having tea.

Look around you and be creative. A painting of a chair with gardening tools and a hat on it in an outdoor setting is just as much a still life as bowls, jars, and fruit on a table. There are also "found" still lifes: indoor or outdoor scenes which have not been set up by any artist but which have all the elements necessary for a vibrant, interesting painting. Many scenes that you might automatically think of as landscapes are actually still lifes; you should try to open your mind so you are able to see them. Charles Hawthorne's *The Weir Boat,* on page 22, is a beautiful example of a found still life, as are the two paintings I did of a model boat builder's studio, one of which is reproduced on the opening page of this chapter and one of which is shown on page 91.

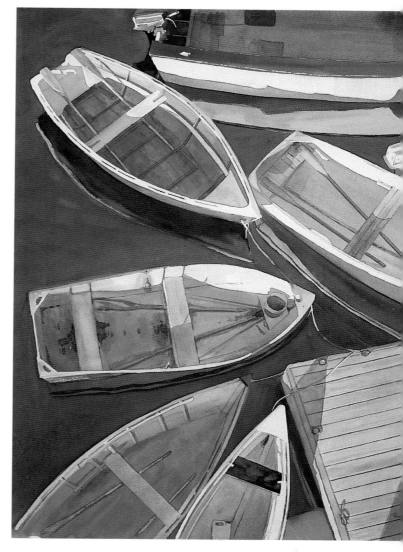

DOCKED ROWBOATS

Although many people might classify this painting simply as a "marine scene," the boats, which are moored, leave very little water showing. The water itself is smooth and evenly colored, and the overall effect is very much like that of a still life.

Following pages:

Left, STATEHOUSE DOME, ANNAPOLIS, MARYLAND

I often refer to buildings as "blocks in the landscape." In this painting we see one of the most dramatic views in Annapolis. The alley through the foreground buildings creates a pathway of light to the tower.

Right, MODEL BOAT ON WINDOWSILL. *16 x 20 inches.*

In this "found" still life in a model boat builder's studio, the boat rests on a windowsill that serves as the "table." This unusual backlit scene is quite dramatic.

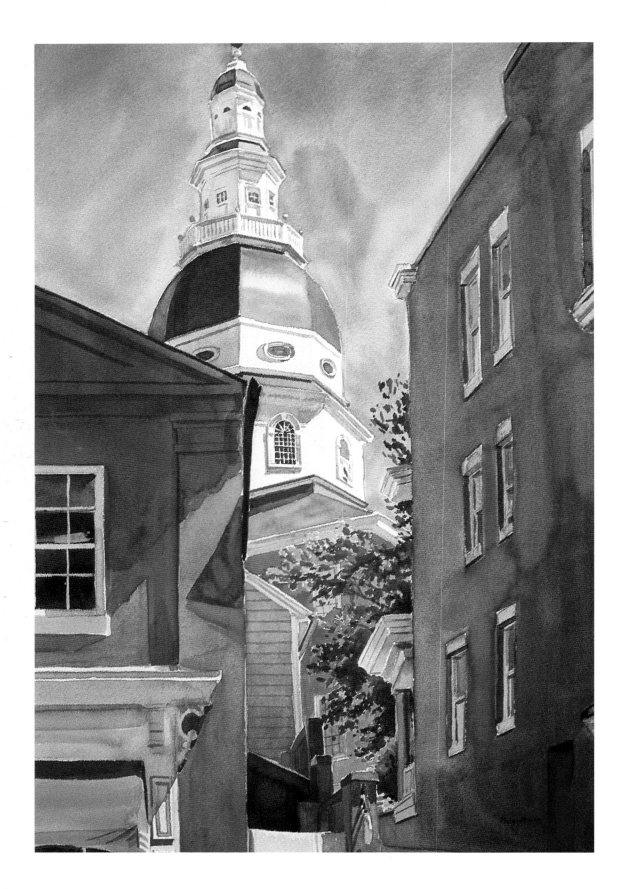

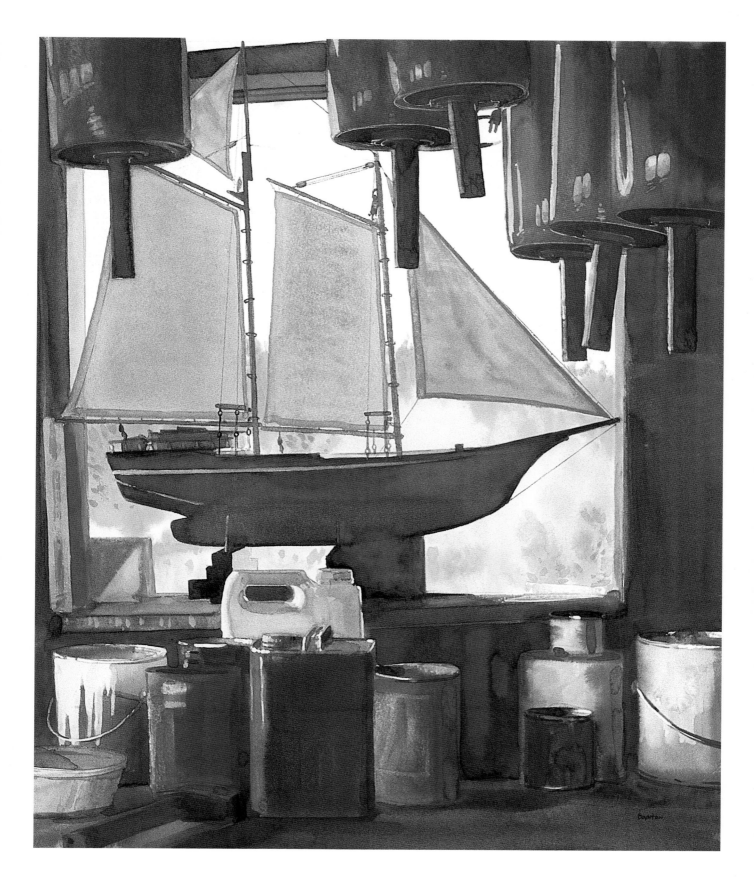

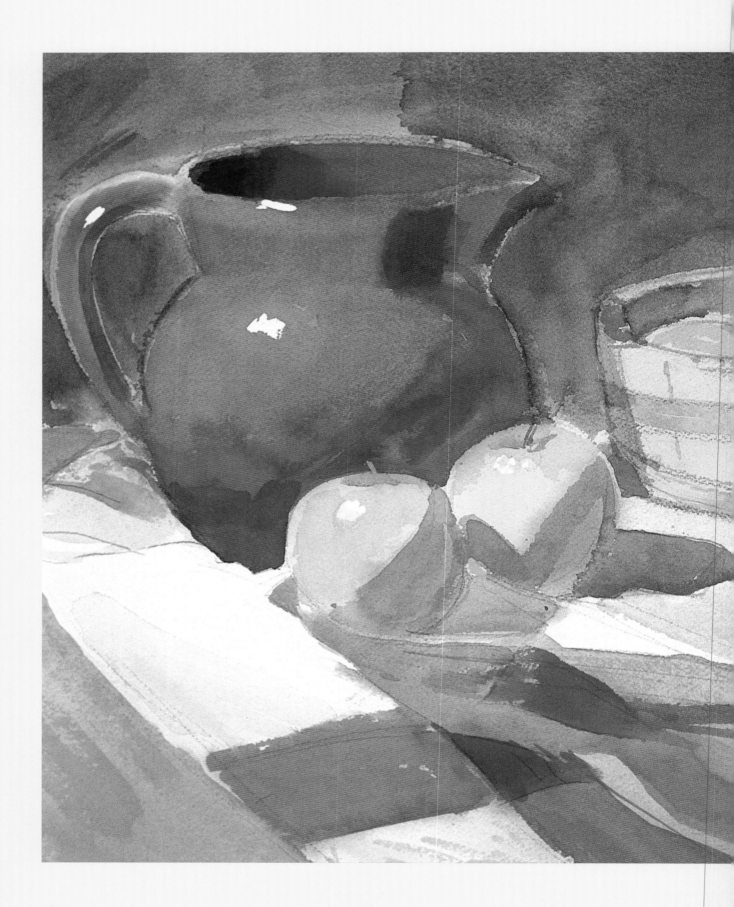

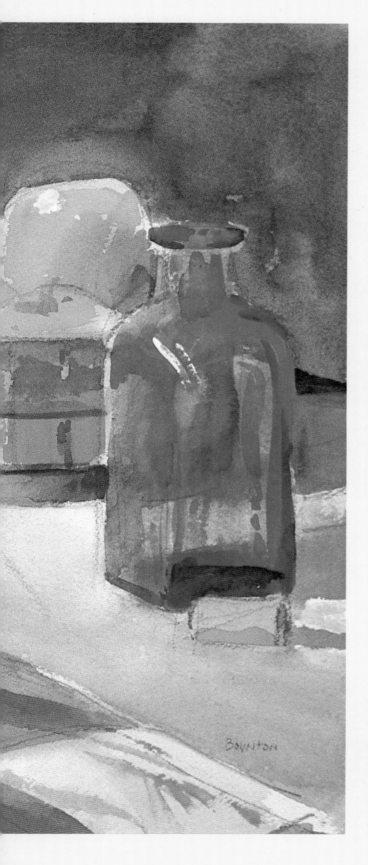

DEMONSTRATION II

PAINTING THE STILL LIFE

If you have followed all the steps in the past chapters, you should now be ready to paint your first still life. Don't be discouraged if your first attempt isn't the way you envisioned it. When people ask me, "How long did it take you to paint that painting?" I say, "Oh, about twenty-five years." It didn't take twenty-five years of putting paint to paper in that specific painting, of course, but it took twenty-five years of study and practice to be able to make that painting look the way it does.

PITCHER WITH TOWEL, TUB OF YELLOW APPLES, AND BLUE BOTTLE, *Lee Boynton. Watercolor, 16 x 20 inches.*
This indoor scene in strong incandescent light uses strong, clear color to depict the light effect. The burgundy pitcher's light mass is a glowing scarlet against the violets and reddish earth colors in the shadow. The apples are a clear yellow in the light and a strong green in the shadow.

STAGE ONE: ANALYSIS AND DRAWING

You might be tempted to skip the analysis and skimp on the drawing in order to finally get started on your still life painting. *Don't.* The analysis and drawing are a crucial first step to a successful painting. Remember, "If you don't know where you're going, you will end up somewhere else." In your beginning paintings you may end up somewhere other than you intended anyway, but if you don't skip this initial stage, you will at least end up closer to the destination you had in mind. With more practice, you will get closer and closer.

PHASE ONE: *First Analysis— Making Thumbnail Sketches*

To determine the best composition for your painting, start by making thumbnail sketches, which will give you design and composition sneak previews of the overall effects of the objects you have chosen for your still life from different vantage points, and even in different arrangements. I still begin with thumbnails because it helps me get an idea of what strikes me about a scene. Sometimes, my first opinion of what the best composition is changes completely after I have done my thumbnail sketches. Thumbnail sketches are also very important in terms of making decisions about the best way to crop the scene and still have everything work the way you want it to work. Hasty decisions about what to crop out can lead to disaster, especially if you have cropped out too much. Some of my students have to learn this the hard way before they become sold on taking the time to make thumbnails.

The objects here are the ones that you will be painting in this demonstration: I chose the objects deliberately. They are different heights. The pitcher and the bowl are unequal in both height and width; the bowl is wider, but the pitcher is taller. The color choice is also important. The ocher pitcher and the bright green bowl provide a nice contrast that doesn't clash, and the oranges harmonize with both of them.

Although the four thumbnail sketches shown on the next page are not drawings of different arrangements of the chosen objects, it is good practice, especially for beginners, to set up different arrangements of objects, or even different objects, and do thumbnail sketches of each, from different vantage points.

On a piece of sketch paper large enough to hold four small drawings, I used my pencil to draw a horizontal and a vertical line that crossed in the center of the paper, then did the same thing for each of the four areas. For thumbnails, you will start out each sketch by using your viewer to maintain on your paper the relationships between objects in the setup as described in Chapter 3 for the full value drawing. I did these four drawings relatively quickly, using the side of my pencil lead to draw geometric shapes, then darkened the shadows. I like to articulate the light and shadow in each setup right away to get a clearer idea of what's going on in the scene. I try to get the shadows cast by the objects and the shadows that are on the objects while leaving the lighted sides of the objects obviously in the light. Darkening the background makes the shapes of the objects more obvious

A

B

C
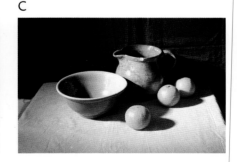

THREE VANTAGE POINTS

THE FOUR THUMBNAILS

Thumbnail sketch 1 is from vantage point A. For thumbnail sketch 2, also from vantage point A, I used my viewer to move the pitcher more into the center of the page. For thumbnail sketch 3 I rotated the vantage point to the right a couple of feet so I could see more of the shadowed side of the objects (vantage point B). For Thumbnail sketch 4 I rotated the vantage point to the left of vantage point A, to do one more drawing of the objects mostly in the light (vantage point C).

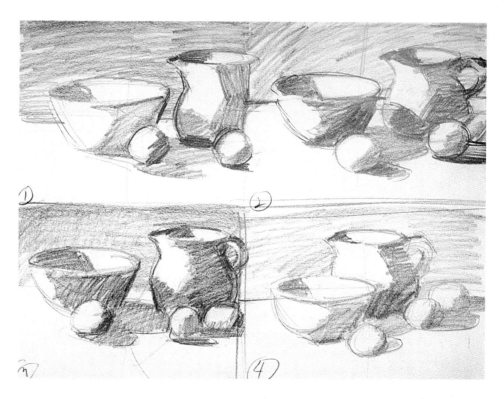

and their relationships to each other are more easily seen and evaluated. For these, I put in only the background cloth halftones. There were many more than three values in this scene, but limiting the values to three allowed me to concentrate on composition.

In all of the sketches the objects are relatively closer to the foreground and thus relatively larger than they are in the photographs. They are not surrounded by a huge area of space on the paper. They are, however, cropped differently. Cropping can be a good way to make important objects larger than they would be if they were included in their entirety, and makes it easier to articulate them.

CHOOSING THE SKETCH TO PAINT

The big question is always, "Which of these am I going to paint?" When I have all the thumbnail sketches done, it is easier to see the strengths and weaknesses of each. At this point I look at each of the sketches critically, one at a time. As I do this, I notice things that would be easy to miss if I just looked at the setup because all of the colors tend to confuse the analysis of composition.

Thumbnail 1

With the pitcher and the orange on the right cropped so much, the focus of the scene is the bowl and the left orange. That's lopsided. The pitcher doesn't work very well without a handle. This is almost like two different scenes; there is no point of contact between the two halves, and this composition is visually weak.

Thumbnail 2

Here I see more of the pitcher and the third orange. The two halves are still disconnected. While the scene is more balanced, it is perhaps too static. The bowl and the pitcher have equal weight.

Thumbnail 3

I do like the reflection of the lighted oranges into the bowl and the pitcher. Overall, though, this composition seems forced. It doesn't flow. The three oranges are in an almost straight row horizontally, which blocks entrance into the scene. The orange aligned with the center of the bowl is too balanced. This scene also lacks overlap of the bowl and pitcher, so it is still like having two pictures.

Thumbnail 4

This setup, from vantage point C, is an attempt to rectify the main problem with the first three scenes: the disconnect between the two halves of the scene. The oranges are on a diagonal ascending into the space behind and to the right of the pitcher. The composition is a triangle shape, with the pitcher at the apex. The bowl and the diagonal line of the oranges create the triangle. This scene has a nice halation of the foreground orange into the shadow on the bowl, and the best focal point. When you look at all of these sketches together, you can see that number four is totally different from the other three, and is a success.

PHASE TWO: *Continuing the Analysis*

We are going to paint the setup—a group of rounded, colored objects—as seen from vantage point C. Incandescent light is shining from the left. The reflection of the bright light into the dark blue background cloth shows as rose. There is also a lot of reflected light and halation of the orange into the shadowed side of the green bowl in the shadow. The middle orange is reflecting strongly into the shadowed side of the pitcher.

The light masses show the influence of the incandescent light. There is a lot of yellow on both the inside and the outside of the green bowl. There's a great deal of orange-yellow on the left side of the tablecloth, which becomes gradually rosier and more violet as it moves away from the light source to the right. I see the light mass of the pitcher as Yellow Ocher.

The shadows on the outside of the bowl are slightly different from those on the inside. The outside has a lot of rosy pink reflecting into it from the tablecloth, whereas the inside shadow contains a lot more Viridian and Ultramarine Blue. The shadow mass on the pitcher has a more greenish, dark olive look than the light mass does; I see them as Yellow Ocher and Cobalt Blue. The shadow masses of the oranges have a lot of bright color. The key to painting those shadows is to establish the mass of the color first, then go after the reflected lights and the individual variations in the masses.

The cast shadows of the oranges, the bowl, and the pitcher are predominantly blue and blue-violet with some orangey reflections into them as well as halation from the orange in the foreground.

PHASE THREE: *Drawing for Painting*

Now you can begin to draw and paint along with me as you did in the block study demonstration. I suggest that you read through the rest of the demonstration before you put pencil or brush to paper. Once you begin, work as quickly and spontaneously as possible.

USING THE VIEWER TO SET UP THE PAINTING

Using your viewer, make a preliminary contour drawing of the final setup. When drawing for painting, always be sure to draw the objects big enough that they are not surrounded by large areas of background and/or foreground. The objects in the scene are your main focus. Often, if you try to get all objects in their entirety in the drawing, the smaller objects will be too small. Also, none of the light and shadow shapes should be so small that it is impossible to paint the reflected light. You may need to cut off, or crop out, part of a larger object or part of an object that is not the center of interest. This can help focus the viewer's attention; it can also add interest by suggesting that the scene extends beyond the edges of the paper. Begin with simple geometric shapes, and use mostly straight lines. It is easier to compare the taper of the two sides of an object if you block it in this way.

Through the viewer, our setup looks like this: The bowl is to the left of the vertical line, and mostly below the horizontal line, and the pitcher is above and

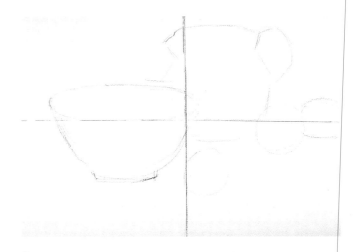

PRELIMINARY SKETCH AFTER USING VIEWER

FINISHED DRAWING FOR STILL LIFE

The final drawing indicates the demarcation between light and shadow on both the outside and inside of the bowl and the pitcher. I drew in the back edge of the table to differentiate the background from the tablecloth, paying attention to where the line of the table intersected the objects so that one side of the table did not look like it was higher than the other. Notice that I drew the line of the table right through the objects to make sure I got it right. The highlight on the pitcher is sketched in, as are the cast shadows on the background, foreground, tablecloth, and the objects. The areas of reflected light will be described with paint, and should not be put in at this stage.

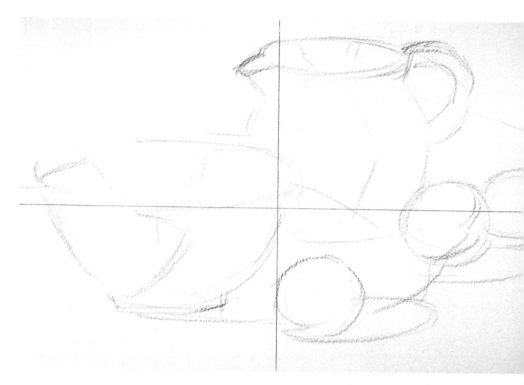

to the right behind the bowl. The opening of the bowl overlaps the pitcher, with the right side of the bowl to the right of the vertical line and the mouth of the pitcher to the left of that line.

Notice the differences between the setup—and thumbnail 4—and my contour drawing, which is shown at the bottom of the previous page. I have shown less of the inside of the bowl, and more of the outside, than is seen in the setup, and I have cropped out part of the orange on the right. And, although the pitcher in the setup is all curves, I have used more or less straight lines to indicate the general shape.

CONTINUING THE SKETCH WITHOUT THE VIEWER

Put down your viewer and check your depiction of the relationships between objects. Using mostly the side of your pencil lead, make broad, light lines to make the lines of the objects more curved and more true to the object. Now articulate the demarcations between light and shadow masses. Remember that this drawing is only for guidance about where the shadow shapes are, not to demarcate reflected details within the shadows,

or to indicate halftones. Delineate planes, not surface details, and leave most of the drawing in the painting to the brush. The importance of accurately depicting the spaces between objects in a setup is often underestimated by students, but without getting the spaces right in your drawing, you will not be able to describe the color relationships among objects.

DRAWING OVAL SHAPES

An invaluable aide to drawing oval shapes such as the bowl opening is to note the placement of the right and left sides and draw short vertical lines to indicate where the bowl ends. Then draw a horizontal line connecting the two vertical lines. Next draw a vertical line through the middle of the horizontal line, with the line ends equal distances above and below your horizontal lines. You will now have on your paper two points defining the width of the oval and two defining the height of it. Then use these points to draw your oval.

STAGE TWO: THE SHOCK OF THE LIGHT

Like the block study demonstration, this demonstration provides directions that you can follow so that you are, in a sense, painting along with me. Read through the rest of the demonstration before you put brush to paper. When you do start painting, you need to push yourself to paint quickly, so that you can complete what needs to be done wet-on-wet before your painting dries.

Preliminaries

Now that you have analyzed the setup and completed your sketch, you are almost ready to begin your first still-life painting. There are just a few preliminaries to take care of. First, get out your masking fluid and shake it well. Wet a small brush reserved for this purpose, and swish it around on your piece of soap. This will keep the masking fluid from sticking permanently to your brush. If some does stick, it can be removed with rubber cement thinner. Look at where the bright highlights are in the setup and apply the masking fluid to those spots. Don't get it too thick or it will take forever to dry. Also, don't get carried away and try to mask every tiny highlight; mask only the major ones. In this setup there are highlights that should be masked on the middle orange, the lip and side of the pitcher, and the rim of the bowl in the front toward the left and in the back toward the right.

While the masking fluid is drying, wet and stir up your paint. Squirt water from your bottle on *all* of the paints on your palette, even if you think you won't be using a particular color. If it's not ready to use, you probably won't use it even if you should.

Once the masking fluid is dry, take your 2- to 3-inch paintbrush and wet the entire surface of your paper. Scrub it a little with the brush, then let the paper absorb the water until it is the consistency of a damp blotter.

PHASE ONE: *Separating the Light and Shadow*

Just as it was in the block study exercise, the most important thing in this phase is keeping the statements of light and shadow very simple. The contrasts must be obvious; the lightest shadow must be darker than the darkest light mass.

Leaving a little edge of white paper around the color masses minimizes bleeding. Beginners may want to use selective wetting. Working as quickly as possible and keeping all areas equally wet also helps keep colors from running together. Pushing yourself to paint faster is a necessary part of controlling the water. I keep a paper towel in one hand and repeatedly dab my brush on it to get excess water out of it as necessary. If the paint you are applying to one area migrates too much into an adjacent area, you can use a paper towel to blot it. Keep this to a minimum, however; if you dry the paper too much, the paint will be siphoned into the drier area. Knowing what the right degree of wetness is comes only through experience.

Get out a #10 brush to start with and have a #8 ready.

Each photograph in this demonstration *precedes* the step-by-step instructions you will follow to achieve the effects shown. As you paint along through each of the phases, refer to the appropriate illustration as often as you need to.

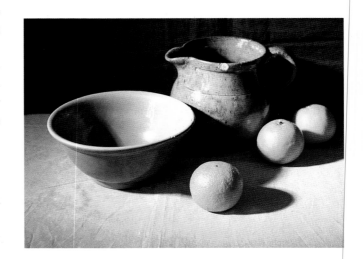

PAINTING PHASE ONE: FIRST STATEMENTS

Bowl: First Look

Begin painting the most obvious color first, which is the green bowl. First paint the light mass on the inside and outside of the bowl with Lemon Yellow. Next go to an adjacent area, the shadow mass of the inside. Remember that the light and shadow will be different colors. Don't just paint the whole bowl with Lemon Yellow and then darken the shadowed parts. For this shadow mass, use Cobalt Blue plus Viridian and a little Chinese White mixed with water on your palette. In the shadow mass on the outside of the bowl first use Permanent Green Light, then let Cerulean mixed with a little Chinese White mix wet-on-wet on the left half of the shadow so it is a little greener than the shadow on the inside.

Tablecloth

Paint the entire light mass in the tablecloth with Naples Yellow. At this point you don't have to be meticulous about brushing on the paint all the same way, or even about using the same thickness of paint; just cover up the white paper in the entire area of the tablecloth.

Pitcher

In the light mass, use Yellow Ocher mixed with Naples Yellow. For the shadow mass, use an olive green mixture of Yellow Ocher and Cobalt Blue.

Background Cloth

First put down the warmth of the light using Permanent Rose mixed with a little Yellow Ocher. For the coolness, mix Ultramarine Blue and Ultramarine Violet together and add a little Chinese White plus a little Viridian. Make a test to see if you've got it right. That's a bluish color, but you need to be careful not to make it too blue. The white is used to float this cool color over what's already down so the cool color can keep its integrity rather than mixing with the initial rose color. Do not apply the blue so that it completely covers the rose.

Bowl: Second Look

For the light mass on the inside of the bowl, mix Cerulean Blue and a little Viridian with Chinese White and put it over the Lemon Yellow that is already there. Cover the shadow mass on the inside of the bowl a little more using a mixture of Cobalt Blue and Cobalt Violet plus Chinese White. Next mix a little Cadmium Red with Chinese White and use just a few brush-

PAINTING PHASE ONE: FIRST STATEMENTS

The light mass on each object is all one color, as is each shadow mass.

strokes to add the reflected light from the cloth onto the outside of the bowl under the shadowed part of the rim and along the left edge of the shadow.

Cast Shadows

As we discussed earlier, each shadow is its own color distinct from the light, not merely a darker version of the color we used in the light. For the cast shadows on the tablecloth and on the pitcher, use Cobalt Violet Deep Hue. The cast shadow of the pitcher on the background cloth is a mixture of Ultramarine Blue and Ultramarine Violet.

Oranges

The oranges are not all equally lit, nor are they all the same color. Mix a little Naples Yellow with Cadmium Orange for the light masses of the oranges. The shadows on the middle and foreground oranges are a mix of Venetian Red and Cadmium Orange with just a dash of Cadmium Scarlet mixed on the palette. The orange on the right has a shadow that is Cadmium Orange over Naples Yellow wet-on-wet.

PAINTING PHASE ONE: SECOND STATEMENTS

Now is the time to begin covering up any white you have left around the color masses so you can see the whole image and adjust the colors in relation to each other. Now, before your picture dries, is also the time to begin differentiating the color masses in the shadow from each other by making their color more accurate. You will need to do the same thing to the color masses in the light, making sure each has its own character and its own color.

Pitcher and Its Shadow

The shadow behind the pitcher needs to be darker so the pitcher will stand out more. Add a mixture of Mars Violet and Ultramarine Violet to it. Add the reflection of the middle orange into the pitcher using

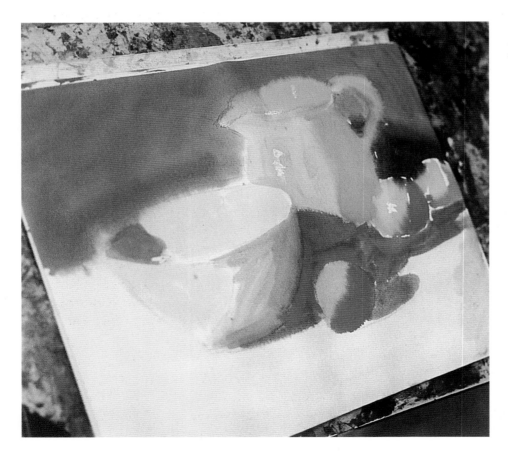

PAINTING PHASE ONE: SECOND STATEMENTS
The colors of each mass have been made more accurate.

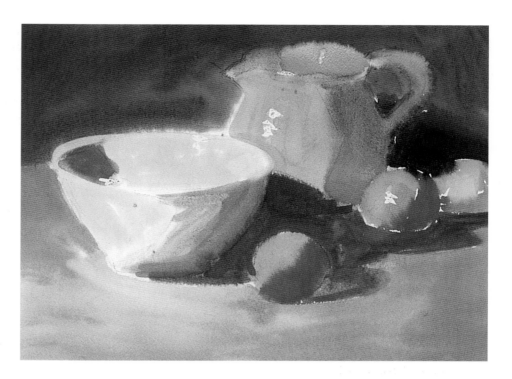

PAINTING PHASE ONE:
LAST STATEMENTS
Light and shadow have been separated
in all areas of the painting.

Cadmium Orange mixed with a little Naples Yellow. The light mass on the outside of the pitcher needs a little Naples Yellow, but don't cover the underlying color completely. The light mass inside the pitcher is a little darker than the outside, so use a little Permanent Green Light mixed with Yellow Ocher. Again mix an olive green of Cobalt Blue and Yellow Ocher for the shadowed inside of the pitcher handle. Add some Viridian mixed with Yellow Ocher to the cast shadow of the bowl on the pitcher. To reestablish the light on the handle, add a small spot of Naples Yellow mixed with Cadmium Yellow on the front of the handle at the top right where it joins the body.

Pause again to go through the entire painting and assess what needs to be fixed. There is a lot to do in a short time, and it gets kind of wild. The painting should still be damp all over.

PAINTING PHASE ONE: LAST STATEMENTS

Tablecloth

Mix Permanent Rose with Chinese White and add it to the cast shadows on the tablecloth right up against the middle orange, as well as between the left orange and the bowl and the pitcher. Brush some Yellow Ocher onto the right side of the tablecloth from the shadow under the left orange to the bottom of the paper.

Wet the entire tablecloth so the pink color put in next will float on it, not completely soak in and obscure the warmth that is already down. Clean your palette so you can mix a fresh spot of color that isn't influenced by colors around it. Mix Permanent Rose and Chinese White and float it over the Naples Yellow you put down originally. You're trying to achieve that little bit of cool pinkness that's there in addition to the warmth. Now go back in with some Naples Yellow to warm and lighten the area right under the light on the left, in front of the bowl. Go back into some of the areas in the periphery of the painting on the right and the upper left to make them a little darker with some more Permanent Rose mixed with Cadmium Red.

The painting is still two-dimensional. Halftones have not been added, nor have any fine details. In the block study, I did not add any reflected light until the end. In this scene, I added some of the reflected light because it is so obvious and important.

PHASE TWO: *Refining the Light Effect*

Again assess your painting to see what areas need adjustment, not to model form, but to strengthen areas where color choice needs to be modified. Remember that we are not adding small details yet; we are only concerned with broad areas, like an entire shadow. Do this thoughtfully but quickly so that your painting doesn't dry too much. You can see in my painting that I need to define some of the shapes more accurately and get rid of some of the fuzziness.

PAINTING STAGE TWO, PHASE TWO

At this point we will use fairly dense paint, especially in the dark masses, and will mix the colors on the palette. Keep your paper towel in your hand to control the amount of water in your brush and sort of make the paint stiffer. There should not be a lot of water flowing off the brush. The first statements we put down were quite wet, but from here on you will be trying to add as little water as possible. You should use a #8 or smaller brush, since you will be working in smaller areas.

Pitcher

We need to darken and cool the color of the cast shadow from the bowl onto the pitcher so it will stay in the shadow. Mix Ultramarine Blue, Ultramarine Violet, and Yellow Ocher and put it over the color already there, letting a bit of the previous statement show through.

Now the shadowed side of the pitcher seems a little redder than our initial statements. Put some Indian Red into the top half of the shadowed outside of the pitcher, stopping short of the orange reflection. Put a small touch of Indian Red mixed with Cadmium Orange under the edge of the shadowed part of the rim where the orange reflects into it.

The pitcher still needs a little more punch. Mix a little Permanent Green Light, Cadmium Orange, Cadmium Scarlet, and a tiny bit of Viridian to make dark olive green. Put this on the front inside lip of the pitcher next to the handle, and on the inside shadowed portion of the spout. Put a narrow line of this same color along the right edge of the pitcher inside of the handle.

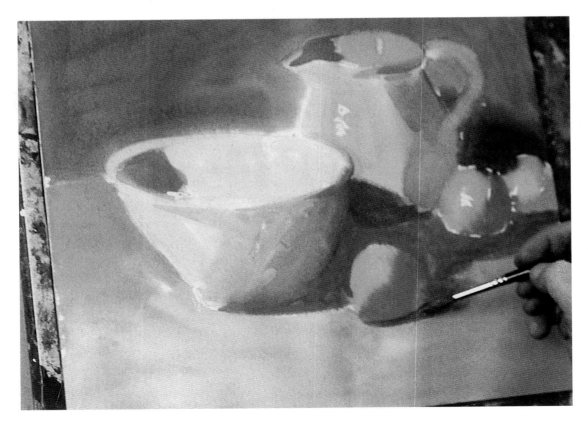

PAINTING
STAGE TWO,
PHASE TWO

Bowl

Look at entire areas of color and make the most important change first, as you did with the pitcher. The color of the shadow on the outside of the bowl makes it stand out too much. Use the same mixture of Ultramarine Blue, Ultramarine Violet, and Yellow Ocher that you did on the pitcher and put it into the shadowed side of the bowl. It is important to look at the shadow on the pitcher and the shadow adjacent to it on the bowl and keep the colors of these two areas coordinated.

Now I see some reflected light that is not yet in my statement. Onto the middle part of the shadowed side of the bowl, add Cadmium Orange for the reflection of the orange. Use Permanent Rose for the reflection of the tablecloth in the same shadow on the right side of the orange reflection and on the right side of the shadow. Also in the shadow, use Cobalt Violet just under the right side of the rim and down the right side of the bowl so the shadowed side will merge a little more with the surrounding shadows.

The rim in the shadow also needs to be improved. Mix Naples Yellow and Permanent Green Light and lay it into the lit front and right side of the rim to make a stronger statement in that area.

Moving back to the shadow mass outside, mix Cerulean with a little touch of Chinese White in a sort of crescent shape to describe the shadow under the rim and the transition from light to shadow on the front of the bowl.

Orange

As part of the clean-up job as we near the end of Phase Two, try to assess the colors again, especially in the shadows. The shadow under the foreground orange needs to be darker and the blurred red edge of that orange needs to be cleaned up. Mix Cobalt Violet with some Indian Red and paint it in a strip just under the bottom of the orange. Extend this statement a little further to the right and blend that light spot into the shadow.

PHASE THREE: *Adding Halftones and Modeling Form*

To further refine Phase Two, we will begin to add halftones to break the preliminary masses into facets of color change within each mass. We are still focusing on color masses within objects, not trying to complete any object entirely. When the color and value are right, the objects and their shadows will be distinct and complete.

Continually look for opportunities to work on halftones in order to articulate the transition from light to shadow. In addition to looking at the light masses, look for opportunities to add halftones to the shadow as well. The shadows should not be uniformly one color; each shadow will have color variations within it.

We're still in Stage Two because, while areas of the painting have begun to dry, we have not yet stopped to let the entire painting dry. We're still able to paint wet-on-wet, although it's getting harder to stay ahead of the drying.

PAINTING PHASE THREE: FIRST STATEMENTS

Pitcher

Add a halftone to the pitcher with a little deeper Yellow Ocher and Cadmium Scarlet. Lay it in quickly on the extreme left edge and on the right edge of the lit portion on the front of the pitcher. Also put a little of this mixture on the back of the inside rim to the right of the shadow. Add a little Indian Red to the left side of the reflection of the orange and along the bottom edge of the pitcher.

Oranges

The oranges need help big time. If you look back at *Painting Stage Two, Phase Two* (page 102), you'll see that none of the oranges is fully described. As you worked on the shadow of the pitcher, you should have become aware that defining one relationship leads to the definition of another. When you make the pitcher more complete, you are also making the oranges more complete. They're all related. These are the things you need to learn to see in order to paint more accurately. The rightmost orange in particular is kind of dead.

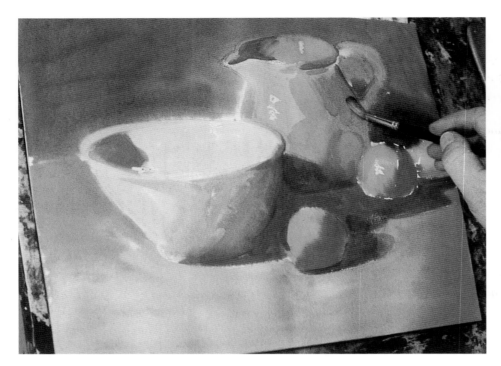

PAINTING PHASE THREE: FIRST STATEMENTS

ADDING LIGHT, STILL LIFE
DETAIL

REFINING THE
SHADOWS,
STILL LIFE
DETAIL

The color in that area needs to be more complete. Add some Cadmium Yellow to the middle of the lit part of the orange on the right, as shown here in the detail.

More Shadows

The edges and the cast shadows also need further articulation, and this can be difficult. Referring to *Refining the Shadows,* use some Cobalt Violet Deep Hue and Indian Red to darken the cast shadows under both of the oranges on the right. The colors of the shadows on the oranges must be darker so they will be more differentiated from the pitcher. To define the side of the middle orange against the pitcher and shadow, put a mixture of Cadmium Scarlet and Yellow Ocher on the left edge of that orange next to the pitcher. Also use this mixture to darken the shadow mass of that orange. Put a little of it mixed with water into the shadow mass of the orange on the right. Be careful not to make it too dark; that shadow is lighter than the shadow mass of the middle orange.

Mix a little Permanent Rose with Cobalt Violet Deep Hue and put it into the shadow area under and to the left of the middle orange to get the reflected light. Finally, put some Cobalt Violet Deep Hue and Mars Violet into the shadow just above the middle orange.

Background

Make the shadow above the oranges darker in order to salvage the edge of the oranges. Go right up to the edge of the orange with a mixture of Cobalt Violet Deep Hue and Mars Violet with a little Ultramarine Violet and then use water to flood it out toward the edge of that shadow. In my painting, I didn't go all the way to the edge, though, because the cast shadow in the setup *actually turned a different color,* becoming bluer because of the natural light that was coming in through the large windows in the room where I was painting.

FINISHING PHASE THREE— AND STAGE TWO

At this point, you need to sort of go all over the place; this is not straight-line thinking. Our aim so far has been to try to get the overall effect, rather than concentrating on small, specific areas. Most of the time in this stage, when we try to work on one particular area, it's not an object in isolation that we are working on, but two or three color areas. A good example of this was our work on the shadow of the pitcher, the two left oranges, the cast shadow behind the pitcher, and the cast shadow in the foreground: a change in any one of these areas affected all of them. Although the steps have been broken down according to specific areas, for example, "bowl," "oranges," etc., so you can follow the instructions more easily, you have really been working on a series of relationships between color masses, a whole family of things.

We are now almost at the end of Stage Two. When you have finished making the refinements described below, you will let your painting dry completely before beginning Stage Three.

Oranges

My orange on the right needs a halftone on its left side and bottom. Yours probably does too, and you can use a very small amount of Yellow Ocher to darken that area slightly. My orange on the left looks a little blobby. Yours may be fine, but perhaps a different area needs better definition. Do a bit of resketching, with pencil, on the dry paper wherever you need to define a shape better.

Shadow

Now we are going to do the same thing for the foreground area that we did for the part of the painting more in the background. Go back to the shadow under the base of the bowl with some Cobalt Violet Deep Hue mixed with a little Mars Violet. Mix some Permanent Rose and Chinese White and use it to get a little more reflected light into the shadow mass on the bowl.

FINISHING STAGE TWO

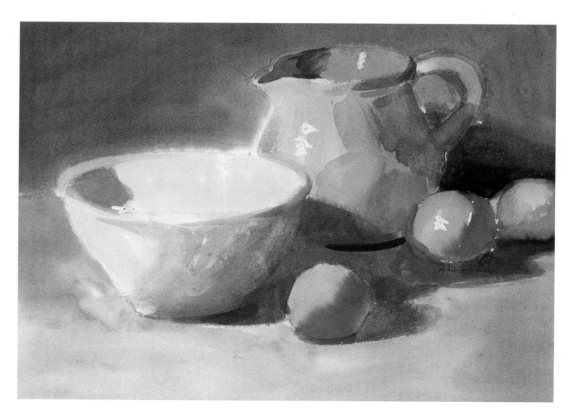

STAGE THREE: REFINING THE FORMS

While your painting is drying, clean the mixing area of your palette completely so you can get a fresh start without being distracted by your previously mixed colors. Then step back, take a few deep breaths, and rest your eyes by looking around you instead of at your painting or the scene.

In this stage you will be adding more reflected light and halation. Reflected light is most obvious in the shadow of an object, from the lit side of an object into a shadow. Halation is the splashing of light and color from the lit edge of an object into another, usually darker, one. It produces a glow, like a halo. Most people don't see halation until it's pointed out to them. (One of my students said she had always seen this glow, but thought it was due to a problem either with her eyes or with her eyeglasses, so she never thought to put it into a picture.) Halation is most obvious in the strong sunlight outside, especially in the late afternoon, but it occurs, perhaps more subtly, in a lot of other situations also.

ASSESSING THE PAINTING

At this point, you will study the whole painting to see what is strong and what is weak and to determine what it needs. What areas need refinement? Do the shadows and the background area need to be darker? Continuously look back and forth between the setup and your painting. In this stage you need more thought than in the previous ones. In general, as your painting develops, you must spend more time making decisions and planning how to accomplish your ends.

Your painting may have different needs than mine does at this point. As you follow my assessment, look at your own painting and pose similar questions. As I looked at my painting, these were my first reactions.

- I saw the following drawing problems. The left side of the pitcher and its spout need more definition, as does the bottom, especially the lower left. The right edge of the bowl behind the orange also needs to be clearer and better shaped.

- The inside of the bowl is obviously lit, but there needs to be more articulation of the light there. The

reflected light and halftone under the outside of the bowl need clearer definition.

- The orange in the foreground needs some modification of the color in the light, as well as a clearer statement of the reflected light underneath.

- The pitcher against the background cloth is too fuzzy. The problem is that I do not want to change the color of the background.

PAINTING STAGE THREE: FIRST CORRECTIONS

Start with defining the edges of the objects, since that is the easiest thing to do. Make the needed pencil sketches first, then take up your #10 brush again and refer to *Painting Stage Three, First Corrections*.

Bowl

Because the bowl, even in shadow, is lighter than the cast shadow next to it on the pitcher, the right edge of the bowl must be defined by painting in the darker area on the pitcher. Use Indian Red on the bottom left edge of the cast shadow on the pitcher.

Develop the halftone on the inside of the bowl by making the top and right edges of the shadow more olive. Mix Cobalt Blue, Viridian, and Chinese White and use a few strokes to add that darker halftone. Lighten this mixture with more Chinese White and water, and put in a lighter halftone to the right of the shadow.

Tablecloth

Add a little water and then some Permanent Magenta along the edge of the tablecloth next to the background to the left of the bowl. We are adding the water because we don't want this correction to be too obvious, like a stripe in the cloth. The color in your brush should also be less saturated with pigment than it was earlier.

Background Cloth

While parts of this need some work, we don't want to destroy the glow of the reflected light into the back-

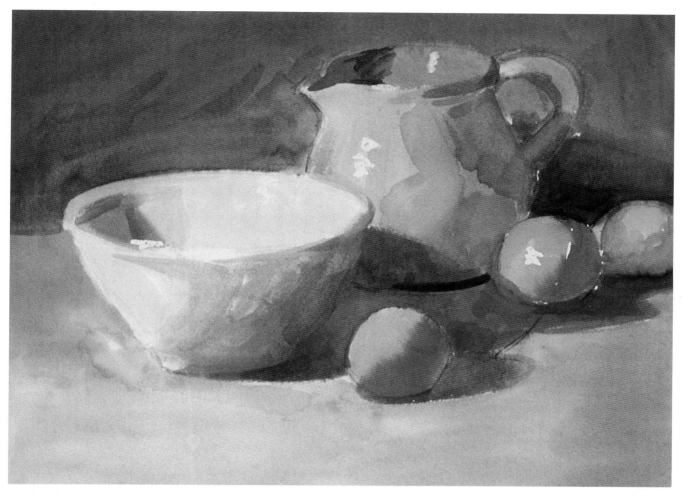

PAINTING STAGE THREE, FIRST CORRECTIONS

Some drawing corrections have been made; the halftone inside the bowl has been added, and more reflected light has been added to the outside of the bowl and pitcher and to the cast shadows.

ground. Rewet the background cloth with a little water to the left of the pitcher and above and to the left of the bowl. Let it soak in. Then take a little Cadmium Red mixed with a very small amount of Chinese White and reestablish the halation by laying this mixture over the violet color along the edge of the bowl and pitcher.

Pitcher

On the bottom of the pitcher next to the bowl and between the pitcher and the bowl and the left orange is really nice halation that isn't in the painting yet. This halation shows up as a glow in the areas around the lit side of that orange.

Cast Shadows

Reflected light from the lit side of the middle orange into the shadowed side of the pitcher is quite strong, as is the reflection from the left orange into the shadow mass on the bowl. Mix a little Cadmium Red and Cadmium Scarlet with a lot of water and put it into the areas between the lit side of the left orange and the bowl and between that orange and the pitcher to brighten those areas and fill them with the warm glow of the light.

REFINING FORM AND CAST SHADOWS

Halftones on the outside of the bowl are further developed, as well as the halftone on the foreground orange. The cast shadow of the the foreground orange is darkened.

REFINING FORM AND CAST SHADOWS

You model the form of any object by looking for and depicting specific areas of color change within the overall mass. Remember that it is the relationship of one color to another, their relative lightness and darkness, that creates form.

Bowl

The area to the right of the halftone on the interior of the bowl needs a color change. There is a pale shape there. Mix together Permanent Green Light, Cerulean Blue, and Chinese White and lay it against the right side of the halftone. Do the same thing to the right side of the interior of the bowl where that triangle-shaped facet has a fair amount of yellow. Use a mixture of Naples Yellow and Lemon Yellow to create that subtle effect. You are building a series of planes on the interior of the bowl, trying to adjust the color of those areas to make the bowl look rounded rather than flat.

Add a halftone shape on the lower portion of the bowl in the light and against the shadow to create a transition plane between the light and shadow. Use Permanent Green Light mixed with Cerulean Blue. These are the same colors used for the halftone on

the inside of the bowl against the shadow, but this time use a little more Cerulean Blue. Go straight across the lower half of the bowl and up the left side a little less than three-fourths of the way from the bottom to the rim.

Pitcher

Put more light into the outside of the pitcher handle to make it stand out better by darkening the background inside the handle using Cobalt Violet Deep Hue and Ultramarine Violet mixed on your palette.

Foreground Orange, First Restatements

This orange needs to be cleaned up a bit. First, use your pencil to define the top of the shadow. Then clean up the lit edge by scrubbing it with a wet stiff-bristle brush to blend in the fuzzies. So far this orange only has light and shadow. Look at it in terms of deciding what the weakest part is. That is the part to work on first. In my painting, the weakest part is the core shadow, the area where it is darkest just before it turns into the light. It needs to be made a little more complete. Mix some Permanent Magenta, Chinese White, and a little Viridian. Try to float this little bit of cool color onto the edge of the shadow, making the upper part wider than the lower one. Now put down a little Cadmium Red in the same place. Do this without rewetting the paper first.

Cast Shadow

Lay some Ultramarine Violet and Permanent Magenta mixed together into the cast shadow of the foreground orange to make the reflected light more obvious.

Left Orange

Now add some more reflected light on the lower part of the shadow mass of the left orange. Mix Cadmium Scarlet, Naples Yellow, a little Cadmium Yellow, and Cadmium Orange to make it brighter. Add a mixture of a little more Permanent Magenta, Cobalt Violet Deep Hue, and Chinese White to the core shadow to emphasize it while this area is still wet, melting it into the edge of the reflected light.

MAKING LIGHT
AND SHADOW
MORE ACCURATE

MAKING LIGHT AND SHADOW MORE ACCURATE

Left Orange

Now that the shadows on the left orange are more established, you can work back into the lit side of that orange, putting in the color changes. Create a transition between light and shadow by using a mixture of Cadmium Scarlet, Cadmium Orange, Cadmium Yellow, and Naples Yellow. Avoiding the highlight spot, brush this mixture around the edges of the orange and along the edge of the shadow.

Middle Orange

Things need to be a little darker in the recesses of the painting. Again painting around the highlight spot, lay Cadmium Scarlet along the left edge of this orange and along the edge of the shadow to step those parts of the light mass down in value and intensity.

Right Orange

Put Cadmium Scarlet into the shadow mass on the bottom of this orange. Now move to the core shadow on the upper right. Use Cobalt Violet Deep Hue, Permanent Magenta, and Chinese White, the same pool of color that we used on the first orange, for that triangle shape of dark shadow. Now put the reflected light into the shadow across the bottom of the orange with Cadmium Scarlet. Add a mixture of a little Venetian Red and Cadmium Scarlet to make that same area dark enough.

This orange still needs help. All of these things are related. Mix Yellow Ocher, Permanent Green Light, and Cobalt Blue to put on the upper left side. If this turns out to be too bright a green, add a little Yellow Ocher and Venetian Red. Just sort of pat the side of the brush on that area and let the paint mix, with some of the green coming through. That orange is kind of murky back in there. The core shadow needs to be darker. Mix Venetian Red, Yellow Ocher, and Chinese White and put it into the shadow across the bottom of the orange.

FURTHER MODIFYING FORM

All of the following refinements apply to my painting, and may not be the same ones you need to make. Just as I did, however, you should be constantly looking at your painting to find places that need further definition.

Pitcher, First Look

The reflection of shadows into the pitcher needs to be strengthened. Put some Cerulean Blue and Yellow Ocher on the top half of the left side of the shadow mass. That orange reflection needs more punch; brighten it with a mixture of Yellow Ocher and Cadmium Orange. The handle needs to be reshaped; it looks blobby. Use a pencil to redraw the inside edge of the handle. Then apply your mixture of Cobalt Blue and Yellow Ocher to darken the top of the shadow mass on the lower inside part of the handle.

Bowl

Draw a few lines with your pencil to sharpen the edge of the bowl against the shadows on the pitcher and on the tablecloth. The shadow under the rim on the right of the bowl needs to be made a little darker using more Ultramarine Violet. Put a fair amount of paint there and carefully drag a little water through it with your brush, fading the color out along the rim of the bowl to the left.

Pitcher, Second Look

First, work on both the inside and the outside of the spout. Put some Ultramarine Violet on the left half of the shadow inside the spout. Then mix a little Cerulean Blue and Naples Yellow to depict that little triangle shape on the outside of the spout just below the rim. Do the same thing to the cast shadow of the bowl onto the pitcher that you did to the rim of the bowl. Use Mars Violet along the top of the shadow. There's a really nice reflection between the bowl and the pitcher. It's a little hard to see, but it is definitely there. Into the shadow of the bowl on the pitcher, up against the edge of the bowl, put some pure Yellow Ocher almost straight out of the tube. Now put some Mars Violet just to the right of that.

All these little color changes help define form. We're trying to turn this pitcher so it looks rounded, and I'm groping for the things that will help do that. I see that some areas are still weak. The shadowed side of the pitcher needs more definition, as do the handle and the front of the rim. Mix Permanent Green Light and Mars Violet and put it along the right edge of the shadow mass of the pitcher. Next to that, put in clear water to fade that added color toward the light in graduated steps. Be sure to leave some reflection, some dry paint, rather than covering up all of what is underneath.

The reflection of the orange isn't quite right. Wet it and put in some diluted Cadmium Orange. Mix Permanent Magenta and Cadmium Red and pat the mixture on the lower left edge of the reflection of the middle orange into the pitcher. Then put a little Indian Red in a triangle shape just above the reflection of that middle orange.

For the shadow at the bottom of the pitcher, mix Ultramarine Violet and Mars Violet, and lay a strip of it from the bowl to the middle orange.

On the upper side of the handle there is a little triangular shadow where the handle joins the bowl. Using Yellow Ocher and Indian Red, put that shadow in and then continue it to the right on the underneath side of the handle.

PAINTING STAGE THREE: FINAL CORRECTIONS

Bowl

Now the edges of our recent halftone statements need to be faded a little. You have to find the small transitional color changes between areas and fade them by adding a little water to make a color change. Put some clear water on the upper edge of the halftone on the base of the bowl. Overlap both the shadow and the light and lightly scrub that area with a soft brush. This will result in a soft gradation of pigment which merges the halftones into one another instead of having an abrupt change from one color to the other.

For the reflection under the rim of the bowl, mix Permanent Rose and Chinese White. Use a #8 or smaller brush to lay a line of this under the rim from the left to slightly past the middle. As a continuation of that edge, use a mixture of Cobalt Blue and Viridian on the shadowed edge of the rim almost all the way to the right side.

With your pencil, redefine the edge of the front rim where it comes against the interior of the bowl. Use a stiff bristle brush to scrub the front rim of the bowl where it comes up against the interior from the left almost to the right side to brighten it up a bit. Be careful not to scrub the shadows and reflections we have put in just under the rim or on the edge of the rim in the shadow toward the right side.

Pitcher

Mix Yellow Ocher with a little bit of Cadmium Red. With a small brush, apply this to the front of the rim of. the pitcher, starting just to the right of the highlight, continuing to the left around the spout and around the back rim almost to the handle.

Oranges

Add some accents under the oranges with Mars Violet to give them a little more oomph. Just put a brief line up against the bottom of the oranges and then fade it a bit into their shadows with clear water.

PAINTING STAGE
THREE: FINAL
CORRECTIONS

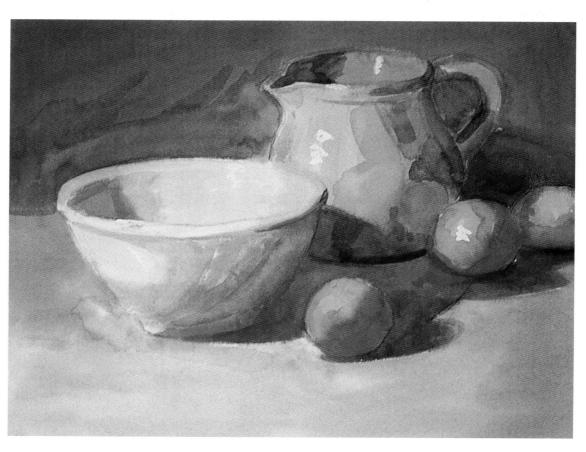

STAGE FOUR: FINISHING THE DETAILS

STAGE FOUR: SOFTENING THE HIGHLIGHTS

There is no formula for deciding at what point you can say, "Aha! I have finished Stage Three and I am ready to move on to Stage Four." It is more a subtle change of focus. Stage Four is the endgame where design and composition and strategy become more important.

In every painting there is a center of interest to which the design of the painting carries the viewer's eyes. In this still life, the center of interest is the bright green bowl. In Stage Four, your overall goal is to more completely delineate and emphasize that center of interest. You are now looking at individual objects to determine how they should be finished as part of the overall scheme that you are bringing to a carefully thought out conclusion.

During Stage Four you will make final decisions as to which details to include in your painting. Obviously, if you've gotten this far successfully, you have already described the roundness of your round objects, and the various colors and statements that create both flatness and depth in your cast shadows. Now you are concentrating on the areas that are the center of interest; you are not so concerned with the areas peripheral to the center of interest. You may want to blur some of the edges in peripheral areas and sharpen and refine edges in the areas that are the center of interest. Always keep in mind that your ap-

proach to the painting as a whole must be carefully orchestrated. If too many pinpoint details are vying for the viewer's attention, there can be visual chaos.

Assessing the Painting

Before you begin your assessment, make sure your painting is completely dry, then take off the rest of the masking. If the painting is not totally dry, you will damage the surface of the paper. With the masking removed, you can soften the highlights.

SOFTENING THE HIGHLIGHTS

Bowl

The right shadowed edge of the bowl needs to be better defined. Reestablish the shadow there with some Cadmium Scarlet mixed with Indian red, diluted with water.

Dab some Lemon Yellow on the edges of the highlight on the rim of the bowl.

Oranges

Use a little Permanent Magenta very diluted with water on the middle orange to soften the edge of the lower part of the highlight. One of the problems with masking is the resulting hard edge, so you often need to overpaint those areas. I sometimes scrub the edges of highlights to get that softness, like you would have on an orange. Use some Permanent Green Light with a little Viridian to add the stem pieces to the oranges.

Pitcher

Dab the same Lemon Yellow you used for the bowl on the highlights on the side of the pitcher. Use fairly stiff paint and brush it on, but don't get carried away; those areas need to stay bright. Now mix some Cerulean Blue with Chinese White. Beginning above the right half of the highlights on the side of the pitcher, put a quick stroke of this mixture down across the right half of the highlights and on the pitcher above and between them. This will create a little form change there. Little blobs don't bother me too much; this is a painting, not a photograph.

Mix a little Cobalt Violet deep hue with Chinese White and put it onto the upper and left edges of the highlight on the front of the rim. Do the same thing to the highlight on the inside rim.

FINAL DETAILS

Background

Use your wide flat brush with clear water to soften the background on the left. You want it just wet enough to soften the paint but not enough to make it run into the other areas. You don't want to lift the paint, but rather to let it "reemerge," smoothing the brush marks and clutter. To this wet area add a very small amount of Cobalt Violet Deep Hue mixed with Mars Violet. Be careful not to make the area darker.

Bowl

Define the top rim of the bowl against the background more, applying a mixture of Cerulean Blue, Chinese White, and Viridian with a #8 or smaller brush. Use a lot of paint with a little water.

Use a little Viridian and Cobalt Blue on the edge of the rim in the shadow, which will define that edge a bit more.

Wet the shadow mass area on the outside of the bowl, and add a very small amount of Indian Red mixed with Chinese White to the reflection of the orange and let it disperse outward to change the greenish edge and make that area subtler and darker.

Pitcher

Put some little dabs of Venetian Red into the interior of the pitcher just above the highlight on the lower rim and into the shadow inside the pitcher. Use this same mixture along the top of the rear part of the rim in the light.

On the lit part of the pitcher handle there needs to be a better transition from the undersurface of the pitcher into the light. Add a brushstroke of Venetian red up against the shadow on the pitcher handle.

The halftone transition into the shadow above the orange needs to be reworked to create more facets of color change. Brush on clear water to overlap the shadow and the halftone. Then add Indian Red mixed

COMPLETED STILL LIFE

with Naples Yellow and a lot of water so that it disperses rather than creates a hard edge. Do the same thing to the left edge of the halftone, this time using Naples Yellow, Indian Red, and a little Yellow Ocher.

Wet the shadow inside the spout of the pitcher and add some Ultramarine Violet mixed with a touch of Yellow Ocher.

WHEN TO STOP

Many paintings, especially beginners' still lifes, are ruined by overworking. Most students yield to the temptation to try to get in every little variation, like the dimples in an orange. It is only through experience that you will learn to answer the question "When do I stop?" with consistent success. There are some guidelines, however.

Keep reminding yourself that the Impressionist still life is not a photograph; if you want photographic detail, use a camera. It's quicker and easier. Your painting should be an impression of the objects in the light and shadow that you see in front of you, not a "portrait" of those objects. For example, we did not even try to paint the wrinkles and folds in the tablecloth and the background, and we left out the chip on the rim of the pitcher. The Impressionist watercolor is washy, tactile, spontaneous, with an intentional "painterliness." It is never slick or photographic.

8
ADVANCED COMPOSITION

Not until you have thoroughly mastered the basics of light, color, and form should you focus on the complexities of advanced composition and design. Then and only then can you look beyond the individual objects in a scene and concentrate on creating movement in your painting and on making good decisions about what you want to the be center of attention and what you want to play subordinate roles.

CLOUDY DAY ON CAPE COD

In this painting, the importance of the center of interest, the red bowl, is reinforced by the color, the spiral composition, and the contrast in detail level between the background and the objects on the table.

RHYTHMIC RELATIONSHIPS

S-SHAPE COMPOSITION

This composition leads the eye in a backward S-curve.

SPIRAL COMPOSITION

This composition is a combination of the circle and the S-curve. The towel leads the eye into the scene to the right and then curves to the left. The two apples reinforce the curve. The circle goes from the two apples to the top of the bottle and down to the left edge of the tub and the single apple. From the single apple, the eye path goes back to the towel, up around the top of the tub, into the tub and around it, creating the spiral movement. The painting of this composition is on page 78.

Good pictorial design often combines several design elements. The S-shape, which is used in landscape painting, can also be used in a still life to direct the eye from the foreground into the distance. It can be used within an overall circular or triangular design to bring the eye from the foreground into the dominant shape. My sensitivity to bringing movement into still lifes was influenced by the concept of *rhythmic relationships* as taught by Henry Hensche and Cedric Egeli. One kind of rhythmic relationship is found in figure drawing that emphasizes the flow of form within a figure, involving the viewer in the movement and life of the drawing. I look for that same flow when I paint both landscapes and still lifes, to create a lyrical sensibility and movement in my work.

Towels and cloths can be powerful tools for establishing a rhythmic relationship among static objects. I simplify the forms of towels and cloths when I paint, using them to create an obvious entry into and flow through the objects and the spaces between objects. Arranging fruit along the path created by a cloth or towel will add interest to the scene as well as direct the viewer's eye.

The towel in the painting on the next page creates an S-curve from the foreground to the left side of the orange plate, where the juxtaposition of the cool blue of the shadowed towel and the warm, fairly bright orange plate helps to emphasize the plate, which is the center of interest. This path into the painting continues around the plate, past the green apple to the right and up around the top of the dark jug, then uses the cast shadow on the background to bring the eye back down. The juxtaposition of the color of the jug against the olive green background provides a strong silhouette that make the orange plate and the green apple stand out.

I included the corner of the table, which is unusual for me, but here it works to make the entire painting more dynamic. The corner echoes the directional elements of the towel's S-curve, giving that curve more velocity.

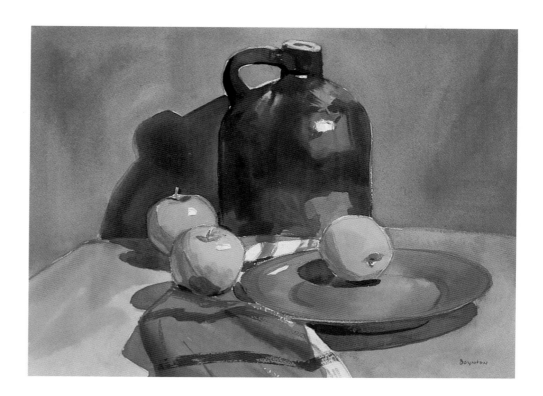

**S-Curve Composition:
Jug and Orange Plate
with Green Apples**
Watercolor, 12 x 16 inches.

The curve of the plate creates a crescent shape on the tablecloth to the right of the plate, echoing and re-inforcing that curve. Look at the shapes created by cropping the tablecloth on the right instead of show-ing the edge of the table and by showing some of the towel between the plate and the jug: Both keep the viewer's focus on the apple on the plate. I deliberately chose to include three apples, grouping them so that the single apple would call attention to itself. The shapes in the background—the large shape on the right, the small one above the neck of the jug, and a shape on the left that is smaller than the one on the right—give greater interest to the background.

The jug is intentionally not centered. The angle of the light is very important in creating the shape of the jug's cast shadow and its contrast to the shoulder of the jug. I took some artistic license in simplifying the cast shadow's shape. I made the shadow of the handle less complicated and more solid than it was in the setup. I wanted that shape to have its own curve and velocity, without any distraction from the shadow of the handle. As you can see, "editing" to enhance the overall effect is a very important part of creating a dy-namic composition.

Cropping

In addition to suggesting a life beyond the edges of the painting and allowing you to make your objects larger than they would be if you painted them all in their en-tirety, cropping can also direct the viewer's eye into the painting. Cropping a towel in the foreground, for example, so it is coming at the viewer on the hori-zontal edge of the painting creates an immediate en-try into the scene. There are several aproaches to cropping the table in a scene. If I am facing the table straight on, I often keep the front edge of the table out of the composition, so the strong horizontal of the edge will not create a barrier for the eye. I often have the table at an angle and even then crop the fore-ground corner.

Center of Interest

Creating a center of interest is not simply a matter of size, color, and composition. It also involves decisions about which areas to make more detailed than others. In general, it is good practice to downplay subordi-nate elements. In still lifes painted outdoors, for ex-ample, the grass or bushes in the background should not be as closely rendered as the objects on the table.

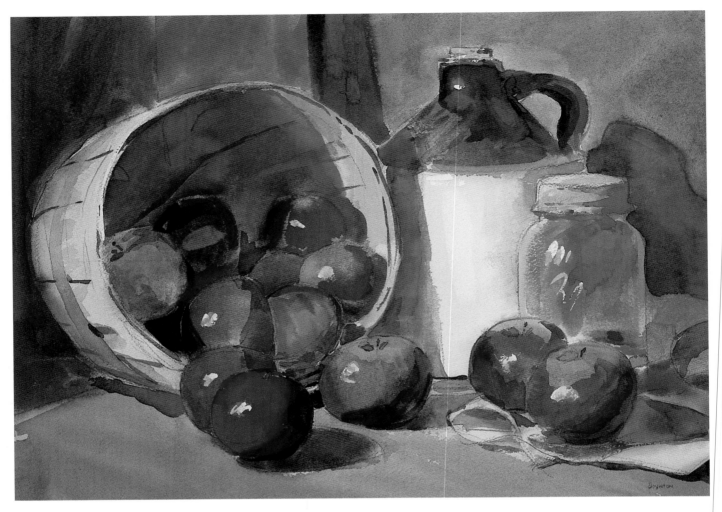

MAKING APPLESAUCE. *Watercolor, 12 x 16 inches.*

The brightly colored apples tumbling out of the basket here (a recurrent device in my painting) work to lead the viewer's eye into the picture where I want it to go. The apples point the way, lining the path into the picture, then the eye is directed around the basket, down the graduated shapes to the jug and then the jar. The circular composition, echoed in the shape of the basket, creates movement.

Keep It Simple; Keep It Spontaneous

Simpler is usually better. If you can remove an object from a setup without destroying the flow, the composition will be better without that object. Experimentation is important. Add one or more objects and stand back to see how the scene looks. Make a thumbnail drawing of one arrangement, then add or delete one or more objects and make another thumbnail so you can compare compositions and see if the change enhances your original idea.

Harvest, the painting on the facing page, is an example of poor composition. I did it as a demonstration, but arranged the objects in haste without considering where I wanted the painting to go. I pretty much just put everything I had in my car on the table and dived in. In your own painting, you will often be tempted to put too many objects in a setup, especially if you have a lot of interesting things from which to choose. Always stand back from a setup to see if you should remove something *before* you start to paint.

HARVEST. *Watercolor, 12 x 16 inches.*

This painting is much too busy. The stongly circular overall composition keeps the viewer's eye from leaving the painting, but there is no clear center of interest. Any one of several objects here could have starred in a painting: the apples in the bowl with the canning jar, the apples in the bucket, the apples on the cutting board, and the canning jar itself. The apples in the foreground form a nice path, but it leads the eye into the bucket, which is a dead end. The towel in the foreground is a good example of what not to do with anything striped. There are a lot of stripes, not just two or three, and this adds to the busyness of the painting and promotes confusion.

There is one more major key to good design: it can't look posed or contrived. Good design is natural and a little hidden from the viewer's first glance. As soon as a composition looks posed, it ceases to describe reality. It is hard to teach good composition; you must develop your eye and educate your intuition. You will be educated through your failures even more than your successes. Remember: Discovering what doesn't work, and figuring out why, is an important avenue to finding out what does work. I have looked for dynamic arrangements and shapes in nature and have developed that vision through experimentation in still life.

9
MORE VARIETY

*T*his chapter covers a number of effects which can be a challenge even for accomplished artists: keeping edges sharp, painting highly reflective and transparent surfaces; painting foliage and flowers; and painting black-and-white objects without using white or black paint.

WHITE BOWL WITH APPLES.

In this painting, the difference between the white in the light and the white in the shadow, and also the red in the light and the red in the shadow, is clear.

KEEPING EDGES SHARP

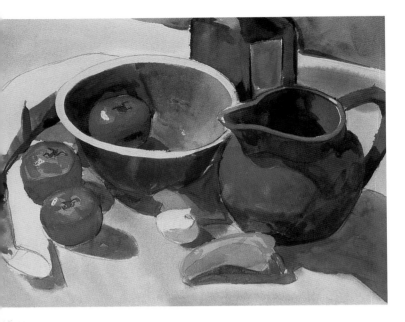

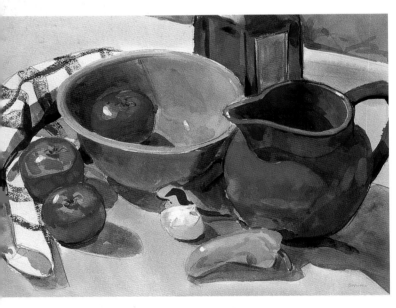

MASKING FOR SHARP EDGES

Top, painting with masking removed; *bottom,* completed painting.

In wet-on-wet painting, even with selective wetting, the places where edges meet is always an area for concern. Sometimes the artist will want these meeting places to be "lost and found," or blurred. Many edges, however, need to kept hard and sharp, especially in cubes, rectangular blocks, or any object that has sharply angled facets. Also, a cast shadow onto a curved surface can have a sharply delineated hard edge.

Using Masking Fluid

Once colors have run together at the boundary between a dark mass and a light mass of color, it is difficult obtain a sharply defined edge. Painting over the darker edge with the lighter color will not always cover over the bleeding of the dark into the light. If the light area is dry, however, using the dark paint up against the light area, where it will cover the bleeding, can sharpen the edge, but doing so may make the light area too small if the painter has not allowed for this from the beginning. And, if the dark area is not still wet enough, the painting will have what will appear as a dark stripe between the light area and the dark. To avoid these problems, the artist can either leave the light area dry from the beginning or use masking fluid to mask the edge where the light mass and dark mass come together. Using masking fluid to preserve the edge is something the watercolor painter must be familiar with, whether using a wet-on-wet technique or selective wetting.

In my early years in Impressionism, I generally sought subjects with strong light and shadow, which facilitated my progress in watercolor. To keep contrasts sharp in such scenes, however, I found I often needed to use masking fluid to preserve highlights and the lightest parts of white objects. After removing the masking, I often put some color in those areas later. Masking out the white areas first requires the painter to think about the painting in a way that is the opposite of thinking about the oil painting. In oil, the lights can be put in at the end. In watercolor, you have to think in reverse.

PAINTING GLASS AND METAL

Learning to paint glass successfully is difficult because each situation is unique, but it is also challenging and exciting. You must study each scene carefully and be able to make accurate judgments about light, dark, and color. You must learn to see the general color and value in variations in the glass and paint them with deftness. You have to learn to interpret what you see and select only the most important variations to include in your painting. In general, you want to keep the glass in your painting simple, maintaining the transparency of transparent glass and capturing the many reflections onto opaque glass.

Setting Up the Still Life with Glass

Compared to other objects, transparent glass rarely dominates a scene, yet the beauty of a transparent glass object lies in this very subtleness. Choose bottles that have interesting shapes and colors but are not overly complicated. Avoid bottles with more than one label and those with one large, cluttered label. If a bottle that you want to paint does have an intricate label, simplify it so there are a minimum of pattern and color changes.

When you are just starting out, you should also avoid clear class, that is, glass that has no color. Clear glass is very difficult to paint unless it contains a liquid, such as olive oil, red wine, or colored water. Another reason I recommend painting colored glass is that the thicker areas have more density of color than the thick areas of clear glass. Even when your glass bottle or jar is not clear glass, it is often a good idea to add a dark liquid. You must carefully observe the background where it shows through the glass. The bottle will often look darker in value and color than the background, even if the glass is transparent. If the background is very dark, however, the value of the bottle will probably look the same as the value of the background. In such cases, you need to make the background seen through the glass darker than it really is in order to distinguish the bottle from the background.

Beginners should also start out with square or rectangular glass objects, which have clearly defined color changes, rather than rounded objects, where the transitions are not so distinct.

I like to let some of the glass objects that I am going to use in a still life stand around gathering dust and grit. Dusty or gritty glass objects have a matte surface that is more opaque than the surface of a dust-free glass object, making the light and shadow areas a little more obvious and making it easier to give the objects a three-dimensional quality. A shiny, highly reflective surface means that you will have to contend with reflections that break up the mass; if you yield to the temptation to depict too many of the reflections, the form can be lost entirely.

WINE AND FRUIT. *14 x 20 inches.*

Notice how I simplified the label on the Chianti wine bottle in this painting. Corks and stoppers in a bottle help portray form. Masking fluid was used to preserve the rim of the colander and the spots of light shining through the holes in the colander. Those spots were then tinted with a little Cadmium Orange and Naples Yellow to show the oranges in the colander reflecting into the cast shadow of the colander on the tablecloth.

OUTDOOR STILL LIFE WITH SQUARE GREEN BOTTLE

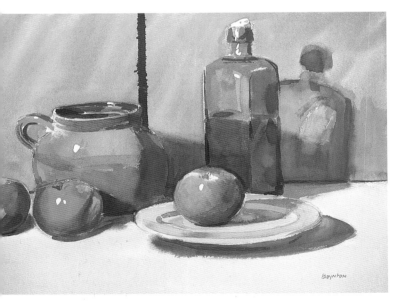

INDOOR STILL LIFE WITH SQUARE GREEN BOTTLE

In the still life on the left, the strong outdoor sunlight streams through both the olive oil bottle and the swirled glass tumbler, resulting in very bright, rich color in both objects. Every variation in form is clearly demonstrated by obvious color changes. The curved top of the bottle shows some blue-green sky reflection. The background also shows through. Moving downward onto the facet facing the viewer, we see first the strong olive-orange of the background, then the clean, clear yellow-olive of the tablecloth, which was achieved using Permanent Green Light and Cadmium Yellow. The colors showing through the thick base are less obvious colors; there is a strong olive, as well as a combination of Cadmium Red, Yellow Ocher, Venetian Red, and Viridian. On the right facet of the bottle we can see a green reflection of the foliage at the top and a pinker reflection of the tablecloth beneath that. Each facet of the bottle reads as one piece, rather than a mosaic with multiple color variations. I have done just enough to create transparency and form, but little else. The swirls of the tumbler are indicated very simply, and we can see the bottle as well as the tablecloth through the glass.

The green bottle in the indoor still life is the same one that was in the outdoor still life, and is in approximately the same position. I put some wine in the bottle, which gives both sides of the lower half a reddish color; only the top half of the bottle is transparent. The right side, which is in shadow, shows a reflection of the tablecloth and the background cloth, plus, toward the bottom, a blue-green quality that says "shadow"; this quality is not present on the lit side. The left side has a cast shadow from the apple. The light here is not as intense as the light outdoors, so the colors are mellow, quiet, and less obvious. I used Cobalt Blue mixed with Yellow Ocher in the see-through part of the bottle here.

Glass and Shadows

You don't really see cast shadows on transparent glass without a dark liquid in it like you do on opaque glass and objects. Unless the glass object is dusty, what you might be tempted to call a shadow is really a darker thickness of glass. The bottom of any glass object, whether round or square, is usually the thickest part.

Those areas of color are usually very dense, with a dark value. It requires a great deal of visual acuity and understanding to accurately portray that effect, but doing so helps give the object three dimensions.

The cast shadow of any glass object onto the tablecloth and background will be seen next to the object in addition to appearing through it. You must very carefully compare the color of the shadow seen through the glass to the portion of the shadow next to the glass. The shadow seen through the glass object will be tinted by the color of the glass, and the portion outside of the glass object will not be. Capturing the value and color differences between these two shadow masses produces the transparent effect.

Notice the way the light plays on the surface of the water in the painting of the canning jar; this elusive effect is captured perfectly here. The bottom of the glass is thicker than the top, and is a darker green. We can see the thickness of the glass on the sides of the jar below the waterline because their color is different from the color of the water and the background does not shine through the sides. The background and the tablecloth are both seen through the water, but we do not see a distinct line where the tablecloth meets the background. Above the water, the thickness of the sides of the jar is not evident, and the background shows through with less change in its color than the part that shows through the water. I described the form of the jar's dusty shoulders by capturing their misty quality. The shadow next to the jar where the light shines through the water takes on a dull greenish tinge, without any of the glowing green we see in the jar itself. It is not as dark as the shadow seen through the jar. The shadow on the background is actually not as dark as the background shadow seen through the left of the jar, and has less color variation. This is because the shadow seen through the jar is broken up more by the sides and shoulder of the jar, as well as reflection from it.

Painting Metal Surfaces

Metal surfaces come in a variety of colors and finishes, and many of them can be extremely difficult to depict. Like glass objects, each metal object is unique, and every setup will present its own chal-

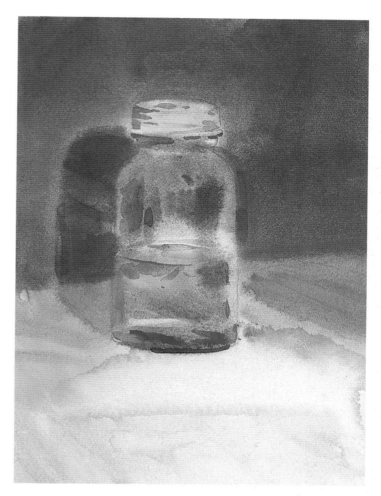

CANNING JAR

lenges. You can, however, make the job easier if you stay away from silver, stainless steel, and pewter; these metals, like clear glass, are colorless. Silver and stainless steel are also highly polished and reflective, and are likely to create confusing reflections. Highly reflective surfaces also have a tendency to dominate any scene they are in.

Copper and brass objects that are not highly polished are good choices. Reflections into copper and brass objects, especially when they are tarnished, are muted and obvious, in contrast to the reflections into highly polished surfaces, and copper and brass objects will not dominate your scene. Copper has a beautiful, subtle glow to it, and is harmonious with many other colors.

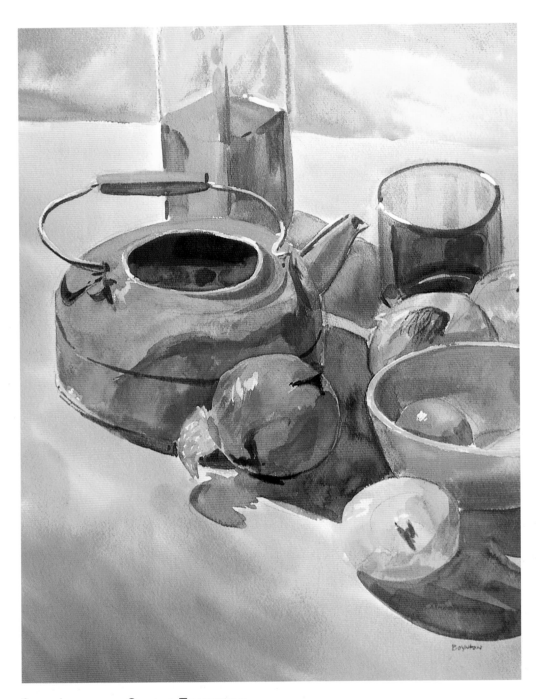

STILL LIFE WITH COPPER TEAKETTLE

I chose this kettle to illustrate the use of earth colors in painting copper. For the lit areas, I used Venetian Red and Naples Yellow, pushed warmer with Cadmium Orange. The shadow mass is generally Indian Red pushed with Cobalt Violet Deep Hue plus Viridian mixed with Chinese White to give the effect of the blue sky reflecting into the metal. I described the very dark inside of the kettle using Mars Violet and Ultramarine Violet for the mass. The halation from the rim throws a strong orange into the interior, represented with Venetian Red and Cadmium Orange. The oranges toward the base and the rosy color in the shoulder in the light add to the metallic effect, as do the dents in the surface. I represented the oxidation that I saw on the kettle by bits of blue-green.

PAINTING FLOWERS

Because I am not primarily a flower painter, very few of the still lifes in this book have flowers in them. However, the basic principles of painting the Impressionist watercolor also apply to painting flowers: The goal is to capture the light effect.

Setting Up

One of the first things you need to do when deciding on what will be in your still life with flowers is to consider the shape of the vase or other container for the flowers, and pick one that is suited to the blossoms it will hold. I usually choose a vase or other clear container that highlights the beauty of both the flowers and their stems as shapes in the painting. Some vases are more suited to small groups of flowers or single flower presentations. Other vases have proportions more suited to wider or taller groups of flowers. Just keep the container simple; remember that the flowers are more important than the vase. It is usually a good idea to choose a container with a mouth wide enough to let the flowers spread out slightly, so the shape of the blossoms will be distinct. With wide-mouth clear containers, you can arrange the flowers so that the stems cross, forming interesting shapes.

Of course, the flowers do not have to be in a vase. As with any other still life, you are creating a narrative, and you are in control of the story line. For example, you might set up pruning shears, garden gloves, and flowers lying on a table or counter top. You might have some flowers in a vase, with others lying on the table, waiting to be arranged.

When you put flowers into a still life, they often become the center of interest. If you want them to be the center of interest, you must carefully consider where within your painting that center is going to be and how to lead the viewer's eye to that spot. I place other objects, often including a draped towel, to lead the viewer's eye toward the flowers.

Most flowers are obvious, bright colors. You don't want the other elements in your painting to distract from or compete with the flowers, so most or all of the other objects should have less obvious, duller colors than the colors of the flowers.

If you want to make your flowers and vase the tallest objects in your painting, chose at least one that is medium height and one that is much shorter. After you have arranged the still life, look at it through your viewer and decide whether and how you want to crop the scene.

I tend to paint flowers in bunches of the same kind of flower. If the flower is very complicated, like a rose, I usually paint just one. Remember that this is Impressionist painting, not botanical illustration. Even students who are successfully painting other objects get bogged down by trying to paint flowers petal by petal and leaf by leaf. This is difficult even with simple flowers; with complicated ones, like lilacs, it is nearly impossible. In all cases, it is unnecessary. You will be surprised by how effectively you can show the observer of your painting what kind of flowers they are seeing with only a few details. Also, remember that distinctive leaf shapes are also clues to the identity of many kinds of flowers.

It is important to recognize flowers as a shape, rather than individual petals or even individual flowers. When you place your flowers in a container, create a design that is an interesting shape, with holes through it, convolutions with some of the flowers drooping, mixing tall and short flowers for more vertical interest. Stick to bunches of one color.

Modifying Your Palette

Not all flowers are strong, obvious colors. Hot pink azaleas are about as strong a color as you can get; pale lilac-blue phlox are very subtle. If you do choose bright, strongly colored flowers, you will find that it can be difficult to capture the brilliance of the colors, especially in the light mass. If you are going to paint a lot of flowers, you may want to add some colors to your palette. Opera, from Holbein, and Scarlet Lake will be particularly useful, especially with spring flowers, along with Cadmium Lemon. If you don't have the specific colors needed on your palette, remember that it is the relationship of a color against the background that makes even a generic "yellow" sing. As always, compare the things in the light to the

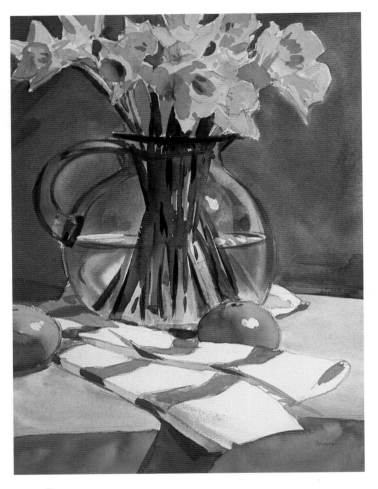

DAFFODILS

things in the shadow; getting that relationship right will often create the color you want. But, because flowers represent some of nature's most extreme color statements, sometimes you will have to go out and get a color that you can use straight from the tube to get the exact color of a particular flower.

For the daffodils I started by painting the clusters with light on the right and shadow on their left. I let the paint dry, then identified some individual flowers by drawing-in their trumpets. I then painted the shadows and halftones to further delineate form. Cropping the top of the daffodils puts the emphasis on their lower edges. Their overall shape is a crescent, keeping the viewer's eye within the painting and repeating the curve of the pitcher's handle. Seeing the stems through the glass makes the painting more interesting. I left some spaces between the stems so the background

would show through and give depth to the scene. The water magnifies the shapes in it, so the lower stems are larger than the parts out of the water. Also, water refracts the light so that the stems under the water are offset from those above the water. These effects are most obvious in the stems at either edge of the bunch.

Basic Guidelines

The easiest kinds of flower to start with are those that are basically flat disks. Start with just a few rather than a large bunch. The simplest ones have a single row of petals, like single daisies and pansies.

Put a few flowers in a glass or vase of water. As I said earlier, clear containers that show the water and stems are most interesting, but an opaque container is easier to start with; it lets you focus on the flowers without worrying about the stems and the glass container. Arrange the flowers so you see different views of them: some facing you, some facing sideways or away from you.

First, outline the shapes of the whole flowers. Try to identify the flat, elliptical disk of each blossom. With these very simple flowers, you can also outline some of the petals, edges that overlap, and the stems that are showing above the vase.

Try to identify how the light is hitting the flowers. Some will be in the light, some in the shadow, and some will have both light and shadow on them. If you are painting a larger bunch of flowers, try to identify clusters of blossoms within the bunch as shapes. Draw the spaces between clusters and also what is in the spaces, such as leaves, the background, or an object in the scene. As always, keep it as simple as possible.

Whether you are painting simple or complex blossoms, first establish the flower mass by painting the entire flower or bunch the dominant color. If you are painting daffodils, for example, paint the whole bunch yellow. Your watchwords here are "simplify, simplify, simplify." After you have established the mass, sketch in some of the flower shapes.

Next, go for the shadows and color variations. Just as in any painting, you must establish the light and shadow masses. The shadow masses in a bunch of flowers are often a little more complicated and broken up than shadows on other objects. The shadows

will depend to some degree on the shape of the mass. The shadows will also be more complicated. The flowers may cast shadows on each other, as well as on the container, the tablecloth, and the background.

Distinctively Shaped Flowers

Flowers like tulips, daffodils, and lilies have only a few petals that are arranged so that they can be easily identified by shape alone. Tulips are basically egg-shaped when closed and cup-shaped when open, with overlapping petals. Daffodils are a six-pointed disk from which protrudes a trumpet shape. Lilies have six pointed petals that curve back from the center into a flared trumpet shape. Tulips, daffodils, and lilies also have distinctive leaf shapes: tulip leaves are broad, daffodil leaves are long and narrow, and the thin leaves of lilies curve off from the stem at intervals.

In describing flowers with distinctive shapes, you will need to pay closer attention to color change and form, delineating their unique features. First, you identify clusters of blooms and outline the masses. After you have made your first statement of light and shadow, you must let the painting dry before proceeding. After it is dry, use your pencil to draw the distinctive shapes, such as the trumpets of the daffodils, and then finish by further refining the light and shadow and adding halftones.

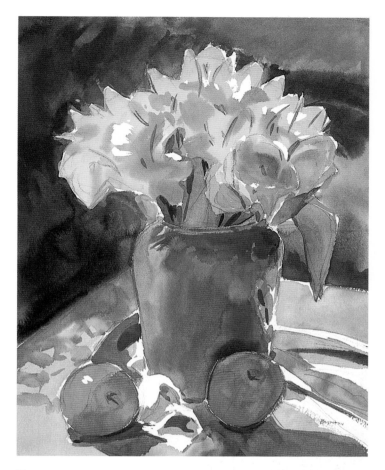

TULIPS

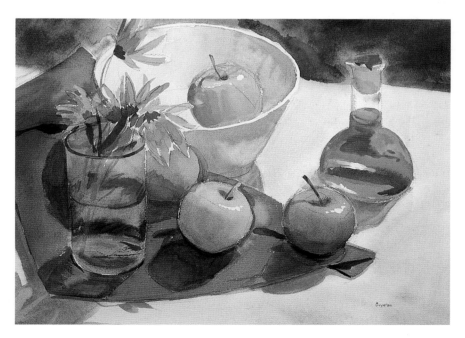

STILL LIFE WITH COREOPSIS

The flowers in this illustration were relatively easy to paint. Coreopsis have simple shapes; there are only a few of them here, and they are mostly separated from each other. These flowers are an accent, rather than the center of interest. I used the apples, the bowl, and the placement of the flowers to accentuate the turn of the bowl and to keep the viewer's eye in the painting.

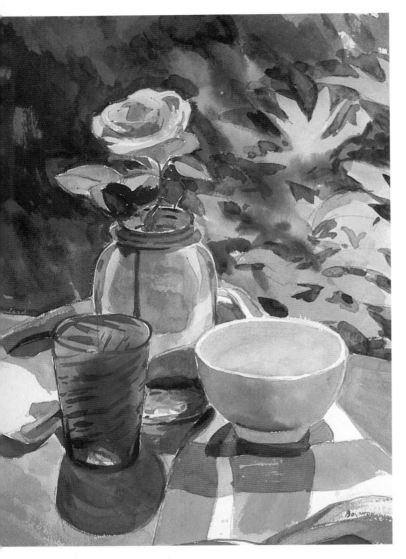

STILL LIFE WITH ROSE

I used a simple canning jar on a table outdoors because I liked the juxtaposition of the beauty and delicacy of the apricot bloom against the more utilitarian object. I kept the unique color of this rose in the light as clean as possible using a mixture of Naples Yellow and Cadmium Orange. When that first statement was dry, I put the shadow notes into the first color to depict the petals and the shape of the bloom. I included the rose leaves to make the scene look more natural. I specifically set up this scene so the entire rose would be in the light against the dark foliage to give contrast and intensity to the rose. The light and shadow shapes in the foliage on the right make it clear that this scene is outdoors.

Double Flowers

Flowers with multiple rows of petals, such as chrysanthemums, peonies, and roses, are more difficult to paint than simpler flowers. Most roses and double peonies are globe-shaped; chrysanthemums can be globe-shaped, or more of a half-ball. You have seen the facetted white ball in several earlier chapters, and have practiced depicting rounded objects. You use the same principle of depicting three values with color changes when painting one of these rounded flowers. First establish the masses of the flower's light and shadow, then go to the color changes that make them look rounded. Many double flowers are multicolored to some degree, and this can complicate their depiction because the masses are broken up. When painting a bunch of multicolored flowers, like some roses and dahlias, you should still follow the basic principles that have already been described: Identify the basic shapes of clusters first; put in light and shadow; then add details. Remember that the lightest color in the shadow must be darker than the darkest color in the light.

Compound Flowers

Compound flowers are those whose heads are made up of many small flowers, such as hydrangeas and lilacs. Even here, you do not need to depict every little flower. As always, establish the light and shadow masses. The shape of the flower heads helps establish their genus: mop-head hydrangeas are round, while lilacs are a drooping cone shape. Phlox are upright cones, and hyacinths are upright cylinders with a slightly rounded top. Leaves are especially helpful here. Once you have established the light and shadow masses and created rounded form, add a few detailed flowers in groups.

Look back at the painting of lilacs that appears on the very first page of this book. Only a few shadows were necessary to depict their distinct form. The shapes of the shadows, as well as the droopy cone shapes of the flower heads, define the species.

SOME MISCELLANEOUS SUBJECTS

Some subjects that are always a challenge, especially for beginners, are multicolored objects, grass and leaves, white and off-white obects, and black objects.

Surfaces with More Than One Color

Although multicolored objects can be exciting compositional elements, painting most of them requires very advanced skills. Stay away from such objects until you can describe light and shadow masses and variations in single-color objects with consistent success. Then and only then should you put a multicolored object into your painting, and even then you should limit the number of multicolored objects to one or a group of similar objects like red and yellow apples. Too many multicolored objects in the same painting may clash with one another, and distract from or even obscure the center of interest.

Keep the number of color variations in an object to a minimum. Too many colors in a complicated pattern break up the masses too much, and can make a painting too busy. Something like the blue and white towel in *Tub with Towel, Apples, and Bottle* (page 78) is relatively easy to paint, and it will add excitement to your still life, but if you pick an object with more than two or three colors, or an object with multiple shades of the same color, you risk overdoing it.

Grass and Bushes

Because the grass and bushes in a still life are never focal points, but are always backdrops, they do not need to be as detailed as they must be in a landscape painting. However, there are several things you need to know before you can paint them successfully.

As I said earlier, the local-color label for grass— "green"—tells us little about the actual colors of grass. Grass contains the yellow of the sun in spring and summer. Early spring grass is a lighter and brighter green, and has more yellow than summer or fall grass. The reflection of the sky into the individual blades of grass results in blues. Dormant grass will be mostly tan, and patches of raw earth will be one of the earth colors. No two scenes containing grass are alike.

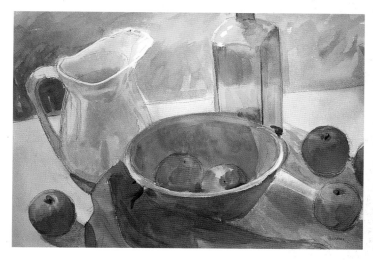

SUNNY AFTERNOON STILL LIFE

The grass in the background in this painting is a mixture of blue and yellow, with a little Permanent Light Green as an accent. The color and value of the grass are related to the color and value of the orange tablecloth so it looks like a floating island in a sea of green.

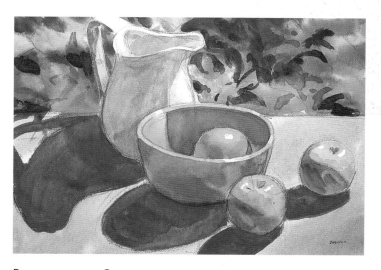

BACKGROUND BUSHES

This painting is one of many outdoor still lifes in this book with foliage and/or grass as background. Distinct leaf shapes can be seen, but not so many that the viewer's focus is shifted from the objects in the foreground.

Grass and bushes are usually best depicted through a combination of warm and cool colors of the same value.

Different atmospheric conditions have a profound effect on the color of grass. On a sunny day, the blues of the sky will reflect into the shadows. In the grass in the light, you will see more warm colors, for example, Cadmium Yellow. A mixture of Cadmium Yellow and Cerulean Blue is often a good, lively grass color. On a gray day the areas fully in the light will be a duller mix of Cobalt Blue, Lemon Yellow, possibly some Permanent Green Light, and one of the violets. If there is no rain, less violet will show. On a sunny day, you will put down the warmth first, since it is the dominant effect, then the cool. On a gray day, you will do the opposite, putting down the cool color and then the warm over it.

Painting White Objects

White is a chameleon; it takes on the reflected colors of objects around it as well as the color of the light falling on it. White has no local color of its own. The color in the light demonstrates the color temperature of the light shining on the object. The color of the lighted side of the object will be the telling description of the light effect. There is always warmth in the light. The light masses, which are tinted by the color of the light falling on them, will be a brighter color than the shadows. If you want to express these effects successfully, you must be sure of what you see and be able to paint it in swift, sure strokes. If either your vision or your brush is uncertain, the results will be muddy.

Reflections are a very important part of any scene with a white object. The light masses of white objects will reflect the color of other objects in the scene. The shadow masses will not be directly influenced by the color of the light source, but reflections of other objects, as well as the cloths, will be even more obvious in the shadow mass of a white object than in the light mass. Portraying these reflections into the shadow mass without darkening the shadow too much can be tricky. With other objects, keeping the shadow dark enough is the problem; with a white object, the challenge is keeping the shadow light enough. When you are painting the shadow mass of a white object, you need to see an averaging of color on that side. The best

way to see this is to squint your eyes enough to blur your vision. This will allow you to see the dominant effect, which is often a cool color with warm light reflected into it. You must first emphasize the coolness. The light is fundamentally warm, so it reflects into the shadow as a warm color. However, the color is not as warm as that in the areas that are directly in the light. The reflected light in the shadow must be duller in color than the object that is creating the reflection, and also darker in value. Even with reflected light in it, the shadow must still look like a shadow, not a mul-

EXERCISE 1: *Painting a White Block in Color*

1. Set up a white block in front of a colored background and on a colored tablecloth. Turn the block so that it has both a lighted side and a shadowed side showing.

2. Paint this scene in color without using any black paint, gray paint, or unmixed white paint.

EXERCISE 2: *Painting a Facetted Ball in Color*

1. Set up a facetted ball if you have one. If you don't, turn to page 77 and use the white facetted ball shown in the photograph there as a model.

2. Paint the ball in color without using any black paint, gray paint, or unmixed white paint.

EXERCISE 3: *Painting a White Object With Reflections*

1. On a colored tablecloth, set up a scene with one rounded white object and a colored object that reflects into the white object.

2. Paint the scene.

ticolored object. You must recognize the shadow as being fundamentally a single color mass; you must not allow the reflected variations to break up that mass.

One of the challenges in painting white is that there must be the same value difference between white in the light and the other lit objects as there is between white in the shadow and the other shadow masses. When in doubt as to the color, concentrate on keeping the warmth in the light and the coolness in the shadow. You need to see the light up against the shadow to see the often subtle warmth in the light. It is not possible to overstate the importance of value and brightness in painting white objects.

Choosing Objects

Beginners learning to paint white objects should start with square objects with matte surfaces, then progress to rounded objects with matte surfaces. Learning to paint white is difficult enough without complicating the process by trying to deal with a highly reflective surface at the same time.

There are some special considerations when arranging a scene that contains a white object. The light value of white objects becomes an important element in the setup. You need to make deliberate decisions about how to use the inherent reflectivity of the white surfaces. For example, you will want to place your white object next to a brightly colored object so that strong color will be reflected into the shadowed side of the white object, creating an opalescent effect in the shadow.

Off-White Objects

Indoors, especially with beginners, I use a strong incandescent light source to make the light and shadow more obvious. In natural light, the same white object will be what we call an off-white. Learning to express natural light is a big part of still life painting, and doing so requires you to develop your skill in painting off-whites.

Off-white objects do have some inherent color of their own that will tint the shadows and the reflections to some extent, and so the colors reflected into the off-white objects will be dulled and muted to varying degrees.

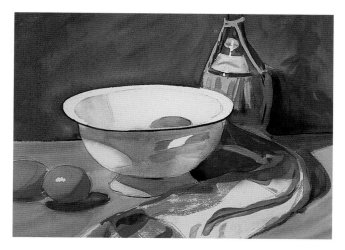

STILL LIFE WITH WHITE COLANDER, INCANDESCENT LIGHT

The white colander in this scene under incandescent light has a nice glow. The reflection from the towel stands out in relation to the somberness of most of the rest of the scene. The dark background here was deliberately chosen to emphasize the colander, helping it pop out as the dominant mass in the painting. The light on the inside of the bowl is faintly colored with diluted Naples Yellow to show its warmth, while the shadow on the inside shows reflections from the tangerine.

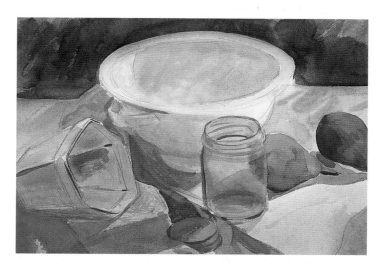

OUTDOOR STILL LIFE WITH WHITE COLANDER, HAZY SUMMER AFTERNOON

This is the same colander and towel used in the previous illustration, but the light conditions make them look very different. The ethereal, glowing appearance of the colander is due to the beautiful reflection of the bluish sky filtered through haze. The overall effect is one of a peaceful harmony, with a very soft focus throughout.

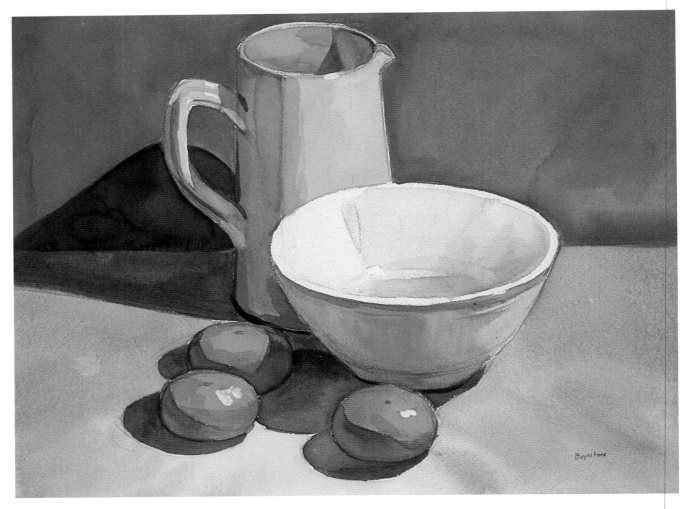

OFF-WHITE PITCHER, WHITE BOWL, AND TANGERINES, INCANDESCENT LIGHT

Pitcher: The overall color is Naples Yellow with a very small amount of Yellow Ocher in the light. There is some Cadmium Red with Chinese White for the halftone. The shadowed portion is Yellow Ocher + Permanent Green Light, with a touch of Mars Violet in the shadows on the handle, on the extreme left edge, and along the bottom.

Bowl: The shadowed right inside and bottom is Mars Violet and Viridian + Chinese White, shading to the left into Naples Yellow with a touch of Venetian Red + Chinese White for the halftone. Once I put these colors down, I added Naples Yellow with a tiny amount of Venetian Red and a lot of Chinese White into the left inside of the bowl in the light. The lighted area of the bowl is paler than any part of the pitcher, including the lighted part, which maintains the distinction between white and off-white. The bright tangerines reflect strongly into the underside of the bowl and back into the cast shadow.

EXERCISE 4: *Painting Off-White Objects*

1. Find an off-white object, put it on a tablecloth in the sun, and paint it. Make paintings of other off-white objects until you are satisfied that you are able to capture the light effect on off-white objects.

2. Add an object in another color placed so it influences the color of the off-white object and paint the setup. Repeat with other off-white objects influenced by objects of different colors.

Off-white colors are rarely a single color directly off the palette. Most often, they are mixtures of complementary colors like violets plus earth colors or greens plus reds. Using off-white objects in your scenes will help you learn to use your palette in a more subtle way. When you use earth tones as quiet warm colors that reflect into your off-white object, you are forced to investigate those colors more thoroughly in order to depict the subtlety you see. As you can see by examining the accompanying painting, the colors in the light do not have to be bright and glowing to say "light."

Painting Black Objects

If you put a black block outside in the sun, you will see that the lighted side is warm and the side in shadow is not, just like every other object you have observed under the same conditions. While white objects have to be the lightest value in both sun and shadow, black objects must be the darkest. The lighted side of the black object must be darker than any other object in the light, and the shadow side of the black object must be darker than any other object in shadow. You must keep that relationship clearly in place in your painting. Although black objects will have minimal reflected color, you will see some reflection. When a brightly colored cloth or object is reflecting into the shadowed side of a black object, there will be halation.

Depicting black in the light usually requires a combination of subtle earth colors. You will use warm colors such as Mars Violet, Indian Red, and/or Yellow Ocher with Naples Yellow or Chinese White. A really dark object will appear warmer in the light outdoors.

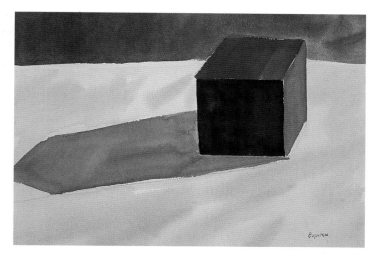

BLACK BLOCK IN LATE AFTERNOON SUN

The lit side has a strong yellow-orange cast and the part of the top facing the sun also has some yellow-orange light. The farther away from the slanting light the top surface is, the more obvious the blue sky reflection is. On the top I first put down Cadmium Scarlet with a little Viridian and then put in the strong blue sky reflection wet-on-wet. We see the strong sky reflection also in the cast shadow, which is reflecting that blue-violet light back into the shaded side of the block.

When another object overlaps with the dark object, the halation from that object will make the dark object reddish where the two objects overlap.

To depict black in the shadow you will need a predominantly cool and dark color, such as Ultramarine Blue, Ultramarine Violet, or Viridian, as the dominant color. Subtle earthy warms, such as Mars Violet, can then be added. You may even want to experiment with Vandyke Brown or Burnt Umber; you will not use these two colors in any other situation, however. These colors are very obscure, and when you mix them with Ultramarine Violet, Ultramarine Blue, or Viridian, you get a very dark color that tends toward, but is not quite, black.

Shiny black objects are, in general, a poor choice for still lifes for the same reason that highly reflective metal objects are a poor choice: the many confusing reflections become more important than the mass.

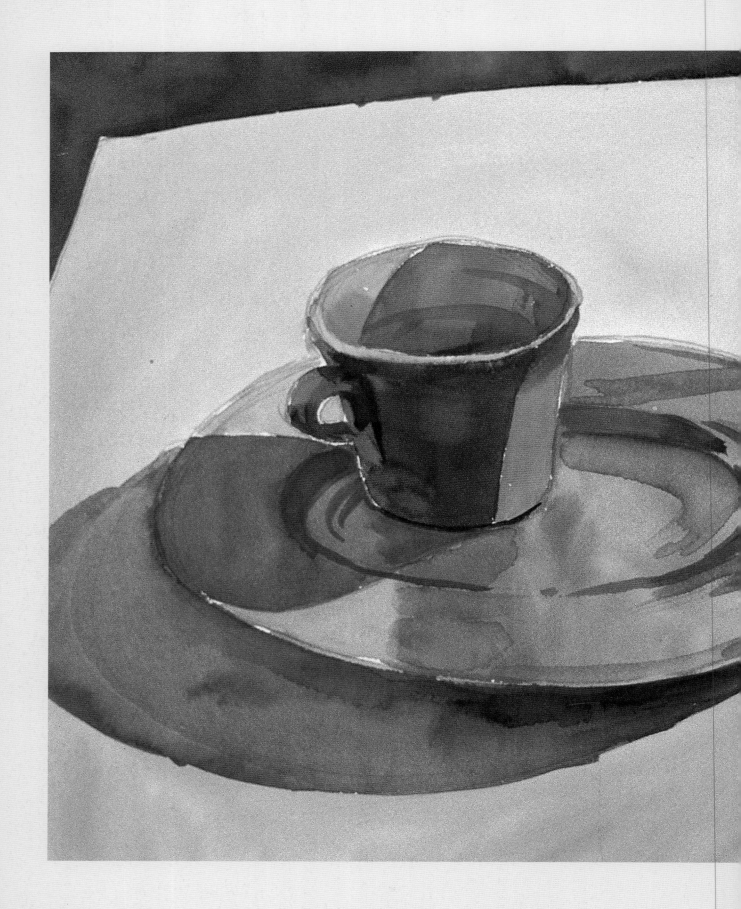

Boynton

10
PAINTING THE CHANGING LIGHT

In previous chapters, we briefly touched on how different the same scene can look depending on the light conditions, and you have done several exercises designed to sharpen your ability to see the differences between indoor and outdoor light. In this chapter, we first develop the subject of indoor versus outdoor light in more detail, and then offer guidelines for putting into practice what you have learned about outdoor light at different times of the day.

BLUE PLATE IN BRIGHT SUNLIGHT
The blues in this painting are much warmer than any blue on your palette.

INDOOR AND OUTDOOR LIGHT

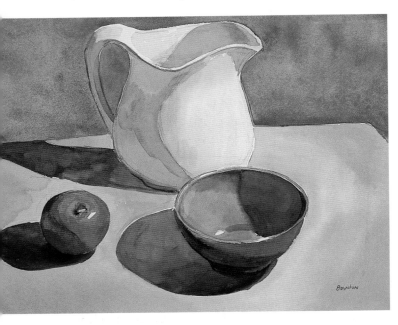

INDOOR STILL LIFE, INCANDESCENT LIGHT,
12 x 16 inches.

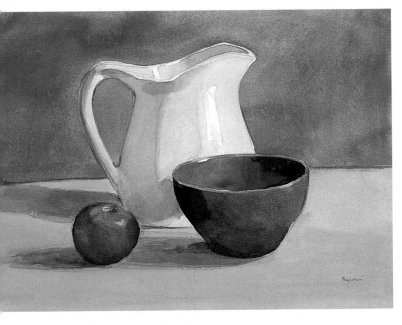

INDOOR STILL LIFE, NATURAL LIGHT

Both the indoor and outdoor settings in the paintings that follow are bathed in light, but outdoors there is more variation in color because the light contains the whole natural spectrum. The range of light indoors is narrower and pitched toward yellow-orange and the shadows indoors are not blue because there is no blue sky above them.

Incandescent Light

The incandescent light gives the light masses in this painting a strong yellow-orange cast. In the light, the pitcher contains yellow and violet. Another effect is that the cast shadows on the table are quite dark and all the shadows contain a lot of reflected light. The tablecloth reflects into the shadowed side of the white pitcher. The shadowed inside of the pitcher is not the same color as the shadowed outside because there is no reflection from the tablecloth. There is, however, a small reflection of the green background. The cast shadows are several colors mixed together because they are influenced by the background, other objects, the ceiling, and the walls. The violet in the white pitcher and on the shoulders of the apple are the result of the ceiling reflecting into them.

The shadowed outside of the bowl reflects the tablecloth and also has some greenish light, while the shadow on the inside is less influenced by reflections, so it is much brighter. This outside shadow is the bluest color in the scene; it is a combination of Cobalt Blue, Ultramarine Violet, and a little green, with some very subtle Cadmium Red on the right upper edge.

The apples in the light are quite bright and tend toward orange. I used a mixture of obvious, bright Cadmiums.

Natural Light Indoors

The indoor still life on the left was deliberately set up near a window so that the light was coming from only one direction. If you have a skylight you must cover it. You have already looked at indoor setups with the lights on and with the lights off. The predominant effect with the lights off is coolness; the yellow-orange effect due to incandescent light is absent. Even strong

light through a window (as long as it is not direct sunlight) will not produce dark shadows. Of course, the light from outside will be dimmer on an overcast day than on a sunny one. Colors are subtler and cooler than colors under incandescent light. Even the tablecloth in this painting is a cooler and quieter color than it was under incandescent light. On the right it is slightly Cadmium Red with a little Cobalt Violet, and on the left there is a little green reflecting from the background. The background cloth looks predominantly blue-green.

The cast shadows on the tablecloth are very quiet and quite cool. I used a mixture of Cobalt Violet Deep and Mars Violet with a little Venetian Red for them.

The white pitcher in the light has a complementary color combination; there are both reds and greens, with an overall slightly greenish effect.

The bowl is a much deeper blue than it was under incandescent light and there is less differentiation between the light and shadow. The outside is purple-gray with a little green in the shadow, while the inside is bluish with a slight green tint in the light. The shadows on the bowl are both dark, with the shadow on the inside being slightly warm.

The apple in natural light is much duller than it was under incandescent light, and so the apple colors are more earthy—Venetian Red and Indian Red with only a little of the slightly stronger Cadmiums—to capture that overall dimming.

Outdoor Light on a Clear Day

In sunlight, the light is stronger and the colors are more intense than they are under artificial light, and the contrast between light and shadow is more striking. The light effect outdoors varies dramatically and the only way to learn to see and paint nature's various moods is to paint outdoors at all times of day and in all four seasons.

Start learning to paint outdoors on a clear, sunny day, when the contrast in light and shadow is most obvious. The shadows outdoors are not usually as dark as those indoors. Outdoor light on a clear day is very bright, and because of the sun reflecting into the shadows, they will rarely be truly dark. There are some exceptions: If you are looking deep into the inside of an object or a window or doorway, or under a bush, the shadows you see will be much darker than any shadow in the open.

The light on a clear day will be very warm. Although the warmth of the strong sunlight will be stronger than the cool of the blue, the shadows outdoors will be more obviously cool than shadows indoors because of the blue sky reflecting into them.

While it is important to learn to paint under all light conditions, some times are better than others for painting outdoors. Avoid the hours between 11 a.m. and 2 p.m., when the sun is most directly overhead, because the shadows are not as pronounced. The hours from 9 a.m. to 11 a.m. and 2 p.m to 5 p.m. are good choices for beginners because the light changes more slowly then. If possible, begin in the summer. It is harder to paint in spring and fall because the weather is often unpredictable, and the shorter the day, the more quickly the light changes.

The color of the light is most dramatic at either end of the day—about an hour after dawn and 1 to 2 hours before sunset—and the shadows are the most interesting at those times. The sunset effect at the end of the day produces a glow on any objects it hits that is especially rich and dramatic. However, early morning and late afternoon light changes rapidly, so if you choose to paint at those times it is especially important to paint rapidly and to choose a small size paper.

Cool Colors on a Sunny Day

On a clear sunny day, without any haze, you need to be able to see and paint both the warmth of the sunlight and the effect of the blue sky. Before trying to describe the light effect of sun on an object that is a cool color, look at the sky to see the warm-cool variations in color there. Those variations are subtle and very difficult to see, but they are always there and you can train your eye to see them. It may take years to learn to see them fully, but once you do, they will rarely seem absent.

Look at the colors on your palette. If you have arranged it as outlined in Chapter 4, Lemon Yellow is adjacent to the greens. If you pretend that the colors on your palette are in a circle, Permanent Rose is next to Mars Violet. Lemon Yellow is the coolest yellow

PROVINCETOWN HOUSES.
Watercolor, 12 x 16 inches.

In this painting you can see how dark the shadows in the doorways and windows are. The depth of the shadows under the bushes is described in dark, rich colors.

and Permanent Rose is the coolest red. These two colors are very helpful in creating the warmth of the sun in a blue object. You can use either of them, depending on the time of day. In the early morning, around 8 to 10 a.m, you'll need Permanent Rose mixed with a lot of water, to get a pinkish cast. Later, from 10 a.m. to noon, you will want to use less water. In mid-afternoon, from noon to 4 p.m., the warmth is yellower, and in late afternoon, from 4 to 6 p.m., Cadmium Scarlet or Cadmium Red are likely to be good choices. The color descriptions for these different times of day change according to the changing temperature of the light. There is no formula that I can give you. A combination that works beautifully one day may be utterly wrong on another.

Some situations will require Permanent Green Light and Cobalt Violet. These colors are a little cooler than Lemon Yellow or Permanent Rose, but you have to learn to see when they will describe the effect you see. For late afternoon still lifes, if you use Cadmium Scarlet to get the warmth in the blue, you are likely to end up with brown; this is where Cobalt Violet plus Permanent Rose can help.

Clear Mid-Morning

In mid-morning the light is more dynamic than earlier, but softer than it will be later in the day. The lighted side of the pitcher in the painting on the right has a little Naples Yellow, but the ivory color is fairly quiet compared with the same area in late afternoon light. The bright orange light on the tablecloth, representing the warmth of the daylight, is a mixture of Cadmium Orange and Naples Yellow. The color of the vibrant, sunlit apple is influenced by the blue of the sky, represented by violet added to the Cadmium Red of the top plane. The strong, warm light throws yellows and oranges into the foliage on the left and the right. Even the light mass of the bowl has a little pink. All these colors harmonize to create the mid-morning light effect.

The shadows show a strong value and temperature contrast to the light masses. They contain a lot of blue from the sky. There are also violets in the tablecloth, blue-violets in the shadowed side of the pitcher, Cobalt Violet Deep on the inside of the bowl, and Indian Red and Cadmium Red in the shadowed side of the apple. The cast shadows are very dark.

The shadowed inside of the bowl is not a pure blue, but has a greenish quality, perhaps from the bushes reflecting into it. The outside shadowed part of the bowl is a combination of Cobalt Blue and, to make it a little greener, Viridian, and it also contains reflections from the tablecloth. The overall sunny quality of this painting is seen not just in the strong light, but also in the reflected light into the shadows. We see this especially to the left of the apple and in the reflection of the white pitcher into the shadow between the apple and the bowl.

There is also halation, which is a sort of halo created around part of an object in very strong light as the result of light splashing into the background or into the shadows, where the right side of the pitcher comes against the deep blues and greens of the background. We can also see the apple reflecting into the pitcher, the bushes reflecting into the left edge of the pitcher, the tablecloth reflecting into the handle of the pitcher and into the overhang of the top edge of the pitcher, and the tablecloth reflecting into the outside of the bowl.

OUTDOOR STILL LIFE, CLEAR MID-MORNING

OUTDOOR STILL LIFE, CLEAR LATE AFTERNOON
On a clear day outdoors, especially at the end of the day, the intense, angled sunlight washes everything in warmth.

The bushes in the background now have a lot of light and shadow, and more variation in color is evident. The cast shadow of the block has more color, with the strong blue sky reflection making it cooler than it was earlier, yet it also has some light in it and the warmth of the tablecloth comes through.

Clear Late Afternoon

As sunset approaches, the angle of the light from the sun becomes lower and lower, heightening contrast, and the light effect is heightened by the color of the reddish light before sunset. In this still life we can see this reddish light effect especially on the lighted side of the pitcher, which is a strong yellow and yellow-orange plus scarlet. The apple is a rich Cadmium Red and Cadmium Scarlet. The background to the left of the pitcher is a strong Cadmium Yellow, and the shadow is a dark color contrasted with the light. In general, colors in the shadow tend to be a complementary color to the light and dark in value. The horizontal surface of the tablecloth gets the light glancing off the high points, and its folds and surface texture become important elements of the scene. Neither the lighted nor the shadowed areas on the tablecloth are clearly one color.

Compared with the way the tablecloth looked in the morning, now it is a strong orange-red with distinct shadows, represented by mauve and Cobalt Violet. The warm outdoor light is stronger than

incandescent light. There is even more identifiable orange-yellow in objects lighted by the late afternoon sun, and the cast shadows are more identifiably blue-violet plus some reds. The blues in the shadowed parts of the pitcher are very strong and they are influenced by the colors around them. Even the blue bowl in the sunlight has an orangey hint from the sun.

Gray Day

Don't tackle a gray, or overcast, day until you have learned to see and paint the light effect on a sunny day at different times and seasons. Then you can start to challenge yourself by painting the differences between a cloudy day and a sunny day.

The light effect on a gray, or overcast, day varies with the thickness of the cloud cover, as well as whether there is drizzle or fog. The light on a gray day is similar to natural light indoors. In the absence of bright, direct light neither light nor shadow dominates. Indoors, light from a window falls horizontally across the scene, but on a gray day outdoors, the light is primarily from above, so the horizontal planes will be lighter in value than the vertical planes. Of course, this effect will vary depending on the degree of overcast. The light may be a little more directional under a light cloud cover than when there are denser, darker clouds. Even so, the clouds filter out the color of the light seen at different times on a sunny day. Gray days

mainly have sky light that results in silvery, warm-cool combinations. The effect of the light on local color is not as obvious as when it is tinted by sunlight so an earthier, more somber palette is required. Colors are obscure, subtle, and confused, rather than clear and clean. Even with a heavy overcast, however, the colors are a little stronger and more obvious, as well as warmer, than they are under natural light indoors.

I chose to paint the picture shown here on a *very* overcast day to emphasize the differences between the light conditions on a gray day and the light conditions on a sunny day.

First, look at how dull the scene below looks compared with the two sunny day paintings on the previous page. The contrast between light and shadow is reduced because of the thick atmosphere veiling the sun. While the objects barely reflect into each other, there is a lot of sky reflected into the horizontal surfaces, making them cooler: the tablecloth, the pitcher spout, the inside of the bowl, and the shoulders of the apple. The surfaces that point toward the tablecloth have some reflected light near their bottoms.

On a gray day it is important to identify the overall color of objects where they come against the background, as well as to compare them to each other. I had to ask myself, "Is the overall color of the pitcher lighter or darker than adjacent areas?" It is lighter than the background, but about the same value as the tablecloth. Value statements are so similar in low light that they are hard to identify.

The other objects here are clearly dark, and one of the unique challenges of gray-day, low-light painting is depicting them accurately. Since light and shadow sides are not clearly differentiated, separating light and shadow is not a priority and I did not start with specifically trying to separate light and shadow but concentrated even more than usual on getting the colors just right, knowing that doing so would indicate what little value differences there were.

In the pitcher there are subtle reflections of the background bushes. The insides of both the pitcher and bowl are subtly different from their outsides because the insides have different reflections than the outsides. The left side of the pitcher is shaded violet, not to differentiate light and shadow, but to model form. The green reflection from the background also helps describe the form of the object.

A Few Words of Warning

Painting outside does present some difficulties. You have to carefully study the shadows and learn to simplify them. There are many, many reflections into the shadows outdoors, and if you try to paint them all, you can lose sight of your main goal: to get the light and shadow masses right. In your enthusiasm to get every inspiring detail into your painting, you may be tempted to abandon the basic principles of painting you have learned thus far.

Another problem in outdoor painting is that the weather, which can be unpredictable, becomes a factor. On a dry, sunny day, for example, your paint will dry very rapidly, and you must adjust your painting speed accordingly. This is a situation where selective wetting is almost required. Even if you decide to wet the whole paper, it will almost certainly dry before you can get to all of it, which means that you will have to use selective wetting by default. High humidity presents a different challenge. On very humid days, at key junctures—for example, when you need to let the background dry before sharpening the edges of your objects—you may need to take the painting inside or into your car with the heater on to dry it. Don't be tempted to try to improve your painting in the later stages without letting it dry; it won't work. You must have even more patience than usual on damp days.

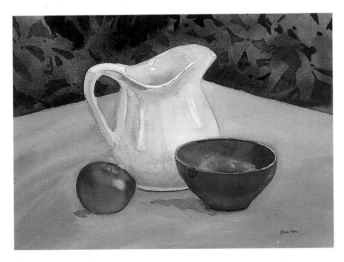

OUTDOOR STILL LIFE, GRAY DAY

Hazy Day

Hazy days are most common in the warmer months, especially near water. The light effect on a hazy day is somewhere between the light effect on a clear day and the light effect on an overcast day. The light will be directional, but more subdued than on a clear day, and so the shadows will be present, but weak. The warmth of the sunlight will also be somewhere between the warmth on a clear day and the warmth on a gray day. Like the gray day, the light effect will vary widely depending on the amount of haze and how much sunlight can shine through it. Usually you can see the sun in the sky through the haze, but the horizon, especially over water, may disappear. There will be some reflected light, usually more than on a gray day but less than on a sunny day. The cast shadows and the horizontal surfaces have a milky quality. The background, like the horizon, may be blurred by the haze the farther away it is. The more haze you have to look through to the background, the more blurred it will be.

In this painting of red, blue, and yellow blocks, you can see the warmth of the sun, and stronger shadows than you would see on a gray day. Both the warmth of the light and the darkness of the shadows, however, are less than they would be on a sunny day.

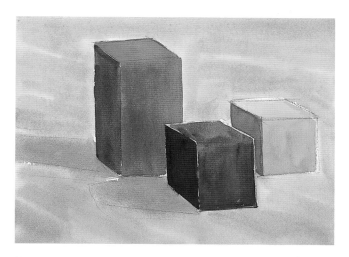

HAZY DAY BLOCK STUDY

The tablecloth is an especially good depiction of this effect: The weak shadows to the left of the objects show a descriptive but very subtle color contrast between the sunny areas and the cast shadows. The same effect is demonstrated in the blocks. The red block in the light is not as obvious a contrast in color and value to the shadow mass as we would see on a clear day. The shadow mass on the blue block shows some tablecloth reflection but it is not obvious and the light and shadow are present but not highly contrasted. The light and shadow on the yellow block also does not show high contrast. There is no background showing, but you can see the milky effect in the tops of the blocks and in the dim cast shadows.

EXERCISE 1: *Painting at Different Times of the Day*

Set up and paint a red block and a yellow block or other simple objects outside, on a clear sunny day, at four different times of day: early morning, mid-morning, mid-afternoon, and late afternoon.

EXERCISE 2: *Painting Cool Objects in Sunlight*

1. Set up a scene with objects in several different cool colors.

2. Paint this scene outside at four different times of day. Pay close attention to keeping the colors cool, while also describing the warmth of the light.

EXERCISE 3: *Clear Day vs. Cloudy Day*

1. Choose three objects and a tablecloth for a still life setup, following the basic principles outlined on page 82.

2. Set up your objects outside on a sunny day. The background should be foliage. Paint the scene.

3. Set up the same object outside on a cloudy, or gray, day, and paint the scene, paying careful attention to how the light effects differ from those you saw on the sunny day.

INDEX